DANIEL
JOHNSTON

DANIEL JOHNSTON

A PORTRAIT OF THE ARTIST
AS A POTTER IN NORTH CAROLINA

HENRY GLASSIE

Photography and Drawings by the Author

INDIANA UNIVERSITY PRESS

This book is a publication of

Indiana University Press
Office of Scholarly Publishing
Herman B Wells Library 350
1320 East 10th Street
Bloomington, Indiana 47405 USA

iupress.indiana.edu

Cataloging information is available from the Library of Congress.

ISBN 978-0-253-04843-1 (paperback)

1 2 3 4 5 25 24 23 22 21 20

Frontispiece: Daniel Johnston in front of his shop, 2014

Contents

for

Mark Hewitt

DANIEL
JOHNSTON

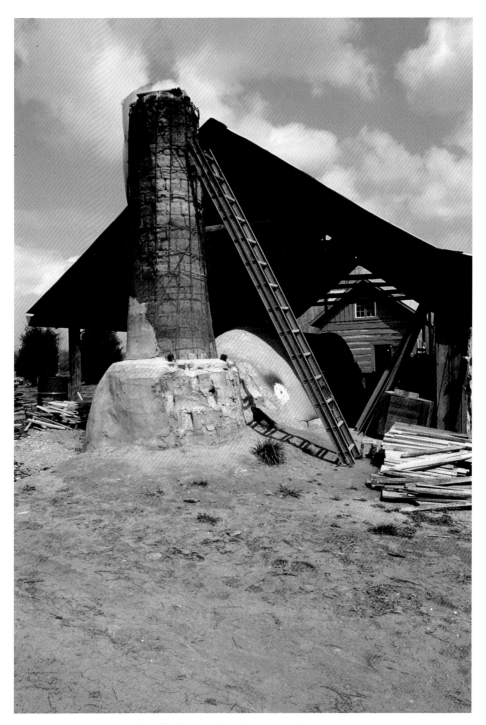

Daniel Johnston's big kiln and log shop, 2007

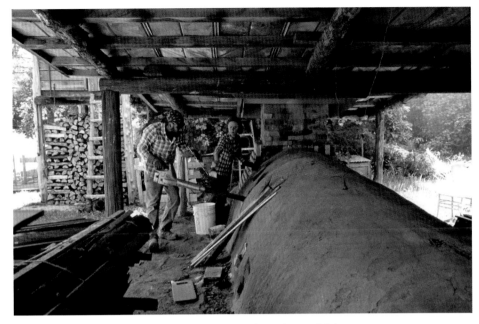

Daniel and Kate salting the small kiln, 2014

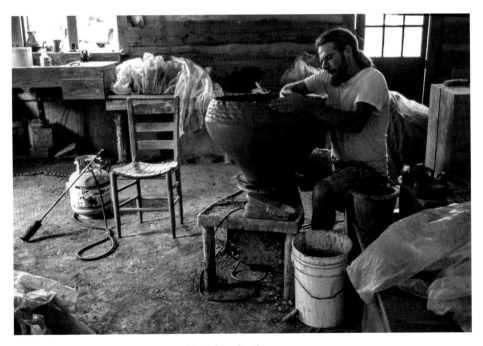

Daniel in the shop, 2012

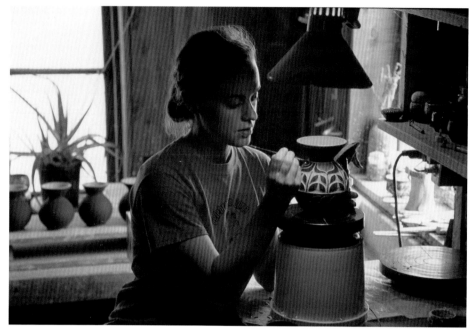

Kate Johnston at work, 2016

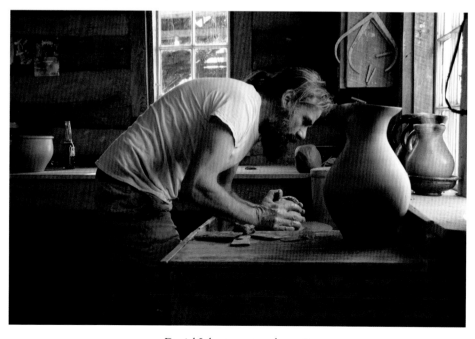

Daniel Johnston at work, 2018

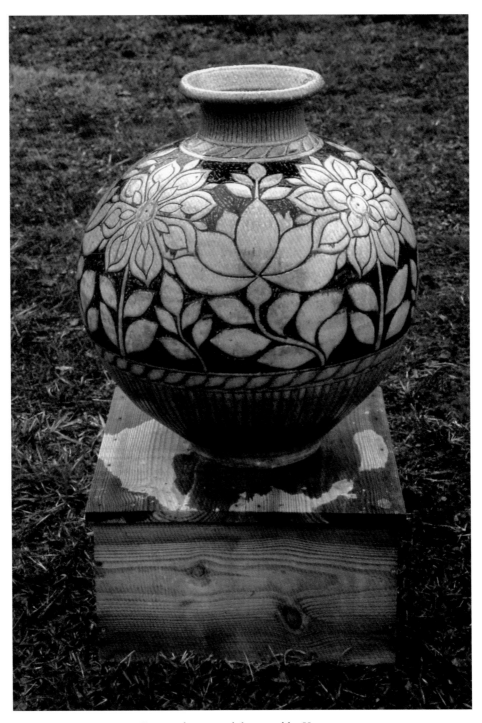

Big pot thrown and decorated by Kate, 2014

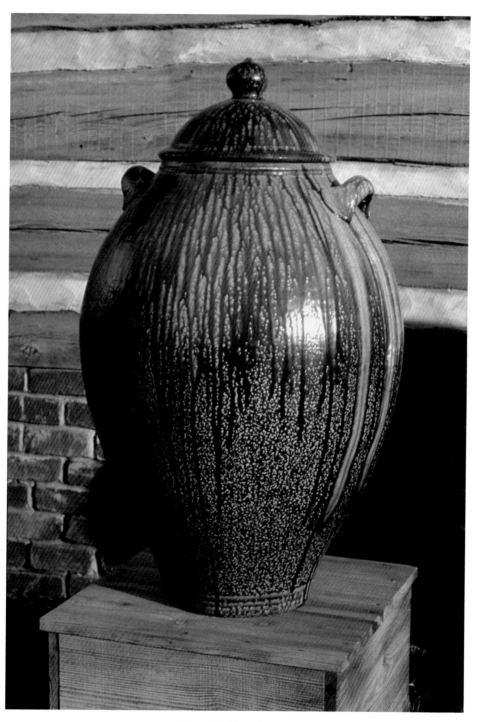

Big pot by Daniel, 2012

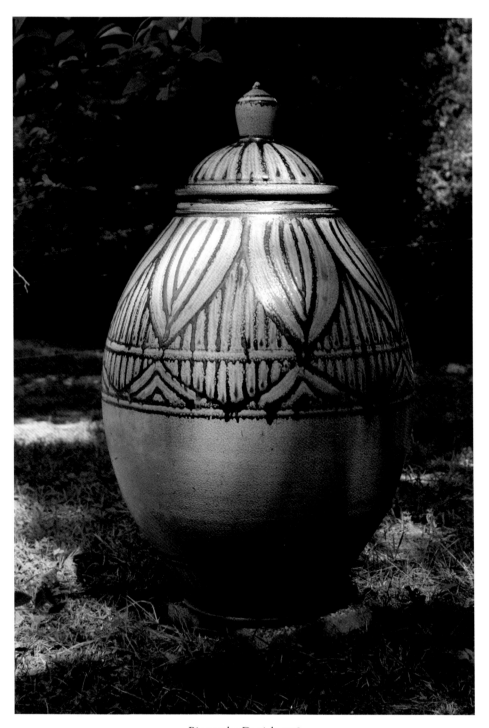

Big pot by Daniel, 2018

Big pots by Daniel Johnston in progress, July 2012

1

BEGINNINGS

No art movement in the united states today is more sincere and significant than the one carried forward by the potters of North Carolina. Within this movement, united by cooperation and competition, Mark Hewitt has been for thirty years the most influential. At an international conference on wood-firing held at Star, North Carolina, in June of 2017, Mark said that the pace in Carolina ceramics is currently set by Daniel Johnston. "He has raised the ante for us all."

Surrounded by the sounds of a southern summer's night, Daniel Johnston and I are sitting in the screen porch of his home above the log workshop he built. It is July 5, 2012. We have been friends for five years, and we are recording the first of the intimate interviews that will roll on for another seven years. Daniel begins by saying he was born in 1977 and raised on a farm in Randolph County. With good clay for turning and stands of pine for burning, Randolph County belongs to the old potters' district that swings around Seagrove in the Piedmont of North Carolina.

Daniel's childhood was over, he says, at the age of five when he began working with his father on a farm of two hundred acres with two hundred head of cattle. At work he learned, as farmboys do, how to manage and repair the equipment, gaining the confidence to solve, with hand and brain, any problem he meets — in plumbing, wiring, welding, carpentry, or pottery.

His early interest in art was strange, Daniel says, "because there was no influence that I was aware of. But I would make these little block sculptures, from wood in the woodpile, and I would glue them together. And that fasci-

Daniel at five or six

nated me — that you could take something that existed and turn it into something else." His father showed him how to operate a power saw, and learning to fit bits of wood together "really opened my mind to the idea that you can manipulate materials. And it really struck me: at that age I realized you could build absolutely anything. It was just putting things together. As long as you understood the theory, you got it."

The family left the farm and Daniel began living "a fairly normal American boy life in the suburbs," but he longed for the country. "It was a real loss of place, a loss of self. We were of the land. We were the farm; it was part of us." Daniel missed the farm and, as he grew, school proved annoying. He was given facts to memorize, but no explanations, and the end came in a class on the American Revolution. He was told a simple patriotic tale, but he wanted to know both sides of the story, and he quit, dropped out of high school.

Daniel already owned a piece of land and was supporting himself. At sixteen he saw an advertisement in the newspaper for ten acres of land in Randolph County that cost no more than the Mustang of his dreams. "I remembered back to the farm and how much I was part of the land, and it brought all of that back to me, that power that land has for poor people." Now his thought has widened, but then he felt, as a poor person, that "getting a piece of land was power; it was your life. It's interesting to look back now. I've just had the realization that it's like a peasant actually getting to own a piece of land."

10

Randolph County, 2018

Daniel's shack, refurbished for his apprentices, 2016

He built a shack to live in. It stands still, downhill on the land where in time he would build a big kiln and the log workshop above which he lives with his wife, Kate, a talented potter too.

Needing money and remembering the joy of building a barn with his father, Daniel wanted work that fulfilled the whole person, satisfying and uniting the mind and body. He might have worked as a carpenter, but the furniture factories of his region were in decline. The pottery business, though, remained robust, and, Daniel says:

"I stopped at J.B. Cole's pottery in Seagrove and asked if they needed any help making pots. They didn't need help making pots, but they needed some labor, so I got a job, you know, laboring for them." He made five dollars an hour, and saw that the potters, doing piece-work and paid by the pound, made more, so he asked if he could make pots too. They gave him a trial week, "a short time to learn," but by the end of the week he was making a hundred pie plates a day. "And," Daniel concludes, "I went on to throw twenty thousand pots a year in Seagrove."

Through repetitive acts, Daniel came to competence. Work at the wheel got built into his body, became second nature, and he was delighted to be working

in the shop beside Nell Cole Graves. Burlon Craig, the hero of Charles G. — Terry — Zug's magisterial history of North Carolina's pottery, *Turners and Burners*, was amazed to hear that a woman was a great potter. He traveled from the Catawba Valley in the west to watch Nell Cole Graves at the wheel, and she was, Burlon said, "throwing them things out. She was fast!" Sid Luck, winner of the North Carolina Heritage Award in 2014, told me she threw swiftly, and the walls of her pots were so thin that her coffee mugs came to a nearly dangerous razor-thin edge. Daniel remembers, "Nell Cole Graves was great to work with; she was really fantastic. She was eighty-three at the time that I was working with her. She really didn't have much instruction for me. It was all by example, and I would watch her."

Not by instruction, but by example and watching — that's how potters in Japan, Turkey, Italy, and Brazil have told me they learned. Daniel goes on, "She was brilliant, Nell Cole Graves. And I remember the day she turned around — and I guess it was the highest compliment she could give me — she looked at one of my pots and she said, That looks just like something my dad would've made. She was a beautiful woman, and even at the age of eighty-three she had that charm in her eye, and it was wonderful."

Daniel got all the work he could handle in Seagrove, making good money, teaching himself about form, learning what pleased the customers, but he experienced moments of rage:

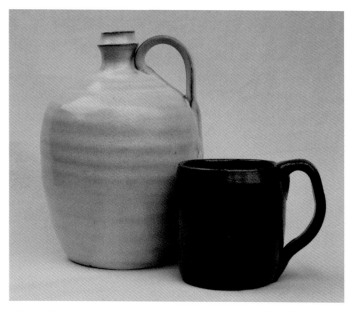

From J.B. Cole's shop: a jug by his son Waymon Cole and a mug by
his daughter Nell Cole Graves

Mark and Carol Hewitt's place, 2006

Mark Hewitt between his shop and kiln, 2008

"I knew there was something I did not know, that I knew was out there. It couldn't be this simple. I didn't know what the answer was, and it drove me mad. And I hated myself during that time.

"Coincidentally, I met Mark Hewitt at a conference in Asheboro. I had known about him. I knew he made these big pots, and I knew he wood-fired, but I really didn't know much about him.

"So, he asked me to come over and help him get ready for a firing, and I said, Yeah. I went over and helped him with the firing. It was kind of eye-opening to me. I saw the large kiln. I saw his nice pots. And it started confusing me, and that's the reason I had to go to Mark's. There were so many opportunities to mess up."

Daniel Johnston was a practiced production potter. Mark Hewitt needed help and hired him. When Daniel first entered Mark's home, he says, "A wave of something comes over me. I looked around and I saw these pots that I didn't understand. The whole atmosphere put a weight on me. I felt, you know, the atmosphere of the place. It was this really nice old farmhouse."

Something deep, at once rural and sophisticated, troubled Daniel's mind. After a lunch served on handsome, handmade plates, they went to work. A broadcast from the Metropolitan Opera was playing in the background. Mark told me he considered turning it off, since it would be alien to a country boy, but he was enjoying it and he thought, "I'll make Daniel listen to it; I'm going to hold his feet to the fire. He didn't flinch." Daniel told me, "Mark put an opera on the radio the first day I was there. I listened to this really long opera. It didn't offend me. I wasn't bothered by it. I was really grateful for that experience. I was starved for that.

"And so, I went back a couple of times to help him, you know, when they were loading the kiln, and then shortly after that Mark asked if I wanted to work with him, to be his apprentice."

That was the beginning, Daniel later told me, of the most important time in his life, the time when he worked as Mark's apprentice.

Mark Hewitt, English by birth, introduced the system of formal apprenticeships to modern North Carolina. In the southern United States, pottery knowledge has been customarily transmitted within familial lines. The young learn, as on a farm, by working beside older members of their families. So it was in northeastern Georgia in the Meaders, Hewell, and Ferguson families. In North Carolina, Ben Owen III began learning with his grandfather, the great Ben Owen, as influential in his day as Mark Hewitt is in ours. Chad Brown

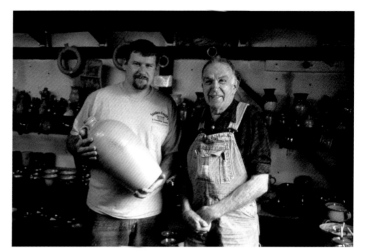

Sid Luck and his son Matt, 2010

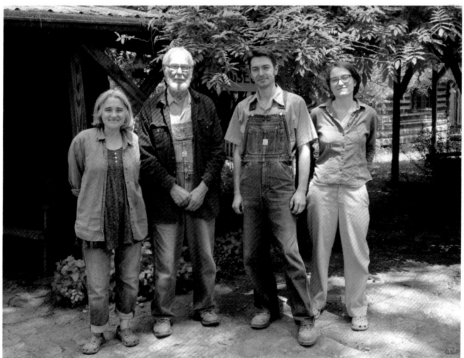

Pam, Vernon, Travis, and Bayle Owens, 2013

first learned in the familial line of descent from William Henry Chrisco, whose fine old I-house still stands near Jugtown. At Jugtown, Vernon Owens, who learned from his father Melvin, joined with his wife, Pam, to train their children, Travis and Bayle. Sid Luck, with four generations of potters behind him, taught his sons, Jason and Matt.

Mark Hewitt's first line of learning was also familial. He was born in the Potteries, in Stoke-on-Trent. In a recent lecture at Yale, Mark introduced himself as "the son, grandson, and great-grandson of industrial potters," and he told me that his father, a director at Spode, was the source of the precision and grace in his own work. Mark, though, was excited in youth by the writings of Bernard Leach, which carried the vision of a modern artistic spirit wed in the individual with respect for craft traditions.

Inspired by William Morris's critique of industrialization and his hope for worthy work and artistic fellowship, Bernard Leach worked with Kenzan and Tomimoto in Japan, then returned with Hamada, in 1920, to set up his workshop at St. Ives in Cornwall. There, in 1923, Michael Cardew became, in Leach's words, "my first, and best, student." A few months after Cardew's arrival, Shōji Hamada exhibited his work in London and went home to Japan, leaving Michael Cardew to take his place. Cardew slept in Hamada's old bedroom, worked in Hamada's old shed, and learned — "painlessly, almost unconsciously" he wrote — at Leach's side in St. Ives.

Then, after Michael Cardew had twice gone to West Africa and twice returned to England, Svend Bayer, who was drawn by the power in his pots, apprenticed with Cardew at Wenford Bridge, in 1969. A quarter of a century later, Svend remembered and wrote that "Michael never taught in a formal sense; he just got on with whatever he was doing." Svend learned beside him, and Michael Cardew had "an impact of parental proportions" on Svend Bayer's life. In her superb biography of Michael Cardew, *The Last Sane Man*, Tanya Harrod reports that, in 1978, Mark Hewitt, "tall with Victorian good looks," took Svend Bayer's place as Cardew's chief apprentice at the Wenford Bridge Pottery in Cornwall.

The stone bridge at Wenford steps over the River Camel, carrying the road that bends and rises past Cardew's old shop. It brings Mark Hewitt "lovely memories of a place where cash was not king, where technology was held at bay," and Michael Cardew, "an old man who was still bonkers about pots," provided a "paternal and familial environment" in which Svend then Mark "learned by osmosis." Mark's apprenticeship began in 1977, the year of Daniel's birth, and ended in 1979, not long before Michael Cardew's death in 1983. So, the noble line in English ceramic artistry runs from Leach, through Cardew, to Mark Hewitt.

Following a long and tiring journey through America, giving lectures and visiting schools, including Alfred University, Bernard Leach wrote in 1950 that

Mark Hewitt, 1986

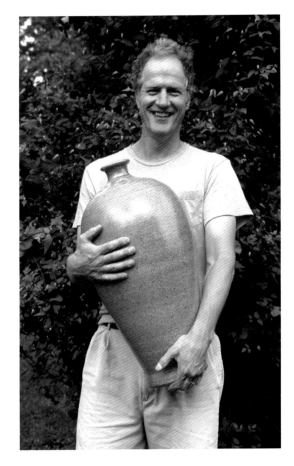

Mark Hewitt, 2004

true artists develop despite or without formal education in art. Students, he said, learn best in an atelier beside a master who offers little instruction but oversees a working environment in which students teach themselves through practice. Unimpressed by the individualistic efforts of modern American potters, Leach imagined a solution. A master from the Old World, where traditions are deeply rooted, might come to the United States and set up a workshop where apprentices could learn while working. He seems to have predicted Mark Hewitt's arrival and success.

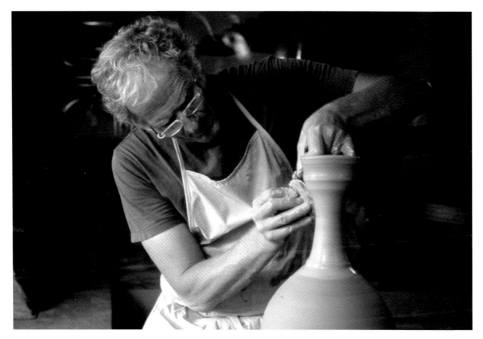

Mark Hewitt at work, 2013

After a trip to Japan, Mark returned to the United States, where he had earlier worked with Todd Piker in Connecticut. This time he was looking for clay, wood, and a lively society of working potters. He married Carol and then, in 1983, the year of Cardew's death, they bought a farm near Pittsboro, far enough from Seagrove to preserve independence, yet close enough to enable collegial exchange.

When Mark built his shop and big kiln, he got help from his neighbors, but as a potter he worked solo in the beginning. "I was unsure of myself," he said, "and didn't particularly like the work I was doing. And the work was not generating a lot of money." Then as the work improved, as his confidence and command developed and sales increased, Mark needed help in the pottery. The time had come to take on apprentices who could supply labor in the mornings and make pots in the afternoons, gaining pay for their work, "not a lot, but enough to make it worth their while." Mark remembers:

"Of course, I had been trained as an apprentice, and I began thinking, well, Cardew was very good at what he did. He was generous enough to take apprentices on, and he had something significant to tell people. And he was making really, really good pots throughout his life.

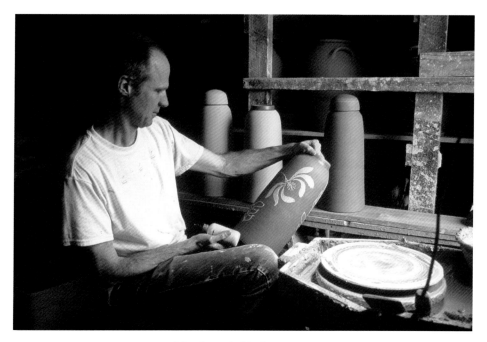

Matt Jones in his shop, 2012

"And if I could give that gift, it felt like the passing of a legacy that was deeply significant. And important. It had to do with materials particularly. And it had to do with skill. It had to do with wood-firing. It had to be locally based.

"That's how it started. It was a sort of synchronicity of a natural authority dovetailing with an expanding market and a growing awareness that the apprenticeship that I had worked actually allowed me to set up a business that might flourish."

Mark passed the legacy on to his apprentices, Daniel third among them. And so, the Leach line continues in North Carolina, running through the four of Mark's apprentices who have set up successful, independent operations in the state: Matt Jones, Daniel Johnston, Alex Matisse, and Joseph Sand. And the line runs on through Daniel's apprentices: first John Vigeland — currently in partnership with Alex Matisse at the East Fork Pottery in the mountains of western North Carolina — then Bill Jones and Andrew Dutcher, and now Charlie Hayes, Natalie Novak, and Jacob Craig.

Joseph Sand and Alex Matisse when they were Mark Hewitt's apprentices, 2009

Charlie Hayes and Natalie Novak, Daniel Johnston's apprentices, 2018

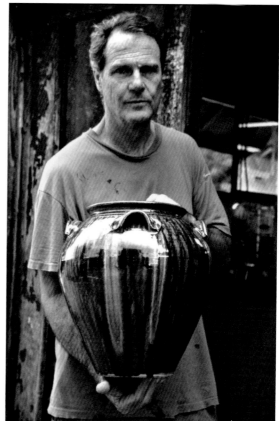

Kim Ellington, 2013

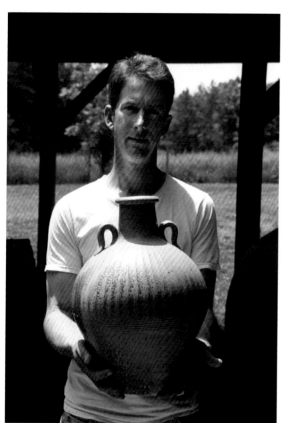

David Stuempfle, 2004

Naomi Dalglish and Michael Hunt, 2012

Now, follow the Leach line through North Carolina, gathering the apprentices who remained in the state. Add the potters who began learning in the family: Ben Owen, Chad Brown, Vernon and Travis Owens, Sid Luck and his sons. Add Daniel's wife, Kate, who was born in New Jersey, and Vernon's wife, Pam, who was born in New Hampshire. Add David Stuempfle, born in Pennsylvania, who worked with Melvin and Vernon Owens before establishing his own operation not far from Seagrove. Add Kim Ellington, who mixed what he learned in school with what he learned from Burlon Craig and works, a master of the kiln, in the Catawba Valley. Then add Donna Craven, Michael Hunt, and Naomi Dalglish, and you have some idea of the people who connect into a loose network of influence, assistance, and social association, together driving the contemporary art movement in North Carolina.

The movement's presence is marked, but certainly not exclusively, by big stoneware pots and big wood-fired kilns. It is a benefit, Mark Hewitt said, that Carolina's movement runs beyond the attention of most art critics, so the potters can avoid the disruptions and temptations of fleeting fashions and bear down on the creation of actual works of art.

The apprentice's wheel in Mark Hewitt's shop, 2018

2

APPRENTICESHIP

Daniel worked with Mark for four years, from 1997 to 2001, always along with another apprentice. Money was the first topic. Mark and Carol promised that he would make enough, about a thousand dollars a month, to pay his bills. Daniel thinks back:

"What I guess Mark saw in me was naiveness, energy, probably honesty. I wasn't smart. I was bright, intelligent, but I wasn't smart, you know. But I asked a bunch of questions, and I exposed myself: I'd give you everything I had."

Daniel wonders what Mark thought, so I asked him, and Mark said that in the beginning Daniel impressed him with his energy and his freewheeling ability to do what had to be done. "And he had a humility," Mark said, "that was endearing from the get-go. And he just seemed like a sweet young fellow. He was willing and he was humble." To be willing and humble, that's the apt attitude for a strong young man yearning to learn.

Daniel continues, "So, I decided I'd go to work for him. The first year was just hell; it was one of the worst years of my life, the first year I worked at Mark's. Man, I felt like I'd gotten dropped on a different planet."

In Seagrove, Daniel had been the kid who was throwing better than the old guys, who quit every afternoon with two hundred dollars in his pocket, but now, he says, "All of a sudden I couldn't throw anything. Mark was the guy who was good. I had learned some bad habits, and I was teaching myself at Mark's. It was a struggle. I had come to the realization that maybe I wasn't as good as I thought I was, which was a hard thing for an eighteen-year-old to admit."

Bad habits, Daniel says, and Mark recalls that when Daniel began throwing pots in his shop, "he'd been working down at Seagrove. So he had a facility, but it was careless, sloppy. If you are working for a production pottery, it doesn't matter whether the shapes are good or not. You are after speed and the money at the end of the day."

The first year was hell. Daniel got up early, drove east to Pittsboro, worked eight hours at Mark's, then returned to Seagrove, working four hours more to make some extra cash. At Mark's, Daniel was baffled and frustrated by all the "academic talk" about Leach and Cardew, men he had never heard of before. But his relationship with Mark was good, he says, and by "the second year I started getting into the groove. I really started making some headway. I started making a little bit more money, probably started handling my money better. I stopped working at Seagrove so much. And with the pots my technical skills started coming around."

By the second year, Bernard Leach, Michael Cardew, Svend Bayer, and Clive Bowen had become distinct and admirable characters in Daniel's historical understanding, and he wanted to go to England. "Me and Mark had gotten close at the point," Daniel says, "and he was really excited for me to go to England." Cleverly to keep him at work and generously to let him go, Daniel was allowed to work overtime, accumulating a month of back pay. Daniel says:

"And so, I went to England and worked with Clive Bowen and Svend Bayer. It was only when I went to England that I really learned who Mark was." Daniel borrowed a bicycle from Clive Bowen and rode from Devon to Cornwall along the route Svend and Mark had taken to begin their apprenticeships with Michael Cardew. "There was something fantastic," Daniel says, "about literally following in their footsteps. And being by myself, and having to spend, you know, six hours on a bicycle, thinking about nothing but: this is where Mark and Svend walked."

At Wenford in Cardew's old workshop, Daniel met Seth, the master's eldest son, then quietly climbed upstairs to find "an aesthetic goldmine" in a dusty crowd of Cardew's pots in storage. "Nobody knew I was there. And I'm sitting up there by myself, surrounded by these pots. At that point, I learned what Mark was. I knew what he stood for. And I learned that it was more than Mark, and it's more than me, and it is more than Cardew. And if we are the best we can ever be, we will just barely get to be part of it.

"It was the culmination of someone being as pure and working as hard as they could for their entire life. And I was sitting right slam in the middle of it.

Michael Cardew's old shop, Wenford Bridge, Cornwall, 2018

"It was powerful. It was powerful."

In that moment of revelation, Daniel was swept into history and converted from a skilled production potter into an aspiring artist. An artist certainly by the definition Bernard Leach derived from his reading of William Morris and his friendship with Yanagi, Kawai, and Hamada, the theorists of the Mingei movement in Japan — artists do the best they can, sincerely making things as well as they can be made, while accepting responsibility for the tradition they have inherited and the needs of the people around them.

Alone with his bike, Daniel looked over "the beautiful green fields that rolled off into the ocean." At work in Devon with Clive Bowen and Svend Bayer, his mind was rattled, his eyes were opened. "Everything poured in. I guess because of the emotional state I was in, I was able to really see for the first time."

At Shebbear in Devon, Daniel was thrilled by Clive Bowen's suave motion in decorating slipware. "God, I saw Clive sweep his arm when he was decorating, and his hand was far from the jar. He would squirt the slip out and the slip would slide through the air and land on the pot and just roll around. And his pots were fantastic. The decoration just sinks into the pots. I mean, what I know about decoration, I know from Clive."

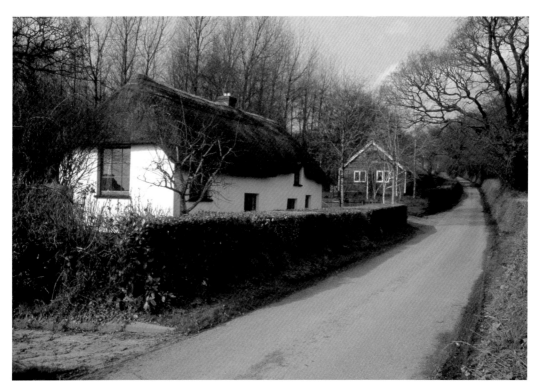

Svend Bayer's home and shop, Sheepwash, Devon, 2015

From that time to this, when Daniel decorates a pot, he is apt to swing his arm freely, shadowing the spontaneity that excited him when he watched Clive Bowen at work. "Clive's brilliant to be around," Daniel says, "because there's not the drive and there's not the ambition. He is so warm, so embodied and nonjudgmental — though full of intelligence — that he can just go and easily create something beautiful, brilliant."

It was different in Sheepwash at Svend Bayer's. Daniel had heard too many stories about Cardew and Svend, about Svend and Mark. When they met, Daniel felt that he and Svend were so alike in personality that things between them could never run smoothly. "Clive, I would have scrubbed his bathroom. Mark, I had sort of fallen in love with Mark at that time. And Svend, I recognized enough in myself, and in him, that we didn't hit it off. But I think Svend's fantastic, and his pots are some of the most fantastic things that have ever been created." Daniel split wood for Svend to use in firing, but, he says, "I knew what I'd get from Svend was nothing he was going to tell me. I would go into his studio and look at his pots and get what I wanted from him. And that was plenty."

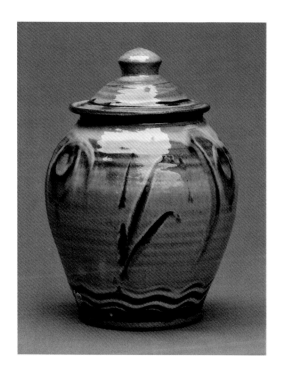

Lidded jar by Clive Bowen.
10 inches tall, 2015

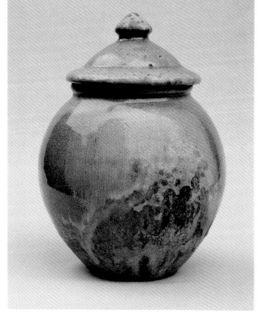

Lidded jar by Svend Bayer.
9½ inches tall, 2015

Svend makes lidded jars. So does Clive, so did Bernard Leach and Michael Cardew. All four of them are represented by lidded jars in the gallery dedicated to twentieth-century studio pottery at the Victoria and Albert Museum in London. It follows that Mark Hewitt would also become a master of the lidded jar, and the lidded jar is Daniel's favorite form. By studying the pots made before him, by striving earnestly on his own, Daniel has slowly refined his forms toward perfection. In 2015, when Daniel had made more than seven hundred big pots, he created a massive lidded jar that was, in his estimation, the best pot he had yet made.

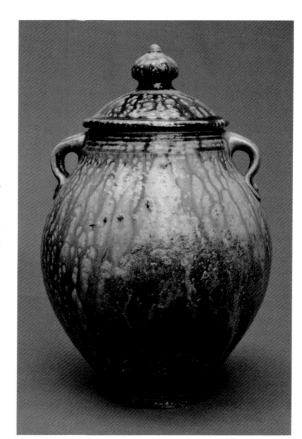

Lidded jar by
Daniel Johnston.
Ash-glazed and salt-glazed,
14 inches tall, 2012

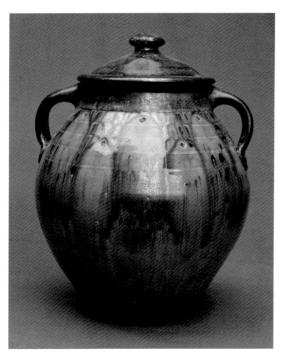

Lidded jar by Mark Hewitt.
14 inches tall, 2002

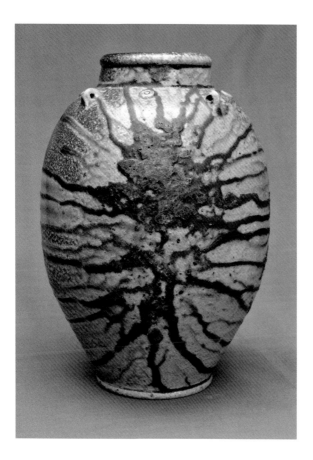

Side-fired jar by
Daniel Johnston.
12 inches tall, 2011

In Devon, Daniel marveled at the effects Svend Bayer achieves in the kiln. Svend fires for four days at high heat to get the colors and violent surprises that enrich the surfaces of his pots. For a few of his pieces Daniel has borrowed Svend's practice of firing pots on their sides so the drips fan out explosively rather than streaming vertically downward.

With my wife Pravina, a professional folklorist too, I went to Devon in 2015 to meet Clive Bowen and Svend Bayer — Clive first because he was about to go to Japan where he has often been and his pots sell well. Clive creates freely within the old and rich tradition of Devonshire slipware. Within that tradition, Michael Cardew first learned, taught by William Fishley Holland in the pottery at Braunton. Willie Holland, the grandson of Edwin Beer Fishley, and, in his own words, "the fifth in a line of peasant potters," opened the shop in 1912 and Cardew began learning from him there in 1921. The pottery had been closed for seven years when, in 1978, I did a summer of fieldwork in Braunton, one of England's three remaining openfield villages. After Braunton, Michael Cardew went to St. Ives and then to Winchcombe, where the slipware he made provided one of the inspirations for Clive Bowen.

Clive and Rosie Bowen, Shebbear, Devon, 2015

We took the bus from Barnstaple. Rosie, Clive's wife, picked us up, took us to Shebbear, and served us a magnificent meal. We talked about jazz, blues, and pottery. Clive had been to North Carolina; he owns pots by Burlon Craig and Vernon Owens. In their home in Jugtown, Vernon and Pam Owens have a pot by Clive. Next to the house, in the building that shelters a big updraft kiln, Clive has a pot that Mark Hewitt left unfinished when he went to America. Clive decorated it after Mark had gone. Two big planters stand by the front door of Clive and Rosie's home. Daniel made them when he was here.

Clive and Rosie recalled Daniel's apprehension before he rode Clive's bike forty miles to Wenford Bridge to see Cardew's shop and pots. They understood his fear, having experienced the savage traffic on Carolina's country roads, having seen the rifles on display in the rear windows of pickup trucks, but they knew Daniel would be perfectly safe on the quiet lanes of the green Devon landscape, and they welcomed him back in a state of awestruck excitement.

Svend Bayer lives in a spartan and tidy, beautiful old thatched house in Sheepwash. In a fine essay from 2007, Mark Hewitt sketched Svend's life. He was born in Uganda in 1946, returned with his parents to Denmark, and then

Svend Bayer, Sheepwash, Devon, 2015

was sent for schooling to England. Michael Cardew called Svend a force of nature, and when he lifts one of Svend's pots, Mark says, "it seems like part of an ancient natural order."

Svend had just finished firing, his big kiln was cooling, and he was weary. Over a tasty lunch of vegan soup and brown bread, we talked about life's course, Svend and I being not far apart in age. He wonders what's next. Svend lives and works alone. His sons are gone. One lives in Bristol, the other in Bath. He has no need for money, no desire for wealth, no interest in pleasing others. Wishing only to uphold his personal standards, he would quit, he says, before becoming "an old man making bad pots. Why continue? Out of physical need? Economic need? Why?"

The buildings on Svend's place form into a neat line (as do the buildings at Daniel's): the thatched house, the studio, the big kiln, then a small one. At the time, the big kiln, the fifth he had built, was cooling from its seventh firing. A couple of years later, Svend pulled his kilns down and built a new one, twelve miles away, that he shared and fired with five others, gaining aid with the labor and getting, he wrote, good results from the kiln.

In his spacious, spotless studio, we went upstairs to see Svend's stock of pots, standing in orderly rows. We were struck, as Daniel was, by the consistent excellence, the bold forms, the wild lively surfaces, streaming and pooling like lava. Daniel didn't, but we hit it off with Svend, enjoying his company, sharing in his melancholy and his fondness for Mark and Daniel.

Excited and enlightened, Daniel came home. "When I got back from England, I was wide open. It was wonderful, the third year was really wonderful." Mark Hewitt's apprentices work in two-year cycles. He normally staggers the cycles so he has two apprentices, one old, one new, working and learning beside him. Nate Evans, the apprentice who was there when Daniel began, had left. A new apprentice, Eric Smith, had just arrived. Eventually Eric would build his own kiln in Massachusetts and Daniel would drive up to help with the first firing. Now Daniel was beginning his second cycle. "So all of a sudden," he says, "I was the top guy of the apprentices. I had really understood Mark. We were getting closer and closer, and my pots started coming along strong, you know, and I started making some beautiful work."

During his third year with Mark, Daniel asked better questions, got better answers, thought more deeply, and came to understand that the heart of his art beat in "the honesty of materials, and the honesty of how you handle materials" while shaping an honest presence for yourself through formed and fired clay. In looking at a good pot — it was Bernard Leach's opinion, an opinion heartily endorsed by Michael Cardew — you are seeing the potter. "The pot is the man," Leach wrote. Works, if art, differ because honest people differ in character, culture, and chance.

Books at the time drew Daniel's attention to form, since form is the aspect of a pot that registers most clearly in the small photos that scatter through books. Mark has an extensive library of books on pottery, Daniel began building one too, and leafing through the books he borrowed or bought, Daniel surveyed the world's variety of ceramic forms, appreciating especially the pots Svend Bayer admired in Thailand. Daniel began testing himself by throwing the strange shapes he had seen in pictures, making "all kinds of wild curves and understanding how they worked, and why they worked." As Daniel came to understand "the psychology behind the pot," he recognized that he was still a craftsman, but a craftsman who was on the way to becoming an artist.

It was a time for experimentation, influences were flowing back and forth, and Daniel's relationship with Mark was coming into balance. Daniel sympathized with Mark who was achieving success in a foreign place. "He was

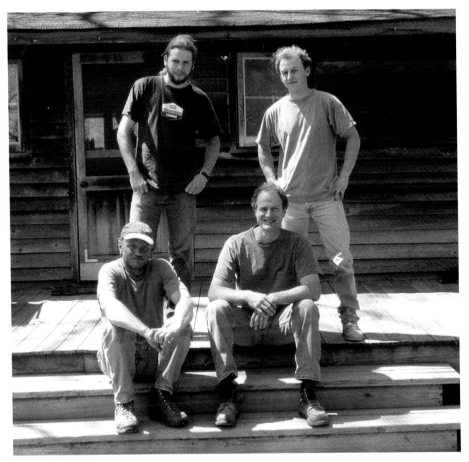

In the third year: Mark Hewitt sits in front with Martin Simpson, a potter from England. Mark's apprentices stand, Daniel Johnston to the left, Eric Smith to the right. Pittsboro, 2000

happily married to Carol, but she was an American girl and they were living an American life." Daniel built for Mark a reminder of home, a "beautiful" wooden gate for his farm, like those Daniel had seen in England, and he gave it to Mark for Christmas. Mark was touched. "That took time, and money as well," Mark told me. "Nobody had done something like that for me. I don't have a son, and my relation with Daniel is like a father-son relationship without the irritation." A skilled craftsman, Daniel also built a clay shed and a small gas-fired kiln for bisque firing, making permanent improvements to Mark's pottery works.

"In that third year," Daniel says, "things started getting improved around Mark's place, and I couldn't imagine being anywhere else. It was a great life. Mark was my college years, and I was exposed to all these new things. My God, how fortunate I was."

Then he began feeling "antsy." Daniel explains, "During the fourth year at Mark's, I was becoming frustrated in the same way I was frustrated when I was working at Seagrove. I was making these pots, and I had moved to a whole new level in making pots and understanding them, and articulating my thoughts about them, and beginning to have an aesthetic opinion about the pots.

"But there was this frustration in my life about what I was doing, because the pots looked very much like Mark's. When I would look at Mark's pots, they were powerful. And I would look at Leach's pots and Cardew's pots, and they were powerful. And I could make those pots exactly. But they weren't powerful; the pots I made weren't powerful.

"So, in hindsight, I realized that I didn't know much about Leach. I didn't know much about Cardew. But what I did know is that I didn't want a watered-down version of their ideas.

"So, Leach, Cardew, those guys went places and they saw pots. So did Mark. And they gathered aesthetics in foreign places that they thought were important. Then they presented them to their students, and their students learned these aesthetics and they went on.

"But I didn't trust their opinion. I wanted to go to places like they had gone and gather that information for myself."

Daniel knew that Leach had gone to Japan, that Cardew had gone to Africa, that Mark had gone to Japan and Africa. Daniel chose to go to Thailand.

3

EAST AND WEST

DANIEL'S DESIRE TO GO EAST AND LEARN at the source aligns him with the great tradition of modernism. Modernist creation begins in discontent. Something is wrong. As early as the eighteen-fifties, wise critics, notably John Ruskin and Henry David Thoreau, had recognized the limitations of materialistic thought and the brutality of an economy based on industrialization. Those problems, among others, remain. Their solution doesn't lie in trusting progress and dreaming of a future that is not more than a hyperbolic projection from the present — more of the same. It lies in close study of viable alternatives from before or beyond the local predicament of the moment.

From frustration and rage to stretches back and beyond, then on the creation of the truly new: the history of the modernist movement provides a plenitude of models. Well over a century ago, William Morris looked backward to medieval England and outward to the arts of Asia while developing theories of artistic design and production that have inspired artists, architects, and writers from his time to ours. W.B. Yeats, who called Morris his chief of men, read back into ancient Ireland; he roved out to do fieldwork among Irish country people and he studied the classical theater of Japan, becoming the greatest of modern poets. Pablo Picasso reached for inspiration toward the ancient myths of the Mediterranean and the contemporary art of Africa. Wassily Kandinsky, excited by the African art he had seen and the art of the Russian peasants he had met, wrote compellingly about the need for the spiritual in modern art and became the first and most sane of abstract painters. The architect Le Corbusier and the musician Béla Bartók both traveled east, gathering the experiences that revolutionized their arts.

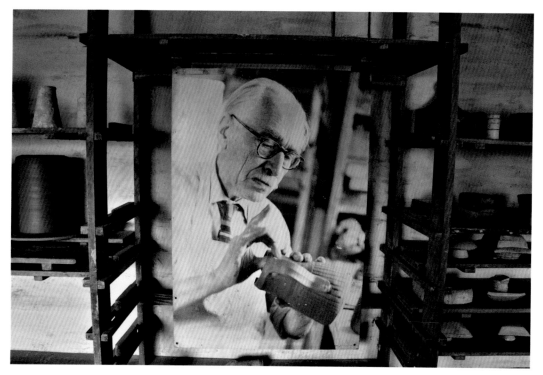

Bernard Leach, photographic portrait in his old shop at the Leach Pottery, St.Ives, Cornwall, 2018

Bernard Leach, who had read William Morris, looked back with admiration at early English pottery, medieval pitchers and Staffordshire slipware. He traveled away to Japan, China, and Korea, and became the key creator of modernist ceramics. It seems nearly inevitable, given his biography.

Leach was born in Hong Kong in 1887. Taken as an infant to Japan, he was returned to Hong Kong, then taken to Singapore, where he got his first touch of clay, before being sent for education to England. There he studied in art schools, and coming to an interest in Japan through Whistler's paintings and Hearn's writings, he moved to Japan in 1909. By nature a draftsman, he was pulled to pottery through friendships in Japan; it would be strange for a sensitive person to visit Japan and fail to be thrilled by the traditional ceramics.

In 1920, Leach returned to England to set up his shop in St. Ives. Then he kept right on traveling back and forth until his death in 1979, the year Mark's apprenticeship ended and two years after Daniel's birth. Gaining international renown through exhibitions, lectures, and his abundant and charmingly English writings, Bernard Leach repeated and repeated one message. Philosophically and artistically, the East and West are radically different, and the future lies in their integration. Western potters must learn from the East.

That had become Daniel's task. His apprenticeship with Mark ended in 2001. In March and April of that year, an exhibition of Daniel's work, titled "Pots from an Apprenticeship," was mounted in Asheboro, North Carolina. The catalogue contains photos of seventeen pots and brief essays by Daniel and Mark. Daniel calls apprenticeship "an unparalleled method of learning to become a skilled potter." He describes the apprentice's day: a morning for chores, an afternoon for free creation. An apprenticeship, Mark writes, is "a bargain between an apprentice and a master. In return for a willingness to do whatever needs to be done, a master endeavors to teach an apprentice everything that he or she knows. It is a fair trade."

At the end of his essay, Daniel acknowledges that the "rich pottery culture in North Carolina" provides a "strong foundation" for his work. A decade later, Mark Hewitt published a paper praising North Carolina for its natural materials, for the masterpieces made by country potters in the nineteenth century, for its vital tradition in which familial skills meet revolutionary departures, and for its wide market of knowledgeable consumers. In Daniel's region of North Carolina, the meshing of East and West, practiced and advocated by Bernard Leach, was not new.

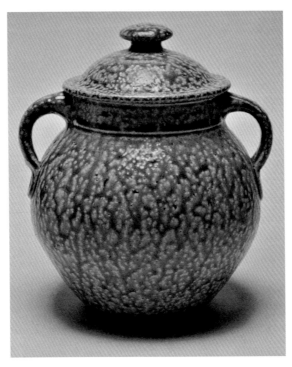

Lidded jar made by Daniel Johnston when he was Mark's apprentice; *Pots from an Apprenticeship* (2001), p. 9

In 1923, the year Cardew's apprenticeship with Leach began, Ben Owen was hired to work at Jugtown. Ben was eighteen, trained as a potter in his father's shop. Jugtown had been established a year or two before by Jacques Busbee whose aim was to produce a steady supply of traditional pottery for sale in the tearoom in New York managed by his wife Juliana. Jacques and Juliana were born into prominent families in Raleigh; both were interested in art — Jacques was by profession a portrait painter — and they came to the old potters' district in the Piedmont hoping to revive a tradition that was changing but not actually in steep decline. (Other new potteries — J.B. Cole's in Seagrove, North State in nearby Sanford — were established at about the same time.) In New York, Juliana's tearoom attracted the rich and famous; the pottery sold well in the city. Work at Jugtown rolled through the Depression and the Second World War, Jugtown became a tourist destination, and the success of the Jugtown experiment was pivotal in the development of North Carolina's wide and lively market for the potter's art.

During the nineteen-twenties, Ben Owen and Jacques Busbee visited museums together in New York and Washington. From the masterworks of Asian ceramics on display, they selected examples that harmonized with the traditional pottery of the southern United States — those with strong, useful forms (not extravagant or convoluted) and those ornamented with rich glazes (not pictorial elaboration). Back at Jugtown, the repertory doubled. Ben Owen continued to throw Carolina's old forms, but he also learned to throw pots inspired by Chinese, Korean, and Persian originals. While the old glazes remained in use, Ben and Jacques added the "Chinese blue" glaze and a thick white glaze that resembles the ricestraw-white glaze used in Hagi, Japan.

East and West had met — as they did simultaneously in England. The ultimate similarity of useful Asian and European forms, thrown on the wheel and then glazed — the grace with which differences can fuse into unity — became basic to ceramic creativity in North Carolina.

After Jacques had died, when Juliana was in her eighties, Jugtown got snarled in legal proceedings. Ben Owen left in 1959 and set up his own shop where the work went on. In that shop, eventually, his grandson began his successful career. Ben Owen III graduated from East Carolina University with a degree in art. Then he went to learn more in Tokoname, Japan, where I have gone with my friend Takashi Takahara who has written, usually in Japanese, admirable studies of Japanese ceramic art. Ben Owen III expanded and modernized his operation around his grandfather's old shop, and he creates a wide

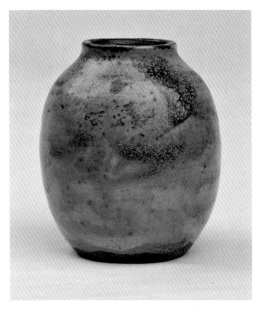

Blue vase by Ben Owen. 5½ inches tall, Jugtown, c. 1940

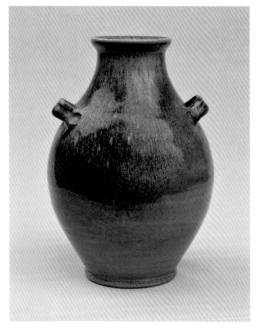

Blue vase by Ben Owen III. 9 inches tall, 2006

White vase by Ben Owen III. 12 inches tall, 2017

White vase by Ben Owen. 5½ inches tall, c. 1970

Ben Owen III, 1990

Ben Owen III, 2016

variety of ceramic beauties, some of them inspired by his grandfather's innovations. A leader among the potters today, as Mark Hewitt is, Ben maintains a strong sense of community, and he is praised by the potters around him for generous acts of aid.

Vernon Owens, Ben Owen's cousin, was hired to work at Jugtown in 1961 when he was nineteen. There he has remained, and today Vernon, his wife Pam, and their children hold to the hybrid Jugtown tradition while advancing creatively. Southwest from Jugtown, the eastern edge of Seagrove's territory swings past Ben Owen's grand home to David Stuempfle's pottery. David works near the territory's southern end in Moore County; Daniel works near its northern end in Randolph County. David Stuempfle worked at Jugtown and widened his considerable skills in Japan and Korea. In his home, David has a teabowl he made in Japan; in his workshop there's a Korean wheel. David fires long and hard, as Svend Bayer does, and his pots, some of them gigantic, all of them fastidiously finished, come from the kiln mottled by the flame and enriched with flying ash, like East Asian marvels.

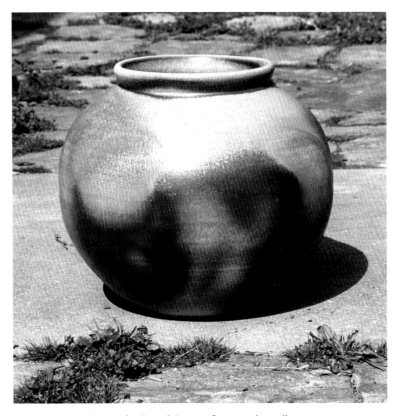

Big pot by David Stuempfle. 16 inches tall, 2011

Louise Cort and Daniel Johnston on Daniel's and Kate's wedding day, 2013

The scene is set. Daniel Johnston's exhibition in 2001 marked and celebrated the end of the apprenticeship phase in his life. The potters he learned from directly — Mark, Clive, and Svend — traveled to the East. Some of his Carolina colleagues — Ben Owen and David Stuempfle, as well as Michael Hunt and Naomi Dalglish — traveled to the East. It was time for Daniel to move on, and he was headed eastward.

Louise Cort was the angel of the road for Daniel's trip to Thailand. Louise is one of the world's leading scholars of the ceramic arts. Her monumental and influential study of Shigaraki in Japan was first published two years after Daniel's birth. Louise wrote one of the essays in the catalogue accompanying an exhibition of Mark Hewitt's work in 1997, the first year of Daniel's apprenticeship. Daniel went with Mark to visit Louise in Washington, where she is a curator of ceramics at the Smithsonian. Daniel and Louise met up at conferences, they became friends, she became a revered mentor, and, Daniel says, "When I would get something on my mind, I would call her and ask her about it. She would very kindly respond and help me try to figure out the answer for my question. She'd never answer a question because, in all fairness, the questions I had didn't have answers.

"So, I knew that she had connections to northeast Thailand, and I told her what I wanted to do, and she told me to come up and visit her.

"So, I drove all the way to D.C. to have dinner with her. And right before the dinner — she's a very direct lady — she asked me why I wanted to go to Thailand.

"And I told her I wanted to learn, to get beyond what I'd been taught. And she smiled and said she would do everything in her power to help me get to Thailand."

Soon, Louise Cort brought Leedom Lefferts, an anthropologist who had worked in Thailand, to visit Daniel in the house he was building in Asheboro. Plans were made, but much remained to be done before Daniel could go. At the time, he was "working production" in Seagrove, making money to live, but missing "the excitement at Mark's," Daniel says, "I was as depressed as I have ever been."

Before he could go, Daniel had to finish the house he was building. That would take a year, and he began calling people about jobs that would pay enough to fund his adventure in Thailand. Dwight Holland, a friend, neighbor, and admirer of Daniel's pots, said he needed help on a project and asked Daniel if he could weld. "I couldn't weld," Daniel says. "I grew up on a farm, so I can, you know, put a stick to metal and get a spark, but I couldn't weld professionally. So, I said I could weld, and he said, Well, we'll start in a week or so."

Daniel got a welding helmet, practiced for a week, then went to work. Using a small model as a guide, he welded together the intricate iron armature for a mountain in concrete, twenty-two feet tall, that stands at the stadium of North Carolina State University. It took half a year, and, paid a professional welder's wages, Daniel earned enough to pay the bills at home while he was away in Thailand. He remembers:

"So, I left for Thailand on New Year's Day, two thousand and three. My dad picked me up at two in the morning to go to the airport. It was about twenty degrees that day when I left Raleigh, and in twenty-four hours I stepped off the plane in eighty-degree Thailand."

Leedom Lefferts, with many years of experience in Thailand behind him, met Daniel at the airport. "Leedom's plan was to spend a whole week with me on the trip to the village. And through that week what we'd do is: every day for two or three hours, we'd sit and we went over the history of Thailand, and went over the history of the village; we went over customs, we went over all of this.

"So, when I stepped into the village, I didn't have to learn all that stuff. I could start understanding the pots.

"I didn't have much time. It was about two or three months that I was going to be there. So, I wanted to get the technique. I didn't have enough time to do anything but go to the village. And make pots. And come home."

Daniel lodged with Mister Sawein, the owner of a large workshop. "It was a little tense as first," Daniel says. "But as soon as I got there, I went out to the workshop and started watching them. By the next day I started to work.

"It was really difficult. At first it was difficult because of the language barrier. But I wasn't intimidated at all. I just wanted a chance to learn. And I had to be fairly aggressive to get that chance.

"I think they thought of me as an honored guest, and I had to put myself underneath them to sort of establish their dominance, so they would teach me."

Daniel was like an ethnographer newly come to a foreign place (a position I've often been in). He didn't want to be an honored guest. He wanted to be a student; he wanted to be taught, to learn. Daniel continues:

"I wanted to figure out, when I was there, how to learn to make a pot. So, we started off, and I started rolling coils and spinning the wheels. They have these large wooden wheels that you have to spin while the other person actually compresses the walls of the pot.

"And so I started that, and then I went on, once I got that, I went on to start coiling the pots, and that was really challenging. I don't know what else to say about it, except it was really hot, and I had waited two years to be there, and there wasn't a damn thing fun about it.

"It is one thing to work two years and go on vacation. It's another thing to work two years and then get abused, if nothing else, by yourself.

"And what happened was: I started being able to do it relatively quickly. We started making pots, and at that time the potters were making ten pots a day."

In his memory of one day, Daniel provides a feel for the process and spirit of work in one village in Thailand:

"A couple of weeks in, once I'd got the technique down, there was a beautiful day, and me and the other potters — we usually worked in teams of two, but this day we worked in a team of three, and we started to almost braid the labor.

"So, I might turn the wheel for Mister Kow who's compressing the pots. And then while he finishes that up, I might go over and start coiling a new pot

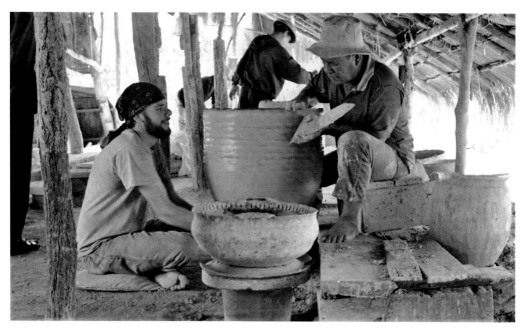

Daniel Johnston working with Mister Kow in Thailand, 2003. *Photo by Joy Silakhom*

while Mister Tao starts spinning the wheel for me. Then Mister Kow would start rolling the coils for the next pot. So, it was a real beautiful braid of work.

"We didn't hardly speak because there was no reason to — couldn't understand each other anyway — and by the end of the day, we'd made twenty pots. Twenty large jars.

"And I remember it perfectly because we were standing there, just absolutely covered in clay, and we took our clothes off, and we ran down the road, naked as jaybirds.

"And there was a beautiful pond they had dug out as a reservoir to pump into their rice fields. And, carrying our clothes with us, we all dived into the water and swam.

"The last time that had happened was when I was twelve years old with my brother. And here I was with two other men. They didn't do that every day. There was this excitement then. We'd worked hard, and we went swimming together."

Work and play mixed, too, when the kiln was fired. "The kiln firings were wild," Daniel says with a laugh. "It was like five or six guys on spring break, you know. We ate raw chicken, we grilled duck. We caught rats in the fields," though rat meat was not for Daniel.

The pots were big. The kiln had to be big. In its basic type — commodious, cross-draft, and wood-fired — the kiln was like the one Svend Bayer built, then Mark Hewitt built, and Daniel was soon to build.

Loading and firing the kiln was "really intense," Daniel says. "We fired a large kiln. And they didn't know how long the kiln would fire for. So, we all just stayed at the kiln while the kiln was fired. Sometimes it fired for three days, and sometimes for five days. You'd have to look at the pots, and when they're finished, you're done.

"The technology was so crude that there's an inability to predict these things. There wasn't an efficient way to establish a rhythm so you could set up a system and know how long the kiln was firing."

Daniel was living, learning, and observing the life around him. He saw that when the potter's work was done, pleasure in the brothels lay ahead. He saw that the shop where he worked was not organized like those he knew in North Carolina. In this village, he says, "You have an owner of the pottery, Mister Sawein, who is the top man. Then you have my teacher, Mister Kow, who is way smarter than the owner. I started to follow the backroom conversation and knew that Mister Kow was actually running the place. Mister Sawein was out in the front, but when things happened, he always pulled Mister Kow to the side, and Mister Kow told him what to do."

It was something like that when the Busbees owned the shop and relied on Ben Owen, without whom Jugtown would have failed. And it was something like that at the same time in England, early in the twentieth century, when studio potters, who had ideas about design and skill on the wheel, would have been lost without the help and technical knowhow of the experienced working potters they hired. But it's not like that in North Carolina today, where the owner — Mark or Ben, David or Kim — is a master, an accomplished and knowledgeable potter who designs and creates the pots, then directs the loading and firing of the kiln.

When management, design, and production unite in an individual, as they do in North Carolina, the shop's pots are bound to display aesthetic and technical coherence. Coherence is a worthy goal, but it is true that equally coherent pots can issue from a big atelier (in Japan, say, or Turkey) where the difficult tasks that take years to learn are distributed among many people, working under the supervision of a master — and this is what matters most — a master who has risen through the ranks and understands the whole process. Daniel's purpose in Thailand was to understand the whole process, so he could come

home and set up a shop like Mark Hewitt's, where he would be the owner, the worker, and the master of coherence.

Daniel sums up his time in Thailand: "I got what I wanted. Out of the experience, I started understanding pots in a completely different way. I learned to make big pots. I started to understand big pots. I started to understand that big pots were objects that weren't decorative, and they weren't some sort of art. They were just these objects that people used, and I realized the importance of them and I started to see them, really.

"And I saw the truth in those pots. I wish there was a word that would describe it better than truth. It's not the adequate word, but that's the word I have to symbolize what I saw."

Daniel had glimpsed the truth and his thinking had been suddenly disrupted:

"You know, when I went to Thailand, man, I was weak in my head. I had everything in a nice little box, and I knew what I was going to do. I had all my ideas in a nice little box.

"And when I came back from Thailand, it was like someone took that box, and they didn't just turn it upside-down; they slung the shit everywhere. I mean, I just lost it when I got back.

"And the culture shock when I came back to America was just violent. It's the paper cups, the paper plates, it's vinyl siding. It is Walmart, it is baby wipes that are warm. It's all that stuff that keeps you from having any sensation.

"The truth — whatever this thing is that I'm describing with the word truth — is really fucking painful.

"When I got back from Thailand, I didn't know what to do with myself."

Daniel was home — toughened, taught, angry, confused, and brave — with a massive project before him.

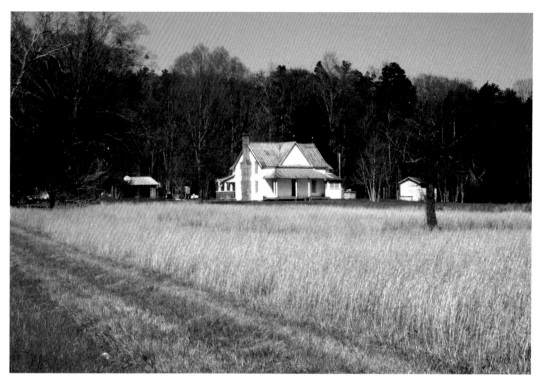

The Seagrove landscape, 2002

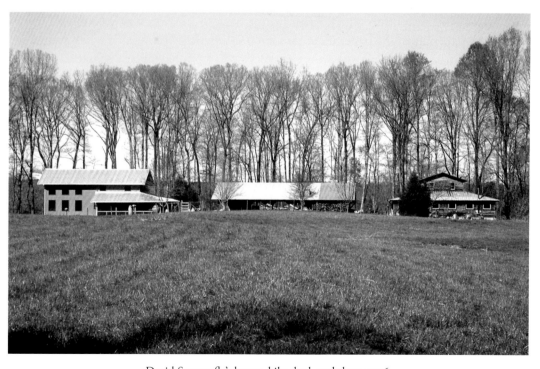

David Stuempfle's house, kiln shed, and shop, 2016

4

BUILDING A SHOP AND MAKING A POT

DANIEL CAME HOME TO THE PIECE OF land he owned on a gentle rise, reached by rough roads, northeast of Seagrove. Hearing that Seagrove is a place with ninety or so potteries, you might imagine a pottery village like Maragoji-pinho in Brazil, with more than a hundred workshops clustered at the river-side, or Kınık in Turkey, where a hundred and fifty trim shops, seventy with kilns, line up, flank to flank, along the neat streets. Or a pottery town, like Arita in Japan or Deruta in Italy, where many workshops stand within walk-ing distance of each other. But Seagrove is a place where highways cross and a few buildings gather, including the North Carolina Pottery Center. Then Seagrove's territory expands over a wide agricultural landscape, dispersed in the usual American way. Farmsteads, churches, and potteries scatter about. From Seagrove on the west it is seven miles along Route 705 to Ben Owen's place in the east, and it is ten miles by road from Daniel's shop in the north to David Stuempfle's in the south. The potteries stand alone and apart, dependent for connection on narrow country roads and smoking vehicles.

In the big ateliers still found in parts of Europe and Asia, when their ap-prenticeships are finished, the potters remain, becoming paid laborers in the master's shop, or, as journeymen, they leave to find work in other ateliers. The hope in both cases is to rise to the status of master — fully accomplished as a practitioner — so shops can have several masters, a few of whom might be brought into partnership in the business. In North Carolina, their apprentice-ships done, potters are sent out to set up on their own, like Native American lads on a vision quest. That was Daniel's job now.

The pattern of isolated shops, managed by a lone master, suits the individualistic character of modern American creative enterprise, but independence is an illusion. The great Japanese potter Kanjiro Kawai — a marvelous modernist who was friends with Leach, Yanagi, and Hamada — wrote a crucial essay entitled "We Do Not Work Alone." No artist does. Potters who purchase sacks of clay and fire in electric kilns might think they work alone, though other people processed their materials and manufactured their equipment, just as someone else made the paint, brushes, and canvas for the wild artist who creates in solitary splendor.

Privileged acts are enmeshed — perhaps embarrassingly — in systems of support. Pioneer potters may dig their own clay and build their own kilns, but when it comes time to fire — whether in the Piedmont where Daniel was born or in the Thai village where he learned — many hands are necessary, just as they were in the past when a barn was raised. Through paid help, trades of labor, or by dint of the kindness of people like Terry Childress who show up at the right time, the potters who work independently in scattered locations connect into networks of aid. However heroic, artists don't work alone. They learn from others, get help from others. North Carolina's pattern is an apt modern compromise between individualistic desire and collective necessity.

Daniel was back, stunned by culture shock. Struggling to readjust to America, he says, "I was in a devastated state. The world had fallen apart around me." He felt depressed, but laughs, "depression is a luxury" and goes on:

"So, I had to work through all this while I had to get my ass in gear and build a pottery. I had enough money — I thought I had enough money to live six months and build a pottery, you know.

"So, I started to work. I had gathered ideas in my head about how to build a pottery for years, and going to Thailand, seeing the architecture there, was very comforting to me.

"And instantly everything came into my head of how to build it. The place you see now is exactly what I had envisioned when I was coming back from Thailand, especially the log building and the kiln shed.

"I had already cut the timber for the log building and the kiln shed. I was not sure how I was going to use it, but I had already cut it. So, I started work, building. I built the kiln shed; the kiln shed cost me nine hundred dollars to build. The log cabin cost me two thousand dollars to build."

It was his idea, would be his place, but he couldn't have done it alone, Daniel says. He had help from his skilled pal Terry Childress and constant help

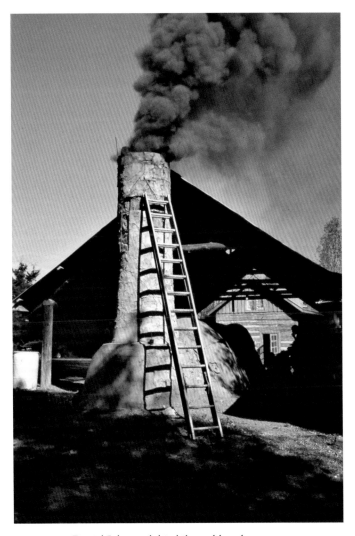
Daniel Johnston's big kiln and log shop, 2012

from Joe Cole, "a really great guy, a Tolstoyan idealist," who had apprenticed with Mark. In six months they were done.

Modifications have continued from that time to this. The log shop sprouted a brick wing, becoming a composite emblem of Piedmont history: log from the agricultural settlement phase, brick from the later industrial phase. In the kiln shed, paralleling the shop's brick wing, a small kiln was added at an angle to the big one, and in time the big kiln was razed and replaced by another. But the original structure of Daniel's architectural composition still holds: a shop and a kiln shed set precisely on axis, visually joined by the alignment and pitch of their roofs.

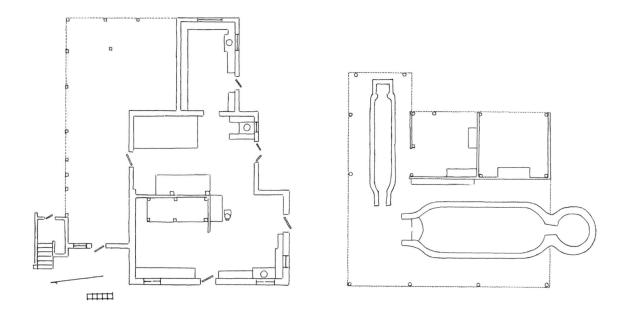

Plan of the Johnston pottery in 2012 (scale in feet)

The log shop to the left, to the north, was built in 2003. The brick wing, extending eastward, was built in 2009. It ends with Kate's studio; her wheel is on the south wall. Daniel works in the log shop, where he stands at the wheel on the west wall or sits at a wheel in the middle, in front of the racks of wareboards. The apprentice's wheel is on the south wall in the middle section where the big pots dry. The open shed to the northeast offers space for work and storage.

Between 2012 and 2018 changes were made. The area to the north, between the shop and the stair leading to the living quarters, was filled with an office; room for storage was added behind it. A small greenhouse was built on the south, in the corner between the log shop and brick wing.

The kiln shed to the right, to the south, was built in 2003. The small kiln was built with chambers in 2007, then rebuilt as a straight tube in 2012. The large kiln, built in 2003, was leveled and replaced with another in 2013, when a shed was built around the chimney.

All the materials are natural — the dirt floor, the log and brick walls, the timber posts — and they must be natural, Daniel feels, to provide the right environment for creating pots out of the land's natural clay.

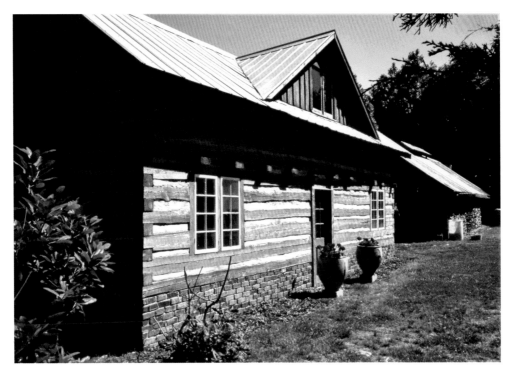

Looking south from the shop to the kiln, 2014

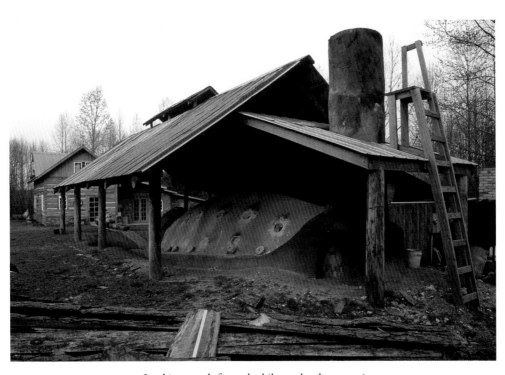

Looking north from the kiln to the shop, 2016

Daniel beside his log shop, 2007

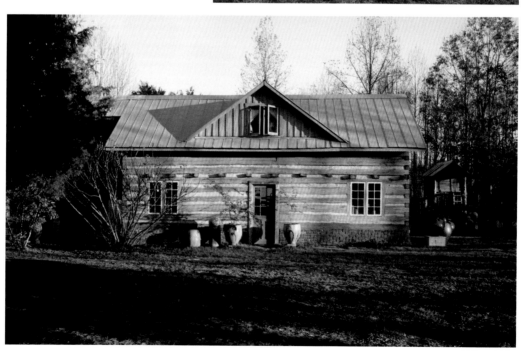

The western face of the log shop, 2018

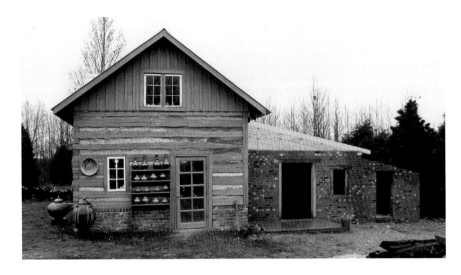

The brick wing under construction, 2009

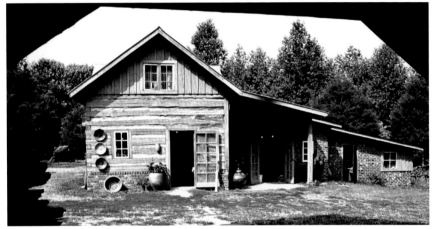

The brick wing complete, 2012

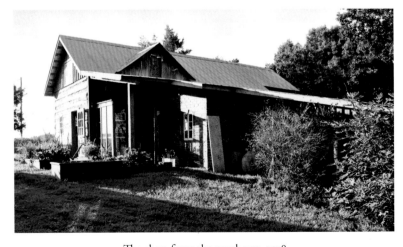

The shop from the southeast, 2018

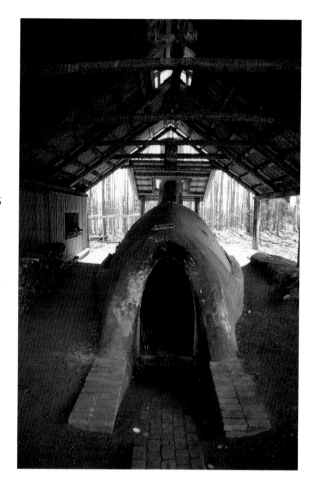

The big kiln, 2016

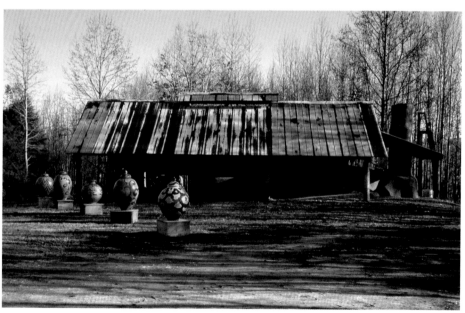

The western side of the kiln shed, 2014

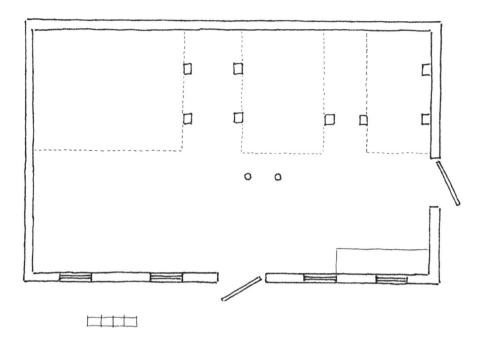

Plan of the old Luck log shop, 2013 (scale in feet)

The log shop repeats the plan of the old Luck family shop, a V-notched log building that stands in the woods on land owned by Sid Luck's brother Darius. Daniel used the expedient of a square notch in the corner-timbering and added an upper floor for a shipshape place to live. Before leaving for his "walkabout" in the East, Daniel had envisioned a heavily framed kiln shed of squared timber, but learning from the rough and ready, impermanent and earthfast architecture of Thailand, he built his kiln shed like a pole barn. The kiln he built on a Thai plan, not far in form from Mark's or Svend's.

His place was set. Daniel was out of money, though, and he had to make some pots and sell them. Working fast, Daniel often fell back, he admits, on Mark's designs, but in Thailand he had learned an entirely new method for making big pots.

"Mark knows how to make big pots beautifully," Daniel says. "He makes some of the most beautiful big pots I know." Mark had watched big pots being made when he was in Japan, then, through determined effort, he perfected a personal technique of creation. Daniel had watched Mark at work, but "Mark told me, he said, Daniel, you've got to go somewhere and you've got to stay there until you have really learned to make big pots." Mark told me he had Japan in mind, but Daniel chose Thailand, and the big pot was the aim of his quest.

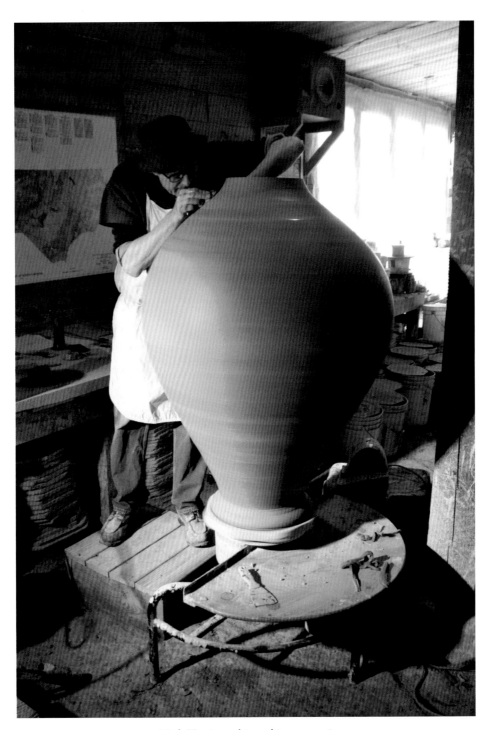

Mark Hewitt making a big pot, 2018

"God," Daniel says. "I did everything in Thailand. I fell in love in Thailand. I learned to make big pots in Thailand. It's the only time in my life I've really been a potter. The only time."

The potter's rhythm for work in North Carolina is pulsed by annual shows where pots are sold in Seagrove, in Charlotte at the Mint Museum, and in Hickory at the Catawba Valley Pottery and Antiques Festival. Those shows offer a chance to track and gauge changes from year to year. The Catawba Valley show, which celebrated its twentieth anniversary in 2017, also features an annual lecture, given by a scholar — Terry Zug, John Burrison, me, Linda Carnes-McNaughton — or a potter. Mark Hewitt was first in 2009. Daniel Johnston was second, and he was followed by Matt Jones, then Kim Ellington.

When Daniel's turn to lecture in Hickory came in March, 2012, I was sitting in the audience next to Mark Hewitt, watching while John Vigeland spun the wheel and Daniel demonstrated the technique he learned in Thailand. Mark whispered that he was envious. His technique involves long, thick, heavy coils. Demanding strength, Mark's method is hard on his back and neck. He was feeling the strain and doubted he would be able to continue making big pots into his old age. But Daniel's Thai technique involves a multitude of short, small, light coils. It demands little strength, produces no strain, and Mark said, "It is kinder to the body."

Big pots, by definition, are too large to raise from the wheel in one move. Their size requires a sequence of acts. Large pots are traditionally made in the southern United States by capping, by throwing a pot in two sections and then joining them. In the old English tradition, coils were added to shaped bases for big forms like ovens, and at Winchcombe, Michael Cardew threw cylinders then added coils to make big pots. Mark Hewitt also begins with a thrown form but his big pots are more than twice the size of Cardew's, and, like some Japanese potters, Mark adds many heavy coils, rolled out so that each one encircles the entire mighty circumference. The technique Daniel learned in Thailand has close parallels in Korea and among Japanese potters of Korean descent, and this how he does it.

He begins with a vision of the finished pot. Daniel doesn't imagine the form in three dimensions but as a flat silhouette, which he occasionally sketches on paper before he sets to work. The silhouette contains an invisible horizon that governs the curves of the form and its subsequent decoration. Bernard Leach wrote that the potter's poles in creation are the straight line and the curve, and during creation Daniel attends to the straight, vertical midline

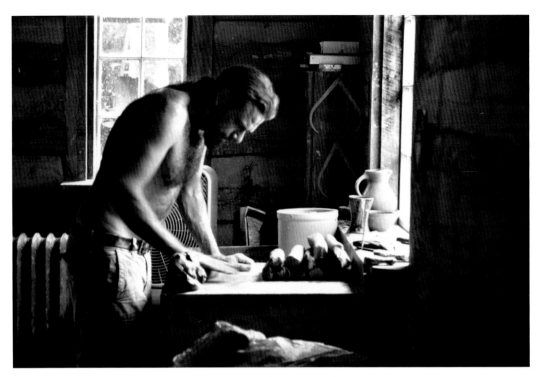

Daniel Johnston rolling coils, July 2012

while shaping the curves of one side, which, because the pot whirls as it rises, will yield a symmetrical whole — a swelling embodiment, slender or rotund, that evokes the human qualities of grace and generosity.

For the pot's body, Daniel uses the Michfield clay, dug out of the old Auman pit north of Seagrove. "It's a very big clay," he says. "It's a combination of really big particle sizes with small particle sizes. The reason that's important is that it's fantastic for big pots." It's the right clay for the job, but what matters, and matters profoundly, is that the materials for the body, the slips, and the glazes are mostly local and natural. Like the natural dyes in a textile, the natural materials in a pot contain impure complexity. If a ceramic piece is made out of industrially processed clay, as bathroom fixtures and cheap china are, then, no matter how artfully contrived, it will look shallow, cold, and lifeless beside a pot made of natural materials, just as a synthetically dyed textile looks dead next to one woven of hand-spun, naturally dyed yarn.

With an idea in his head and good clay in his hands, Daniel rolls a pile of coils, each ten inches long and weighing a pound and a quarter. Now he moves from the bench, lit by the window in the shop's front, and sits at a low wheel deep in the shop, lit by the light from the door that leads to the kiln.

Having watched the process often, making sketches and taking frenzied notes, I will describe Daniel's way to make big pots with a characteristic instance. Since Daniel works too quickly for me to take photos and notes at the same time, my description follows a single pot, but the accompanying photographs show several similar pots in progress during the month of July in 2012.

To his left on a board, Daniel has coils piled up like logs. He places a bat, a circular board, on the wheel before him, and centers a soft cone of clay on the bat. Pounding down with his fists, he spreads the clay and smooths it into a pancake. Then with a long, slim, sharpened shaft of bamboo, supported on his shoulder and held down to slice into the pancake, he spins the wheel to get a perfect circle and cuts a groove inside the circle's edge. Daniel has made the pot's base.

Daniel picks up the first coil, then pressing and twisting the clay with his right hand against his left, he flattens the coil and attaches it to the base along the groove. The second coil overlaps with the first, the third overlaps with the second, the wheel turns clockwise, as wheels do in Thailand, and Daniel completes the first pass, a continuous fused and compressed ring of fourteen coils, running along the groove in the base. Daniel also calls the complete rings coils; I'll say passes for clarity. During the second pass, sixteen coils

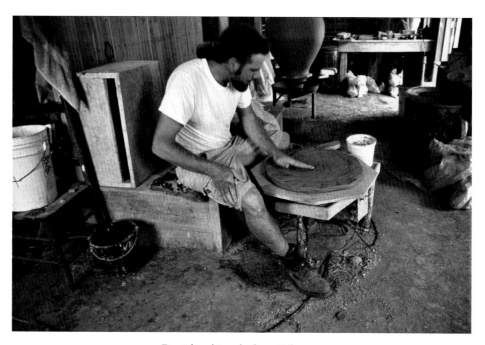

Daniel making the base, July 2012

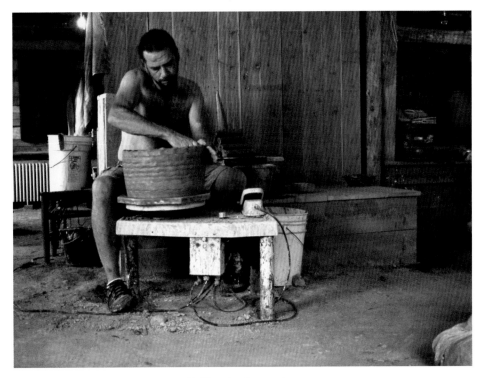

Coiling the first section

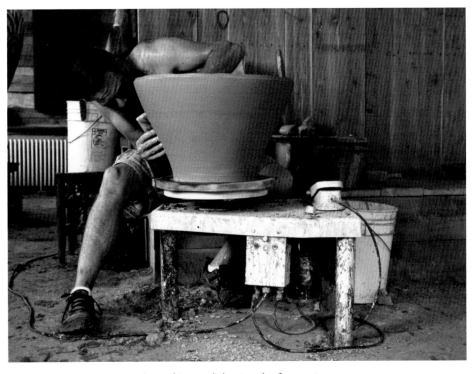

Smoothing and shaping the first section

overlap with each other and with those of the ring below them. The degree of overlap between the passes determines the thickness of the pot's walls. They are thicker toward the bottom to support the pot's weight, thinner toward the top.

After twelve passes, while the number of coils increased from fourteen to twenty-two, the pot, in its first phase, stands as a cylinder, sixteen inches tall. The wavy pattern of parallel bands, left along the trail of the individual coils, will disappear as the wheel spins counterclockwise and Daniel smooths the surface downward with a damp chamois cloth, then upward with flat, squared strips of wood, called ribs or chips. With a rib in one hand inside the pot and a rib in the other outside, Daniel compresses the coils into unity and brings the pot into shape, broadening the top, curving the sides, then curving them more until the pot has taken the flaring form of an upside-down truncated cone, keystoned in profile. The first section of the pot is complete.

At this point, Daniel's pot resembles the forms Mark Hewitt throws before adding his heavy coils. In Thailand, Daniel says, the pots are built in three successive sections, but his pots, bolder in their curves, require more sections to reach the desired height. Several pots are made at the same time in Thailand, so the first section is set aside to dry while a new pot begins. To preserve the integrity of his design, though, Daniel makes his pots one at a time, and, instead of waiting, he uses a blowtorch to dry the pot enough to support the next section.

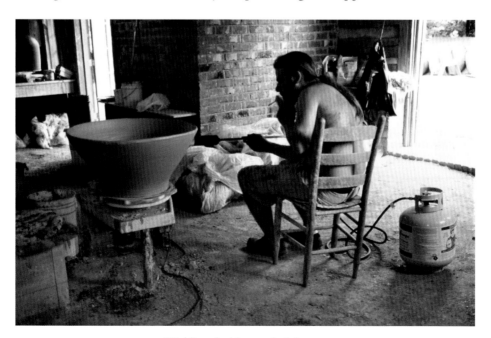

Wielding the blowtorch, July 2012

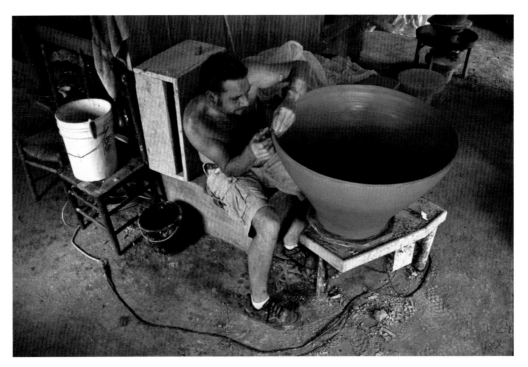

Smoothing and shaping the second section

The top of the first section was leveled and beveled, and the whole thing was torched, to receive the second section. After seven passes over a wider circumference, Daniel stops and seals the joint between the first and second sections with vertical scratches. As the wheel turns again, Daniel again smooths the surface and shapes the form, connecting the rising curves that reach their widest extent at this section's top. Joining the sections so they maintain the grace of their curves, Daniel says, is a challenge.

Another torching, another pause for a smoke, and the third section is laid on with seven passes, sealed, smoothed, and spread out to continue the curving lines upward. The blowtorch does its job again. Then with the five passes of the fourth section, the walls begin to bend in, and Daniel steps away to declare, "This is going to be a beauty. I don't know how to describe it; you just know when it's right. Good is not good enough. This one's right." It was the third big pot he'd made that day, and he had found the groove.

As the pot grows in height, Daniel puts a box on his seat, then turns the box on end to add the final rings of coils. After the fourth section gets sealed, smoothed, and torched, the five passes of the fifth section are shaped to bend inward. "This one has a confident form," Daniel says. "It has volume and strength, but it is still graceful. In this one, the qualities of my career come together."

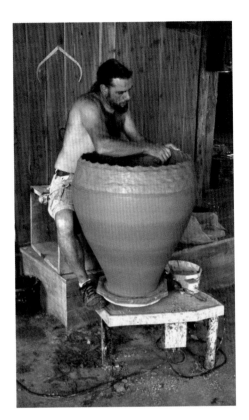

Coiling the fourth section

Coiling the fifth section

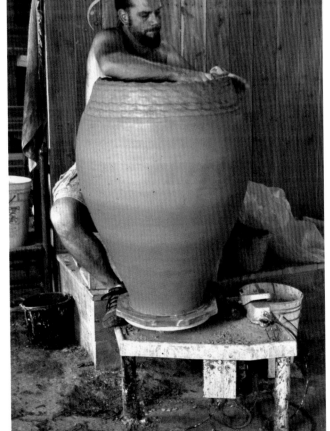

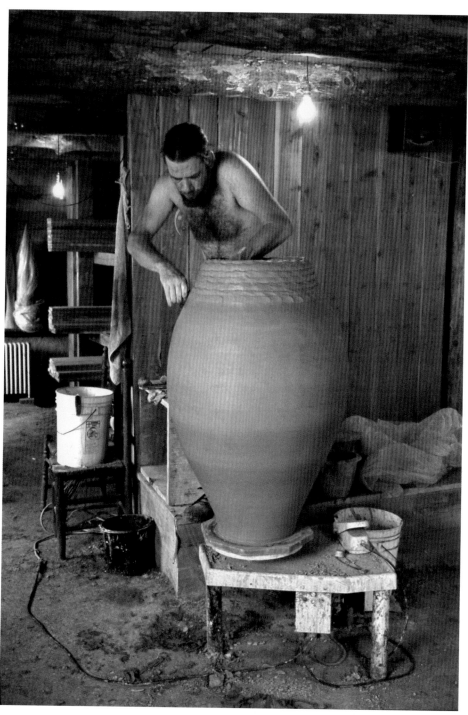

Daniel Johnston coiling the sixth section, July 2012

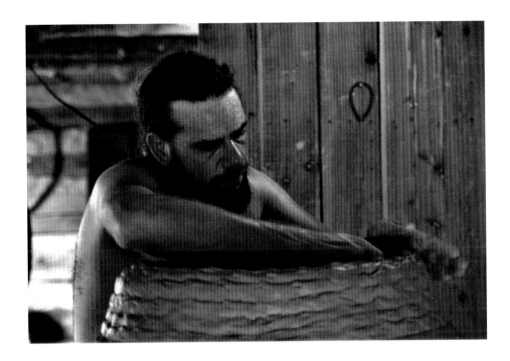

Sealed and smoothed, shaped and torched, the fifth section is followed by the last, a sixth section of five passes that rise up vertically. Now Daniel forces the erect section inward and swings it up, through a band, to the lip of the pot's open mouth. "It takes a while," he says, "till you are both — you and the materials — satisfied with the result. This pot looked good all the time, and it ended perfectly — no adding or eliminating of materials." Daniel sponges the whole surface, giving the body a final smoothing. The form is nearly done.

The pot's form will achieve completion with a lid, usually tipped with a pointed finial, so the body swells generously and sweeps gracefully up to a final gesture of closure and aspiration. When a monumental jar stands on the wheel near its end, Daniel steps back and draws a bead like a marksman to evaluate the form. If the pot seems weak, too slim, he might score the surface with vertical incisions to echo and stress the curves. More often he dresses the form with raised bandings to emphasize shifts in the curves, and most frequently he adds handles, two or four of them, balanced high on the shoulders to encircle the lid. But when a form stands proudly near perfection, a lid is all it needs for completion. The grand lidded jar, though, is far from done.

Form springs from the idea Daniel had at the beginning, but, the process being long and complex, the result might not match the intention; it could be better. Creation unfolds from a dialectic of the planned and emergent. It's not until the finished form stands before him that Daniel can take, with certainty, the next step in the process, and the next step returns us to the clay.

The Michfield clay that Daniel uses for the pot's body was used in "the old churns you see around Seagrove," and, Daniel goes on to say, "I also use that clay in my glazes. Okay, what that does is it makes the glazes fit the clay body. I refine all my materials for my glazes, and I predominantly use all natural materials that I dig myself for all the slips and the glazes."

Daniel also uses a local red clay that, he says, looks like an earthenware clay, but it's not. "It's actually a heavy, iron-rich stoneware clay, but I call the red clay earthenware clay for a generic term. I use the earthenware clay to start off making my slips, and the earthenware clay is about eighty percent of that slip material, and I add commercial feldspar to make it melt a little bit.

"So, the red slip, that's my first material, my base. And then I add black manganese oxide, which is a chemical that turns black, and it holds up black in all the firings.

"And I take a five-gallon bucket of the red slip that's been refined, and pour black manganese into it until it turns black. I don't measure or anything.

"It's very instinctual, from the gut. It requires you paying attention. I do that because you're going to get variation from one batch to the next, and it always keeps my pots a little bit fresh. And it's relying on me to do that."

So, Daniel has the options of a red slip and a black slip. And he gets a third slip, a white one, by using the Michfield clay alone. The Michfield slip is soft and earthy, so Daniel gets a fourth slip, a brighter and "more vibrant" white, by taking a tin glaze, like that used in Italian *maiolica*, and thickening it into a slip; he calls it his tin slip.

The form is set, the application of the slips comes next in the process. Daniel uses his four slips to decorate the pots, decoration meaning, for Daniel, drawn ornament that rides on the surface. His decoration, more common on small pots than large ones, is rarely representational. Daniel does sweep pots with floral forms, derived from a design of blooming leeks that Mark Hewitt uses on plates. A pot carrying a stylized fish, hooked from Michael Cardew's repertory, once floated through Daniel's shop. Usually, though, his decorations are purely abstract. They are calligraphic and gestural, inspired by Clive Bowen and comparable in their freedom, Daniel consistently says, with art by Picasso. Or Daniel's decorations shape into the neat geometric patterns that Bernard Leach likened to folk melodies. But Daniel uses his slips most often — on pots of all sizes, but especially on the giants — to cover the pots as a whole, providing an undercoat for the play of the glaze.

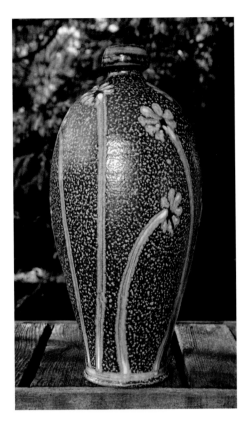

Flowered bottle by Daniel Johnston. Red slip base, tin slip decoration, salt-glazed with flying ash, 16 inches tall, 2016

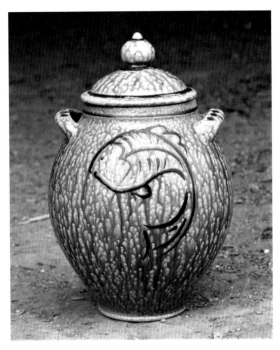

Lidded jar with a slipped fish by Daniel Johnston, 2012

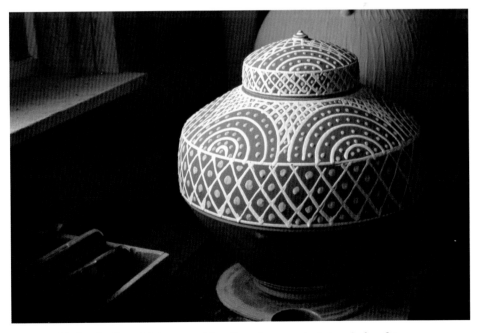

Lidded jar by Daniel Johnston with a slipped geometric design, before firing, 2012

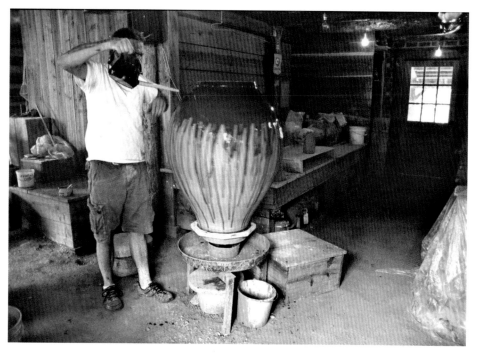

Daniel slipping a big pot, July 2012

A couple of days after the big pot I described had taken shape, Terry Childress was working on a project of his own at the apprentice's wheel on the side of the shop. Terry helped Daniel lift the bat on which a big pot stood, and balancing the great weight with difficulty, they carried it over the dirt floor and stood it on the glazing wheel that Daniel made. The wheel turns in the middle of a wide metal basin that catches the watery slip's runoff and drops it through a hole into a bucket. Daniel fills an oil can with slip and tips it, flowing slip over the pot. If the pot is too wet, it might collapse under the slip, too dry and the slip won't take correctly. Once the slip is dry to the touch, the pot can be moved, ready for the next step, the glazing.

The stoneware glaze traditional in Daniel's region of North Carolina is made by throwing salt into the kiln during firing. The salt vaporizes and fuses with the silica in the clay, glazing the pots. That method was invented in medieval Germany and brought to England late in the seventeenth century. Along the Atlantic seaboard, salt-glazed stoneware was common in the nineteenth century from New England, New York, and New Jersey, through Pennsylvania, Maryland, and Virginia, to North Carolina.

Salt-glazed jug by Chad Brown. 18 inches tall, 2018

From South Carolina, through Georgia, to North Carolina's Catawba Valley, the potters used an alkaline glaze, usually containing wood ashes and called ash glaze. Chester Hewell, with four generations of potters behind him in Georgia, told me he thought that ash glaze was developed locally by potters who noted the effects of flying ash in wood-burning kilns. Possibly, but it seems more likely that ash glaze was introduced in South Carolina by Abner Landrum, potter and physician, who could have read translated and published versions of the celebrated letters, written early in the eighteenth century by a French Jesuit, describing the use of ash glaze in China. If that's true, and it probably is, then ash glaze provides an instance of the meeting of East and West in southern ceramics a century before Ben Owen, at Jugtown, was throwing forms and mixing glazes that were inspired by Asian precedents.

The two southern glazes differ in materials and application, in history and regional association, but, like Mark Hewitt before him, Daniel Johnston uses them both in combination to create deep, rich, vital surfaces for his pots. Alex Matisse who apprenticed with Mark after Daniel did, told me that Daniel's pots have beautiful forms, but what excites, amazes, and daunts him are the surfaces Daniel gets in the kiln with his glazes.

Daniel is not the only contemporary potter who has developed an ash glaze after reading Terry Zug's description of Burlon Craig's glaze in *Turners*

and Burners. Clay and wood ashes blend in the glaze. The clay is the same Michfield clay Daniel uses in the body; it is rich in quartz and silica, he says, and if ball-milled, it melts like a glaze. Ashes make the flux. Daniel heats his place with woodfires, so he has a plentiful supply of ash. The firewood is mostly pine, and that, he says, "is the key because most people burn hardwood, but I burn a mixture, and it's not a measured mixture. It is a very conscious and deliberate unmeasured mixture and the randomness creates a pattern." Like the unmeasured mixes in his slips, and Daniel goes on:

"You also have to take into account that all the wood that's cut around here falls upon the ground, which is red clay. So, there's a tremendous amount of red clay that's in your woodstove when you burn it. You're getting iron from the clay in your ash as you burn it, and that comes through in the glazes" — enriching the ruddy, tawny tone.

Daniel mixed his first batch of ash glaze, tested it in a small gas-fired kiln, and "it came out absolutely spectacular." Then he used it on his first kiln load of pots, and when he opened the kiln, he found "the most random piles of shit that I'd ever seen. The glazes were anything from a bright, beautiful celadon green that ran all over the place to a dry orange. I had no idea what happened. It was so sporadic that I couldn't see anything but a disaster."

Later when Daniel saw some of the pots that survived from the disaster, he was surprised to see they had "absolutely beautiful glazes." In the meantime, he began experimenting and arrived at a mixture of five parts clay, seven parts ash, and two parts crushed glass. Then he traded the glass for feldspar, which, he says, smooths glazes mixed of different materials into consistency, and since there's silica in the clay, there's no need for the glass.

With ash glaze, Daniel says, "you have to understand nothing about chemistry. Really, the less you know, the better off you are. You really don't have to know anything about materials. Because what you have to do is pay attention.

"Ignorance of the materials allows me to look at what actually happens. Okay, and that's the important thing: to look.

"So, I started to pay attention to the kiln a lot. I started paying attention to where the glazes do what within the kiln. And the ash glaze — no problem."

Not like the scientist in a lab who combines precisely measured elements into a new substance, more like the chef in a kitchen who takes tastes while preparing a splendid meal, and quite like the artist in a studio who looks to see how colors blend on canvas, Daniel judges his glazes by how they register on the retina. The gifts that the glazes make to the eye come in color and motion.

Ash-glazed syrup jug with glass runs by
Matthew Hewell, Gillsville, Georgia.
16 inches tall, 2004

An ash-glazed pot — let's say a jug made by Matthew Hewell in Georgia — comes from the kiln wearing a mottled green and brown jacket, streaked by the darker drips that collide and divide in descent. Such colors and motions have been traditionally enhanced within the ash-glaze territory by glass runs. The Hewells drove from Gillsville in Georgia to Vale in the Catawba Valley to learn the technique from Burlon Craig. After that, pots by Matthew Hewell, his father Chester, and his grandfather Harold were occasionally ornamented by bits of clear or blue glass that were placed on the pot's shoulder to melt freely into the downward flow.

When Mark Hewitt, a scholar as well as a potter, assembles historic pots from North Carolina for exhibitions, he includes masterpieces made in the middle of the nineteenth century by Daniel Seagle in the Catawba Valley. Seagle's bold, rotund forms are inspirational for Daniel Johnston, and Seagle's pots frequently feature glass runs. With Daniel Seagle (who died in 1867) and Burlon Craig (who died in 2002) before him, Mark Hewitt, too, adds glass runs to the mix. Mark's characteristic practice is to embed tiny diamonds of clear or blue glass in the clay that run with the heat. So then, following on, our Daniel has the option of adding glass runs to the vigorous surfaces of his pots, and he has also let temperature cones melt into the flow to get dark as well as light runs in the glaze.

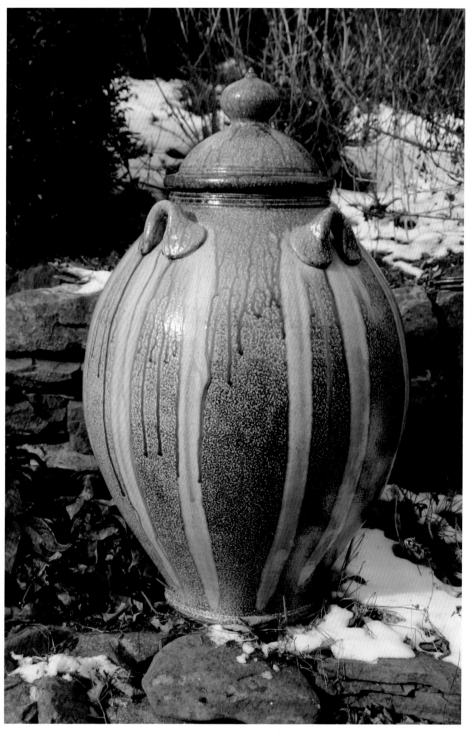

Big pot by Daniel Johnston. Black slip, salt-glazed with flying ash and glass runs, 36 inches tall, 2017. The American Folklore Society commissioned this pot as a retirement gift for the Society's director Tim Lloyd in the fall of 2017.

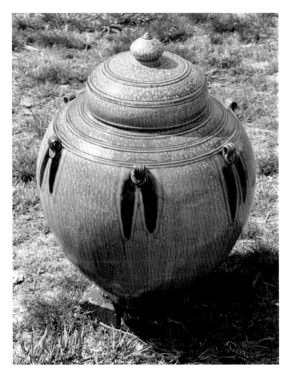

Big pot with cone runs by Daniel Johnston.
26 inches tall, 2007

Daniel summarizes: "So, essentially how I handle my glazes is that I layer different materials upon the pot to create the surface I want. Essentially, I'm mixing a glaze by layering all the materials on a pot."

The surface Daniel wants is smoothed. Then the pot might be slipped, receiving, say, a dark red engobe and then slip-trailed decoration in white. But it might go forward without a slip. Then it is coated with dampened ash glaze when small pots are dipped in a vat and large ones, erect on the glazing wheel, get the ash glaze poured over them; they will get a second dose of ash in the kiln. But the pots might enter the kiln unglazed to be salt-glazed and enriched with flying ash during firing. The options are many, but there will be salt, ash, and heat at the end.

The last in the sequence of layers comes when salt enters the kiln late in the firing. "Salt has a disastrous effect upon other glazes," Bernard Leach warns the potter in *A Potter's Book*. But Leach's friend and colleague, the great Shōji Hamada, felt the use of salt in his layered glazes, while difficult, was stimulating and exhilarating, and Daniel Johnston dodges the problems and gains aesthetically by using salt and ash together. Too much salt, Daniel says, might yield a slick surface, but it will bleach the color out of ash glazes, so Daniel balances and blends salt and ash during firing to get positive results.

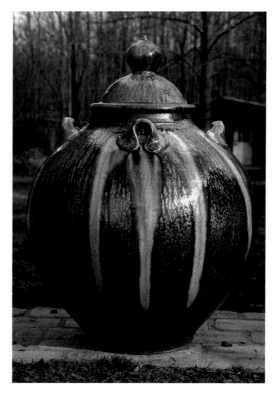

Big pot with glass runs by Daniel Johnston, 2016

For one thing, Daniel's mixture fills the gaps between the ash runs; it looks as though an ash glaze was added over a salt-glazed ground. For another, the mixture hastens the melting, releasing a richer flow and brightening the surface. For yet another, it produces drips in surprising, unpredictable spots on the pots. When an ash-glazed pot is fired in a cross-draft kiln like Daniel's, it will have a hot side with more action in the flow. But Daniel can create runs and drips anywhere on the pot, on the cool side as well as the hot, toward the bottom as well as the top — a desirable aesthetic effect that Daniel gets with the technique he invented. "I figured it out for myself," he says. "It's an accumulation of knowledge from experience.

"What I love about it is the quality of the way the ash lands on the pots, and the spacing of the way that ash lands on the pots. It's like nothing I've seen before. But I'm using the same materials that Daniel Seagle and those guys used a long time ago."

Glaze, slip, form, and clay: it all comes together in the kiln. "My philosophy," Daniel says, "is that you have to work with the kiln. You have to work with the kiln, the pot, the slips, and the glazes. And the fire. You have to understand all these things. I'm not practicing chemistry, you know. I'm practicing art.

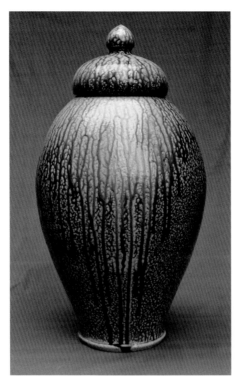

Big pot by Daniel Johnston. Red slip, salt-glazed with flying ash, 26 inches tall, 2013

"And I try to allow every part of the process to have its own space. I try to allow the glazes to have their own independence, and the clay to have its own independence, and the kiln to have its own independence.

"And I'm the guy sort of leading the orchestra. I can't play the music, but I'm making it all happen."

Through close management of the fire and the introduction of salt in the kiln, Daniel's pots come to completion. Then once they have cooled and stand in the light, Daniel evaluates the results and begins to prepare for the next firing.

During preparation, he processes the materials, thinks about form, and throws pots. He has different slips that he has learned to apply one above the other to get different effects. He has an ash glaze and with it the option of glass runs. He also has "a classic celadon glaze that comes all the way from Cardew; it's made of twelve materials, including a lot of local materials, so you have to adjust it to the local materials. But it's essentially a clear celadon, a very clear glaze, but it has depth to it and richness. It's a very stable glaze, and we used it a lot at Mark's. So, I have that in my repertoire as well."

And so, Daniel's pots are ready, headed for their trial by fire.

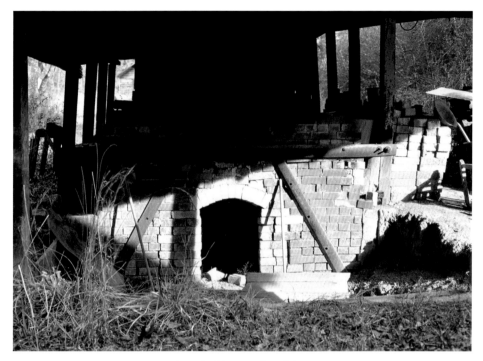

Ben Owen's old groundhog kiln, 1980

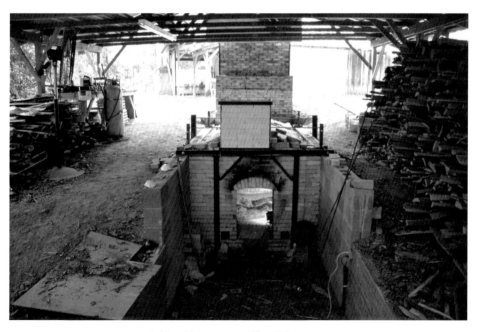

Sid Luck's new groundhog kiln, 2004

5

FIRING

DANIEL'S KILN EXEMPLIFIES A TYPE THAT WAS developed out of models from Thailand and occupies the midpoint, he says, of a formal range. To one side stands the simpler groundhog kiln of the southern United States. To the other stands the architecturally complex climbing kiln of Japan. All are cross-draft kilns, radically unlike the cylindrical updraft kilns of England, a type I have found to be also prevalent in Brazil. The updraft kiln is like a chimney, a firing chamber at the bottom, the heat rising, the smoke escaping through a hole at the top. The cross-draft kiln, by contrast, lies along the ground, a firebox at one end, a chimney at the other.

Wood-fired groundhog kilns once unified the tradition of ceramic production in the South. The Hewells use a groundhog kiln to fire their ash-glazed pots in Georgia. Burlon Craig used a groundhog kiln in the Catawba Valley. When Ben Owen left Jugtown to establish his own operation, he built a groundhog kiln. A groundhog kiln was built beside the museum at the North Carolina Pottery Center in Seagrove. Chad Brown — a man like Daniel with experience as a production potter behind him and great skill in his hands — demonstrates throwing for visitors to the museum, and by firing the kiln and explaining its use, Chad has mastered the groundhog.

A straight, arched tunnel, loaded and stoked from one end, the groundhog in its simplicity presents the potter with problems aplenty. But Chad Brown got used to its quirks, learning from it over time how to get the results he wanted. Still, when, through hard work, Chad had gathered the money and materials to build his own kiln on his own hilly land, he didn't build a groundhog.

Chad Brown at the kiln in which he fired the 1001 mugs that he sold to finance the construction of his big kiln, 2014

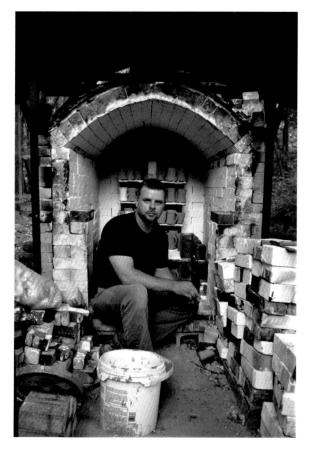

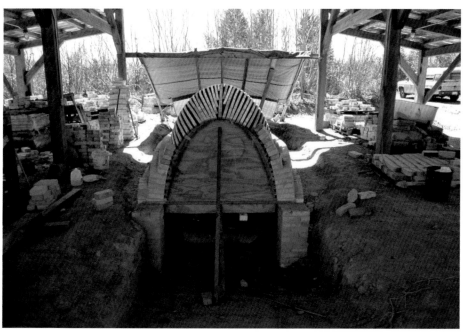

Chad Brown's big kiln under construction, 2016

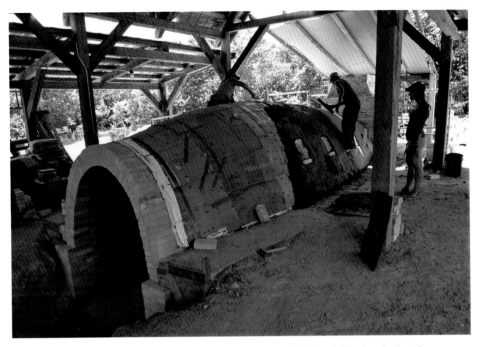

Capping Chad Brown's big kiln, 2017. Eight people helped Chad with the job;
Julie Rose Hinson, Kirsten Olson, and Erin O'Toole appear in the picture.

He built a kiln similar to Daniel's and Mark's. Not exactly like theirs, his arches are rounder, but Chad's new kiln also belongs to North Carolina's new family of kilns. He calls them flame-shaped. Instead of the groundhog's straight sides, the new kiln's sides curve, narrowing like a flame toward the chimney end. The heat is easier to control, the results are more consistent.

In comparison with the old groundhog, the most obvious thing to note is the size. The new kilns are larger; they are generally called big kilns. You had to crawl through the groundhog's mouth to load the kiln with the churns, crocks, and jugs needed on the farm, or later with the face jugs favored by the fanciers of folk art. The new kiln has to be big to welcome the big pots that signal North Carolina's contemporary art movement, while accommodating as well the small ones, the bowls, vases, and mugs, that are easier to sell. The kiln is large, the mouth is tall; you can walk right in. One consequence of larger kilns is fewer firings, and a consequence of fewer firings is that, in making enough pots to fill the big kilns, potters improve their forms through long stretches of steady repetition.

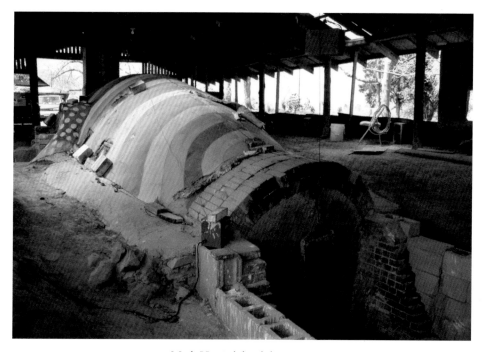

Mark Hewitt's big kiln, 2000

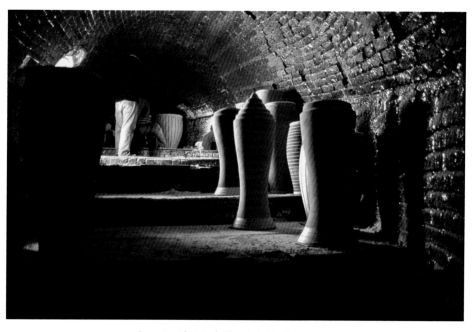

Steps inside Mark Hewitt's big kiln, 2012

Size is one thing. Other aspects of Carolina's new kilns edge them toward the Japanese climbing kilns I've seen in Seto and at Kawai's in Kyoto. The climbing kiln rises steeply. The grade is gentler in North Carolina's new kilns, but steps inside do lift toward the chimney, just as the sides narrow toward the chimney, funneling the flame.

The Japanese climbing kiln and Carolina's big kiln both have an entry for fuel at one end, an exit for smoke at the other, but the climbing kiln is built on a hill in a series of separate but connected chambers that can be stoked from the side. North Carolina's new kilns, like Chad's, Daniel's, and Mark's, can also be stoked from the side. The rows of portals for side-stoking along the kiln's walls are a feature as new and significant as the size and shape. Though the kiln's interior is not walled into separate chambers like the Japanese kiln, the pots are arranged inside in an alternating rhythm of walls of small pots and rows of big ones that mimic the effects of separate chambers stoked from the side. Like the curving of the walls and the rising of the floors, the portals for side-stoking and salting increase the technician's command and the artist's ability to get a richness of color and motion. When Kim Ellington, a master burner who gets thrilling surfaces on his pots, saw the holes for side-stoking on Mark Hewitt's big kiln, he recognized that they solved the problem of uneven heat in the groundhog and he added side-stoking portals on his kiln out in the Catawba Valley.

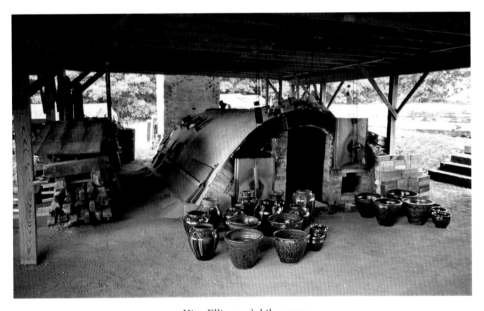

Kim Ellington's kiln, 2013

It's time to fire. Daniel told me he needs ten weeks between firings and normally fires four times a year. The pattern he shares with the others who fire big kilns is a firing in March before the Catawba Valley show in Hickory, a firing in May before the summer when collectors are most likely to visit the potteries, a firing in August before the Mint Museum show in Charlotte, and a firing in November before the Seagrove show and the Christmas shopping season. I'll describe a November firing in 2012.

On Tuesday, I stopped by Mark Hewitt's, where Mark and his apprentices, Mark Kozma and Seth Guzovsky, were loading the kiln. At Daniel's the kiln is already loaded. Inside, a bagwall has been built by stacking shelves of small pots, mugs mostly. Behind it the pots have been arranged to create seven distinct sections; Daniel calls them chambers. Each chamber is served by holes aligned on opposite sides of the kiln. They are called portals, ports, or portholes; Daniel usually says stoke holes. For the first six chambers there are two holes on each side, one high, one low. The contracted seventh chamber has but one hole on each side. With twenty-six stoke holes, Daniel says, he has more portals for side-stoking than most potters do, so he can get more variety in each firing.

At dawn on Wednesday, Daniel lights the fire with a burning dollar bill. When this kiln, which has been fired forty-nine times, is leveled and replaced with a new one, Daniel will start the fire with two dollar bills, one for the new kiln, one to commemorate the old kiln's spirit. Firing has begun, and stoking the kiln from the front will continue steadily for four days.

Daniel begins with oak, then when the heat has reached 800 degrees Fahrenheit, he will switch to dry pine slabs, the wood also preferred by potters in Turkey. Daniel will take turns at stoking from the front with Terry Childress and John Vigeland. Daniel met Terry when he was an apprentice and Terry, a Vietnam vet, came to help Mark with a firing; now Terry helps both Mark and Daniel at firing time. John Vigeland is Daniel's first apprentice, now joined with Daniel and Kate in a tight circle of affection and expertise. Daniel says that John is better than he is at rolling coils for big pots, and he is already making fine pots of his own. Later in the firing sequence, Remo Piracci will take his turn, ramming pine through the big kiln's mouth. A house painter by trade, Remo learned how to make big pots from Daniel, and he has come down from his home in the mountains of western North Carolina to help with the firing.

I am most familiar with firings in Asia, in places where the potters don't use pyrometers. They gauge the heat by the flame, smoke, and ash, but gener-

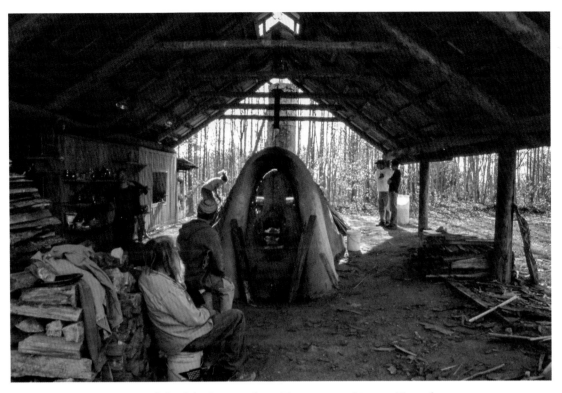
Firing Daniel's big kiln; Remo stoking, Terry awaiting his turn, November 2012

ally they think that earthenware firings reach a peak heat of about 850 degrees centigrade and that stoneware firings peak at about 1250 degrees centigrade. Daniel has a pyrometer. His kiln has three holes along the spine, one in the front, one in the middle, one in the back. A probe in each hole is rigged with an electric lead to a digital monitor that can be switched to reveal the heat in different parts of the kiln, but it normally and consistently reports the heat in the front. So, checking the monitor, it is easy for me to track the heat through time in Fahrenheit terms.

The firing's first phase, the preheating phase when the pots are dried and the bricks are warmed, has begun. The stoke holes are closed, and the kiln will be fired from the front every half hour to keep the heat between 150 and 200 degrees for thirty-six hours.

On Thursday evening, the stoking speeds up, the heat increases, and by noon on Friday the temperature stands at 800 degrees. It's Remo's turn to stoke from the front. Of firing, he says, "It's a breathing thing. It brings people together, and that's why I like it." By three in the afternoon, the fire has reached 1000 degrees. "That's when things get tricky," Daniel says, but once the heat

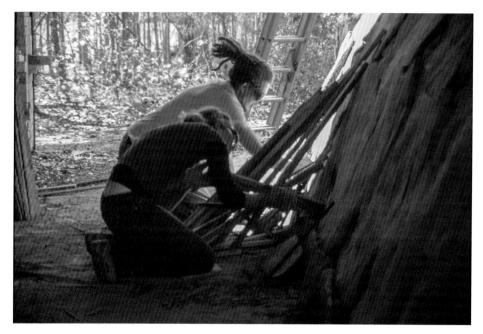

Catarina Krizancic and Andrew Dutcher side-stoking, November 2012

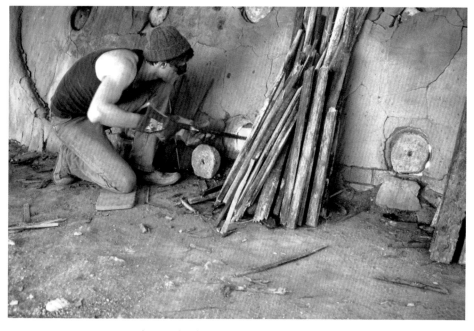

John Vigeland side-stoking, November 2012

has passed that point, it rises smoothly to 1400 degrees and holds there while Daniel eats and takes a quick nap in preparation for the firing's next phase.

Most people, Daniel tells me, think that the final phase when the heat reaches 2300 degrees is the most important, but he thinks the penultimate phase when "the foundation is built for the final phase" is more important. So he takes the midnight-to-six shift, staying up all night and managing the kiln alone. I stay up with him; the talk is good. At midnight, the temperature has reached 1900 degrees; by three in the morning it has reached 2120. That's the temperature in the front of the kiln. The back is 600 degrees cooler. In the front, the fire is white, the pots stand out clearly in a pearly, silky diaphanous swirl; the flame in the back is deep orange. Now Daniel begins the side-stoking, soaking the front chamber, then moving chamber by chamber toward the chimney to lift the heat in the back of the kiln. At four in the morning, the cocks crow, the heat stands at 2200 degrees, and that's where Daniel wants it to remain for the beginning of the final phase. At six, he puts the kiln in John's hands and goes to bed.

At noon on Saturday, with the heat at 2250, Daniel has two teams of side-stockers, using slim strips to work the heat toward the back of the kiln. On the right, he has Kate and John. On the left, Catarina and Andrew. Catarina Krizancic, an administrator at the University of Virginia with a doctorate in anthropology, has driven down from Charlottesville to help with the firing. Andrew Dutcher is twenty, a college student and potter, who will later become Daniel's third apprentice, completing his term in 2017 and buying a house with the delightful Erin near Seagrove. During the tiring side-stoking, they will be relieved by Steve Dean and Wei Sun from Raleigh, potters who are also collectors of Daniel's work.

At half past one, the temperature in the sixth chamber has reached 2260 degrees, the kiln is close to unity in heat, and Daniel begins the salting. He has added a funnel to a leaf blower, and, in sequence, he fills it with salt, then with a mixture of four cups of wood ashes to two cups of salt, then with ashes alone, finally with salt alone. He starts in the first two chambers, then moves back and forth between the third and fifth chambers, blowing his salty mix through the stoke holes.

Then at half past three, with the temperature at 2265 degrees, Daniel shouts, "Terry, go for it! Let's get it up there about twenty-three hundred." Terry fires furiously from the front, the monitor hits 2300, Terry leaps in triumph, and Daniel begins salting the sixth and seventh chambers.

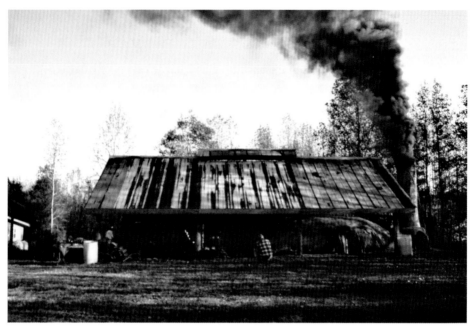

The chimney smoking, November 2012

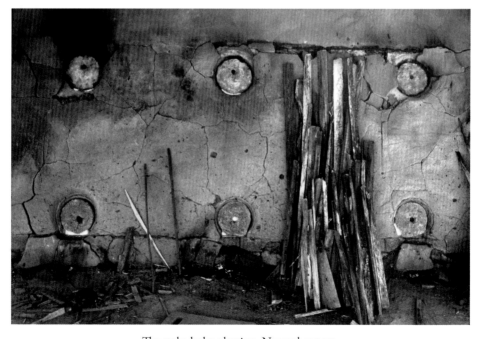

The stoke holes glowing, November 2012

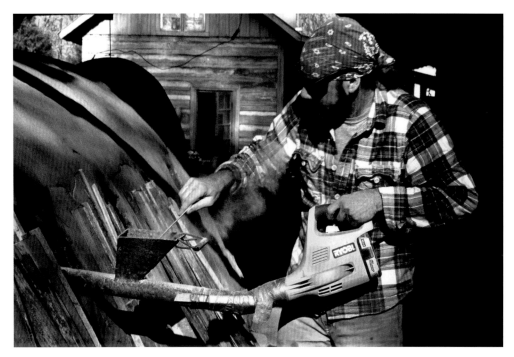

Daniel salting the kiln, November 2012

As the time passes, Daniel remains in motion, backtracking again and again to concentrate on the middle chambers, three, four, and five. Two hours later, the kiln has consumed five cords of wood and two hundred pounds of salt, the monitor still reads 2300, and the stoking suddenly stops. All the stoke holes are opened, and in forty-five minutes the heat has dropped from 2300 to 1600 degrees. The kiln has been "crash-cooled."

His kiln, Daniel says, "has holes at the top and bottom, high and low, and that allows me to reach all my pots with that blower. Okay, I can blow salt and ash onto all the surfaces of the pots.

"The ash alone wouldn't do it. And the salt alone wouldn't do it. But the mixture hits the pots and it starts to melt immediately, and it makes the ash stick to the pot. And then, with a little bit of time, the ash will flux itself. And that's where you're getting the depth because you're getting a glaze that's been created on the pot over time, and not applied.

"So, I've got twenty-six stoke holes in my kiln. And at the end when I remove all those porthole covers at one time, that lets a tremendous amount of cold air rush into the kiln. And when that cold air rushes into the kiln, it crash-cools the kiln and it freezes that luster on the pots, just like the old groundhog kiln."

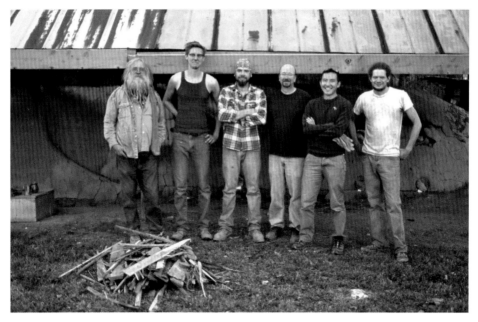

Men of the firing team: Terry Childress, John Vigeland, Daniel Johnston,
Steve Dean, Wei Sun, Andrew Dutcher, November 2012

Crash-cooling preserves the high gloss on the pots, solving a problem Daniel had in early firings when his pots came from the kiln with dull surfaces. He asked around about the problem. Everyone told him he was getting dull surfaces from crystal growth, but no one could explain how to prevent it. Daniel thought about it and talked with Phil Morgan in Seagrove who wants crystal growth on his pots:

"I said, Look, I've got a problem. I've got a lot of crystal growth. That's what you want. I want to get rid of it. What can I do to get rid of it? And he came, and he looked at the kiln, and he told me exactly what to do to get rid of it."

So, Daniel reversed Phil's process, cooling his pots suddenly rather than gradually. "I don't know how it works," Daniel says with a smile. "But I know it works." The crash-cooling that leaves the pots with bright, juicy surfaces is the last step in Daniel's artistic process.

With the temperature down to 1600, the stoke holes are closed and sealed with red mud; the kiln can be left to cool slowly. The women — Kate, Catarina, and Pravina — leave to take showers. The men remain, standing in a victory line to have their photo snapped. Daniel invites everyone to a celebratory dinner at a Thai restaurant in Asheboro. Most of his helpers are too beat, too whipped with work, and they head wearily for home, leaving Daniel and Kate, Catarina and John, and Pravina and me to enjoy the feast at Taste of Asia.

On Sunday morning, the kiln has cooled to 800 degrees. On Tuesday evening, a week after it was loaded, the kiln will be opened and the pots removed. They will provide three months of income for Daniel and Kate. Now they stand, cool, lustrous, heroic works of art, their surfaces as spontaneously active, Daniel says, as paintings by Jackson Pollock.

If your idea of art is based on quality and beauty, you won't find it hard to associate Daniel's pots with paintings by Pollock or Rothko, Vermeer or Jakuchū. They are works of art. Still, despite the writings of theorists like Morris and Kandinsky who widened the idea of art over the past century and a half, some remain who define art narrowly by medium. Paintings are art; pots are not. Since Daniel works in clay (as many great sculptors, including Bernini, did) they would classify Daniel's works as craft, not art. If there is something more in a universal definition of art by medium than intellectual lethargy, ethnocentrism, or class bias, it probably lies in the assumption that craft techniques are restrictive and repetitive, while art techniques require a multitude of free decisions.

But we have come slowly to this point, following the literary ideals of accuracy and exact details, in order to get some idea about the multitude of free decisions that go into the making of Daniel's pots — decisions about clay, about form, about decoration, about slips and glazes, about the architecture of the kiln and its firing. Craft, in Daniel's case, is a stunningly complex procedure, and art is its result. "Art is art," wrote Michael Cardew.

With craft as the process and art as the result, we have come to a simple conclusion. Simple but insufficient. Not every complicated procedure eventuates in art; an automobile, for example, issues from a complex process of manufacture. But when an artifact's designer is also its maker, when someone like Daniel manages the whole process from one end to the other, then flurries of free decisions fuse into a sign of the self. Then as the anthropological phenomenologist Robert Plant Armstrong argues in his great trilogy on art, the artifact is not a mere object; it is an affecting presence, a subjective revelation of its creator. That's what Bernard Leach meant when he wrote that in looking at a pot, you are seeing the potter. The work of art arrives through a long train of choices and stands inevitably as an abstract self-portrait of the artist. As James Joyce said, works need not be signed; the entire work of art is its author's signature.

Art divides from lesser things by bodying forth, sincerely, passionately, the particularity of its creator. That understanding can be thwarted by the observ-

er's point of view. Viewed from afar, works of art — paintings in Paris or pots in North Carolina — clearly belong to traditions. It can seem as though the tradition creates itself through human agency. But viewed from within, on the ground, all traditions live or die within human command and all artistic traditions are individualistic. The indicators of individuality differ from tradition to tradition, but once they are grasped, the paintings by Manet or Renoir, the pots by Mark or Daniel will not be confused. When Mark or Daniel visit our home in far off Indiana, they spot their own works first, then identify at a glance the pots by Kate, Ben, or Kim, Vernon or Pam, David or Chad, Matt, Alex, or Joseph. The equally abundant ceramic works from Turkey in our house are, for them, Turkish, but for me they are clearly creations by Ahmet, Nurten, Mehmet, or Ibrahim.

In the Covered Bazaar in Istanbul, foreigners purchase Turkish carpets. The merchants sell carpets that they know come from different regions named for market towns, from Bergama, Konya, or Malatya. The middlemen, who buy in provincial towns then bring the carpets to the city, know the names of the mountain villages where they were woven. Get to the village, and everyone can look at a carpet and name the woman who wove it, Nezihe Özkan, Rahime Balcı, or Aysel Öztürk.

You have to get to the village. Bluntly put, fine art is the art that is customarily and respectfully viewed from within, in terms of the intentions the artists set for themselves, while folk art and craft are the arts that are customarily viewed from a distance as products of a force called tradition. But, so long as you are knowledgeably situated, all works of art will be understood as the creations of individuals who employ their techniques so deftly, so maturely that their works stand for the traditions in which they learned, for the societies in which they live, and for themselves alone — whatever their medium or social class or gender or race or location in space.

A man of the South, a potter in North Carolina, Daniel Johnston says he works in a tradition that reached excellence in the nineteenth century with Daniel Seagle in the Catawba Valley, that advanced with the masters at Jugtown, Ben Owen and Vernon Owens, and that entered a new phase when Mark Hewitt made the first big pot and built the first big kiln near Pittsboro.

From a deeper historical perspective, Daniel can be understood to work in a region that runs down from Pennsylvania, along the Blue Ridge and the Valley of Virginia, into the Piedmont of North Carolina, where English, Irish, Scottish, and German immigrants met and mingled in the back country with

Mark Hewitt, 2000

Ben Owen III, 2000

Native Americans, absorbed influences from the coastal people of African descent, settled on small farms, and developed a tradition of excellence in music and craft. The old folks of Daniel's place were masters of carpentry and pottery who made good use of the forests around them and the clay the Indians had used before them.

Daniel lives in a loose society of potters who, he says, work differently toward different ends. At the center, in Daniel's view, Mark Hewitt stands, surrounded by the "fraternal circle" of the apprentices trained by Mark and Daniel. Mark Hewitt, heir to the Leach tradition, and Ben Owen III, heir to the Jugtown tradition, are the twin pillars of the mixed tradition, the community's leaders, the most successful practitioners. Daniel's society of creators also includes the active elders, Vernon Owens and Sid Luck, the excellent potters who are older than Daniel, David Stuempfle and Kim Ellington, and Daniel's age mate, Chad Brown, who labored as a production potter in the same shop Daniel did, then worked beside David and Mark before going off on his own.

Vernon Owens, 2002

Sid Luck, 2003

Chad Brown, 2010

These connections are real, Daniel says, but only recognized in retrospect. When he is at work, in the heat of the moment, he isn't thinking about tradition or social associations. Knowing where he is going, but not exactly how he will get there, he bears down on the work before him, driving confidently forward, getting into the flow and solving problems as they arise in order to make the best pot possible. That pot, for Daniel, is not a product of tradition, but the yield of his personal devotion.

Daniel doesn't call himself a studio potter. That term raises an image for him of a posh gentleman who dabbles amateurishly in the clay. Nor does he accept the label artist-potter that Bernard Leach, unable to escape the conventions of social class, used to separate himself and his educated friend Hamada from workaday potters. Daniel Johnston is a potter who makes art.

Art, for Daniel, comes from commitment. "We have our daily chores," he says, "and we have to maintain an idea of what our commitment is to humanity. Commitment is not signing a contract; it's an unwritten contract of loyalty. That's commitment; it's an unwritten contract of loyalty to yourself. It's the virtue you proceed with."

In defining art, not by the critic's judgment or the historian's story, but by the artist's personal intentions, integrity, and drive, Daniel is, I firmly believe, philosophically correct, and his "commitment" aligns gracefully with Kandinsky's "inner necessity," Suzuki's "devotion," Cardew's "concentration," and Leach's "sincerity."

Commitment governs Daniel's decisions and actions during the three main phases of creation. "I understand that I have to have local materials. I have to have conceptual ideas of form. And I have to have this fantastic kiln to produce anything that's truly great." Of these three, form is the least technical and most personal. It centers Daniel's idea of art:

"When I think about quality, I think about form. That's very important for me. And when I think about where the idea of quality comes from, the judgment can only come from the intuition within ourselves. Intuition within ourselves is basically the history of ourselves. That's all intuition is; it's the history of ourselves.

"With me, in creation, I trust my experience from the past. I was lucky enough not to have had an academic experience. I was lucky enough to not have someone tell me in a class what form was.

"I was very fortunate in that. I had to figure it out for myself, and form has been a very strong point for me.

"The non-academic study of form has made me look at everything quite critically. And going to work at Seagrove early on as a production thrower, I began my understanding of the architecture of the pots and how they related to people. And I think that was very important in the way I started to see form."

Being unhindered by academic training, Daniel's quest to refine his intuitions enabled him to encounter directly the works of famed artists. Knowing nothing about their biographies or traditions, Daniel could appreciate, purely in terms of their renditions of form, the "emotional line" of Matisse, the cubism of Picasso that broke form apart to reveal it, and the paintings of Lucian Freud that make ugly forms appealing.

No proper models to copy were presented to him in a classroom. His encounters with fine art came late and served only to confirm what he already understood. Daniel learned the most by observing his environment: "I'm really happy that I was ignorant for a long time as I looked at forms. I gathered the idea of forms by looking at the places around me. And I think that's the most fundamentally correct thing that I did.

"That's my sense of form. It is all around us. I looked at things and I saw them."

Daniel looked at trees and saw how they rise though the natural logic of growth into beautiful forms, the distinct forms of different varieties — oak, pine, sycamore — just as artists, maturing through expanding experience, come to create characteristically different forms. From the buildings on his landscape, from architecture, Daniel saw that people live comfortably within a grid of straight lines, the horizontal lines of level floors and repetitive clapboarding, the vertical lines of fence posts, columns, and chimneys. An invisible grid hides, too, in the pot — a horizon at its breadth, crossed by a rising midline — and architectural verticality, shadowed by the upward reach of the tree and the erect posture of the human animal, strikes Daniel as especially significant.

Innately, Daniel says, people understand the "sensibility of uprightness." They need and appreciate stable verticality, and by shaping a plumb form around a vertical midline, a central axis, Daniel makes the first move in the creation of an appealingly beautiful form. "You have to understand," he says, "that the pot is a cylinder on axis, and everything is related to that axis. Curves are related to the axis of the pot.

"I make pots from the inside. They push out from the inside. I'm worried about the core of them; that's what makes them perfect. I'm less worried about how a curve sweeps out, because the sweep of the curve doesn't matter so long as everything is in proportion to the axis."

In the creation of beautiful forms, Daniel's first step, inspired by architecture, is to establish the central axis. The second step is to make the shape that ends the pot's outward thrust in taut curves. Human presence is implicit in the invisible midline. The human body is explicitly evoked in the symmetrical shape at the limit of the pot's spread. Daniel says:

"You know how when a young woman gains weight fast, you know how her skin gets tight. Everyone recognizes it, but they might not say it because it is not politically correct. But when they gain weight very quickly, the tension of their skin is phenomenal.

"When you see that, you're seeing power. There's a fullness without flab, an inherent power. This is not a judgment; it is an observational perspective on form. And it is that power and that tightness of the skin of a plump young woman that I want in my forms."

His pot's architectural force is released from within to whirl around the core. His pot's bodily appearance is shaped to the ideal of beauty that the great art historian Robert Farris Thompson discovered through his analysis of Yoruba sculpture. Named ephebism by Thompson, this is the beauty of healthy young bodies ripe with life — no wrinkles or sagging, but a splendid, smooth and swelling radiance.

Daniel knows what he wants — a plumb, robust, ephebic beauty — and he has the skill to get it. To explain himself, Daniel divides artists into two kinds. Both begin with a concept and aim for beauty. One kind of artist makes "conceptual-based beauty," which, Daniel says, is "the idea that the concept of the work is more important than the work itself." Such artists imply, but don't achieve beauty. Daniel, though, creates "skill-based beauty," the beauty that is realized "when somebody has the technical ability to produce something, and their technical ability does not stand in the way of their idea. So, if they want to produce an emotion in their work, their technical ability does not stop them from doing that."

Daniel continues, "I'm technically ready for the ideas I have. If I'm not ready, if I can't make you feel the emotion I want you to feel, I can lay in bed for three days until I figure it out. And when I wake from my drunken slump,

then I want to get out and practice that until I can make you feel the way I want you to feel.

"I can do what I want to do, and that's skill-based beauty to me."

Skill appears in every phase of his work, and during skilled action, Daniel uses two instruments, the wheel and the kiln, to make his art visible, just as musicians use instruments, a piano or fiddle, to make their art audible. Kilns like his, Daniel says, are "the worst technology in the world, some of the oldest technology, and by any engineering standard, it would be insane to build one, you know. But they create these objects that are phenomenal. They are some of the largest, most beautiful tools, these big kilns.

"They're like whales. They're large tools, some of the largest tools in the world. We don't get that many good pots out of them. But what we get is a few really great ones. We get a few great ones out of these big kilns, and the great ones are really great. Every time I think about building another kind of kiln, I think about these few great pots."

Kilns, naturally enough, were the topic when I stayed up all night with Daniel during the November firing in 2012. In England, Daniel said, he was impressed by the beauty and permanence of the old stone buildings, but in Thailand he learned to respect the casual impermanence of the architecture. He saw no need to preserve the kiln he had built when he returned from Thailand, no need to cleave sentimentally to his past. Now he was firing it, but soon he would tear it down and replace it with a new kiln because he was about to reach the prime of his career and he didn't want to take time from his prime to build a new kiln. Then as he aged, Daniel told me, he would raze that kiln and build a smaller one, easier to manage as his strength declined.

Daniel's new kiln will be bigger, he said, because he was making more big pots — five years later he declared that he would only make big pots — and he wanted a kiln that would hold thirty-five big pots in every firing. He intended to keep the firebox and chimney of the old kiln, so the new kiln will be larger in its breadth. The old kiln was a "straight tube." The new one will be "bulbous," its curving walls swelling out and then narrowing into a form that Daniel likened to the hull of a trim boat, overturned and keel-side up. Chad Brown was planning his new kiln at the time, and he called it boat-shaped as well as flame-shaped. The old kiln's floor was flat; the new kiln's floor will rise through steps, much like Mark's. Leveling the old kiln, Daniel said, would be a "self-destructive act"; he will obliterate his past. The old one was the kiln of his "development." The new one will be the kiln of his "mastery."

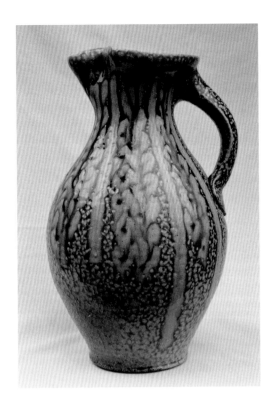

Large pitcher by Daniel Johnston. Red slip; decorated with tin glaze, celadon slip, and ash glaze; salt-glazed; 14 inches tall, 2013. This is one from a series of pitchers Daniel made and sold to finance the building of his new kiln.

Seven months later, in July of 2013, the old kiln is gone, dismantled in June, the new kiln is in progress. Daniel made and sold a special line of big pitchers to finance the change, and he is in motion. He can move more quickly, he says, when working alone. Collaboration slows him down, but other people offer their ideas, and in the end, he says, collaboration often leads to better results. For this project, he has plenty of collaborators. Terry Childress repaired the chimney. Bill Jones, a new apprentice, trained in architecture, has joined John Vigeland, Daniel's first apprentice who will soon leave to work with Alex Matisse at the East Fork Pottery in the mountains to the west. In building the new kiln, Daniel leads and his apprentices follow, learning less by instruction than by participatory observation.

Before building began, Daniel took his apprentices to see other kilns. "People look like their kilns," Daniel says. David Stuempfle's kiln is "straight, neat, and open," just as David is. Mark Hewitt's kiln is "artistic, voluptuous, curved, and organic." Joseph Sand's kiln is burly like Joseph. Ben Owen's kiln didn't interest the apprentices. "It looks more like a machine than a tool," representing, Daniel says, "the NASCAR side of southern culture, but Ben's pots are excellent, streamlined like race cars." Fast automobiles with sleek lines hold much appeal for Daniel.

When building begins, Daniel's team expands; he gets, he says, "a little help from my friends." In addition to Kate and Terry, Bill and John, Daniel has Catarina Krizancic and Andrew Dutcher, who helped with the November firing, as well as Alex Ferrante, a student from Texas, and Bryce Brisco, a potter and close friend from Arkansas. Everyone makes plans, Daniel says, but different people operate with different ratios of planning to action. Daniel plans, but he is primarily a man of action who makes quick visual judgments and charges ahead, trusting in experience and leaving little room for pondering or regret, while his helpers work more by mind than eye, taking more measurements and proceeding more cautiously, more slowly.

Daniel has planned a boat-shaped, flame-shaped kiln of curves. I chance to comment that my dear friend Ibrahim Erdeyer, who has built kilns in Turkey, said that if a kiln is composed only of curves, like the domes of an Ottoman mosque, the heat moves smoothly through it. Daniel agrees and adds that curved walls are also stronger.

To get his kiln of curves, Daniel has cut twelve boards into arches — like the ribs in a ship's frame or a whale's skeleton — that stand in sequence, marking the widest extent of the kiln's plan at the sixth board and rising to the highest point of the kiln's profile with the seventh and eighth boards. Inside, six curved steps lift toward the chimney, creating seven distinct chambers. They will be stoked and salted through twenty-eight holes in a pattern close to that of the old kiln, the difference being an additional hole on each side at the firebox end. Now Daniel, Bill, and John are nailing laths from the front to the back over the arch boards, rendering in wood the kiln's flowing form.

Five days later, Daniel's team is laying brick in rows over the frame and up the kiln's sides. A few days before, David Stuempfle told me that he admired what Daniel was doing. At his age, fifty-two, David said he couldn't possibly go through the difficulty of building a big new kiln, a small one maybe, but not a big one. Today Daniel says he is glad that he is young enough to take the job on, yet old enough to admit that his new kiln resembles Mark Hewitt's. "Sometimes my pots are quite like Mark's. I've absorbed Mark into my own self-expression, and I've matured to the point where I'm not rebellious and I don't have to build a kiln to look unlike Mark's."

As he watches his kiln take shape, Daniel says he knows how he will fire it, how the flame will move, how the pots will turn out. "But," he says, "I hope I'm wrong. I want the kiln to fight me. I want that challenge. But I've made the right kiln, the best kiln I could plan."

The arched frame of Daniel's new kiln, July 5, 2013

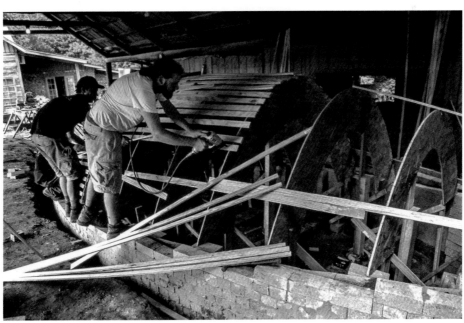

Bill Jones and Daniel Johnston nailing lath over the arch boards, July 2013

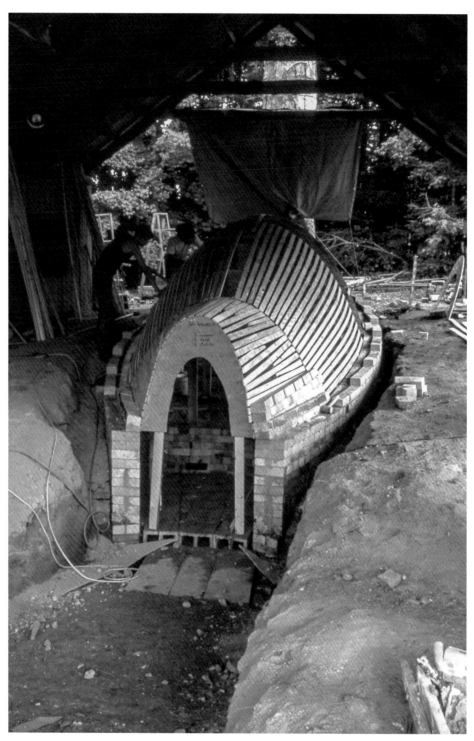

The wooden framework and sheathing complete, Daniel's new kiln, July 2013

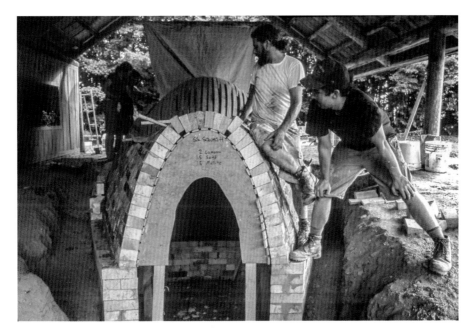

Daniel Johnston and Bill Jones bricking the kiln, July 2013

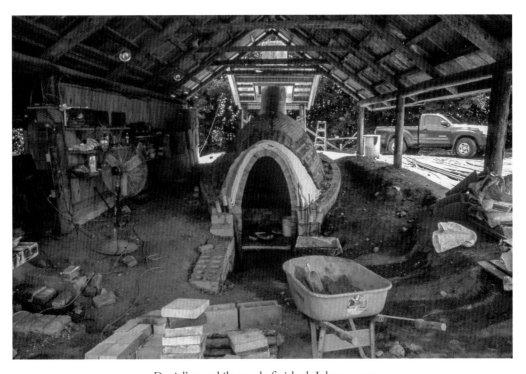

Daniel's new kiln nearly finished, July 29, 2013

John Vigeland, 2014

Bill Jones, 2013

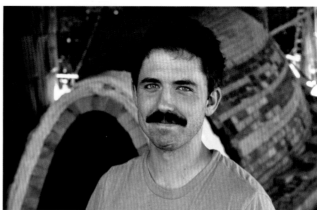

Six more days pass. The brick arch over the kiln's mouth is complete and the team is digging a trench around the kiln so block can be laid to reinforce the lower walls. Daniel is worried about the schedule. The kiln is not finished, no pots have been made, money is running out, and the work has been interrupted by visitors from Sweden who learned about Daniel on the internet. Despite it all, Daniel says, "The new kiln shows how damn good I am, translating my emotion into a form that is sleek, elegant, modern, but not disobeying the history of ceramics. The outside is not so exciting, but it makes people want to look inside. I'm fucking thrilled with myself."

A week later, the brick vault of the kiln is complete, dry, and firm. The wooden centering has been removed, the floor is being bricked. An e-mail from the Swedish visitors reports that they had no idea that there was anything in the world like Daniel's workshop, so amazingly authentic, rustic, and lovely. Daniel says that he is now standing steadily on the shoulders of Mark and the potters before him and just as he is beginning to feel completely confident, he has become aware of the burdensome weight of the apprentices who stand on his shoulders. He is sad that John Vigeland is about to leave and go

to work with Alex. He is relieved that Wild Bill Jones, his second apprentice, will remain. Five days more, his kiln is close to completion, Daniel gathers his helpers for coffee, and bids them a fond and grateful farewell.

In the middle of the month it took to build the kiln, Daniel and Kate hosted a dinner party. They are both excellent cooks who enjoy having friends around the big table in their cozy quarters. Mark and Carol came, bringing Mark's new apprentice, Adrian King, a talented man who, after his apprenticeship, will find gainful employment as a potter in the state of Maine. Pravina and I, Terry, Bryce, John, and Bill were also there.

Before dinner, Mark stood looking at the kiln in progress. He said little, but smiled broadly. At dinner, how great it is, he said, to see a mass of people working together, the apprentices learning beside a master and absorbing the standards that guide creation. Ideas flowing in from outside, Mark said, can be fruitful, but if they remain incompletely assimilated, they will prove disruptive, contradicting the deep values learned in lived experience. When potters work in a community, like that around Seagrove, they learn from each other, developing natural differences while holding to core values and becoming able to sell their work to a wide market of people who share some notion of those values. "Everyone," Mark concluded, "has to be a seller."

Mark's concluding comment on commerce set the topic for the table. Bernard Leach wrote that, ideally, the potter works in collaboration with a scientist and a merchant, but if the merchant's values prevail, disaster results. In North Carolina, the potters are their own scientists and merchants. They make the experiments and sell the products. Disaster or triumph — it's their own doing.

Daniel took up the topic, arguing that cooperative selling doesn't work and potters are fools to think they can survive on grants from art agencies. "The problem is we have to be entrepreneurs," he said, "and that sets up a tension between our delight in the creative moment and the pull of wealth and fame. Obviously, wanting wealth and fame can ruin the creative moment. And obviously satisfaction in the creative moment doesn't lead to fame and wealth. You've got to make enough to live.

"Mostly what you do is work. People ask if it's pleasant, relaxing. No, it's necessary. It's not fun. You've got to do the work. You've got to sell to live."

It's quiet around the table. Mark, Daniel's teacher, smiles gently. John and Bill, Daniel's students, sit adrift in contemplation. Creation and commerce conflict; both are basic. Just as a book is not done until it is published, a pot is not done until it is offered for sale. Selling comes next.

Daniel charming customers at his shop, 2009

Kate and Daniel dealing with customers at their kiln opening in December 2014

6

SELLING

IN HIS AUTOBIOGRAPHY, WILLIAM FISHLEY HOLLAND, who gave Michael Cardew his first lessons on the wheel, warns young potters that pots are easier to make than to sell. That is how it has become in these late days. Much earlier in Holland's England or Daniel's Carolina, the work was hard but selling was not. The potter's products — churns, crocks, jugs — were needed for food processing and storage on every farm. During a decade of trips for fieldwork, I found that it was still like that thirty years ago in Bangladesh. At the time there were six hundred and eighty rural villages of potters, as well as fifteen shops in the old potters' district of Rayer Bazar in the capital city of Dhaka, where earthenware was made by hand and fired with wood, where women and men made the vessels for carrying water and cooking food that were needed in millions of households.

Over time — in England where industrialization began, in the United States where corporate capitalism has nearly crushed the small entrepreneur, and even recently, if less completely, in Bangladesh — people supplied with industrial products have lost the need for handmade pottery. Demand is slight in the United States; still, some people, though in numbers far smaller than in Japan, do want handmade tableware. In our house, for daily use at the table, we have a teapot by Mark and casseroles by Kate; we have plates by Mark, Daniel, Vernon, Alex, Michael, and Naomi; bowls by Mark, Daniel, Sid, Vernon, Chad, Bill, and Andrew; pitchers by Mark, Sid, and Travis; coffee mugs by Mark, Daniel, Sid, Vernon, Kim, Chad, Alex, Andrew, and Stillman. Mark Hewitt loves to make mugs, and the mug, Kim Ellington said, is "the gateway drug" for the collector.

Walter and Dorothy Auman's shop, 1980

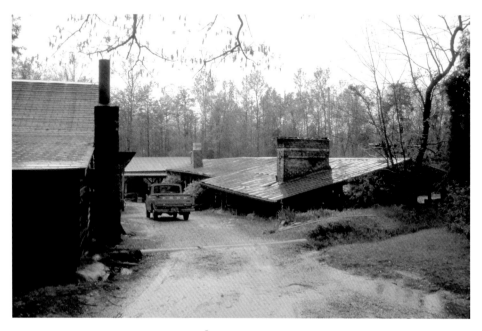

Jugtown, 2000

Kim had in mind the collectors who buy creations made by potters they admire, potters with names, creations that are at once symbolic of southern culture and affordable works of art, returning more bang for the buck than, say, a painting. (A painting as good as a pot by Daniel would cost ten to a hundred times more.) Collectors use pots, as they might use paintings, to decorate stylish homes, though they rarely stop there, filling the corners, then shelves in the cellar with sets that keep expanding since the potters keep making changes as their careers progress. Collectors — people like Bill Potter, Patricia Hyman, Dwight Holland, Harris and Kathy Brown, and Monty and Ann Busick (who, Mark jests, paid for his daughters' education) — provide the foundational economic support for North Carolina's art movement.

Pots are sold in galleries around Asheville, an attractive draw for tourists in the mountains of North Carolina. In Boston, the fine Pucker Gallery has held exhibitions of works for sale by Mark Hewitt and Ben Owen III. But galleries lift the price for the buyer, lower the profit for the potter, only occasionally provide opportunities to meet the artist, and, finally, contribute only marginally to the potters' economy. Collectors find happier hunting at the annual shows in Seagrove, Hickory, and Charlotte, where many potters display their latest work, sell directly, and stand willing to chat amicably with their admirers. The potters, in general, say they do well at the shows, but like potters the world over — in Seto, Japan; in Kütahya, Turkey; in Montelupo, Italy; in Tracunhaém, Brazil — they say they do best when people come to their workshops. Having made the effort to get there and charmed by the atmosphere, they always buy.

Jugtown was the first rural destination for collectors of pottery in North Carolina. The sales cabin at Jugtown set a precedent. Walter and Dorothy Auman had a shop for sales at their pottery in Seagrove. Ben Owen III has an elegant, well-lit showroom in a separate building in front of his workshop. Others, like Sid Luck and Daniel Johnston, have racks of ware for sale in their workshops to meet the needs of random visitors. Dominant among the potter-merchants today, though, is the kiln opening that, announced on postcards and websites, brings numerous eager buyers to the potter's shop. Terry Zug has described the frenzied buying at kiln openings by Burlon Craig and Mark Hewitt. Tom Mould filmed a kiln opening at Mark's, and Mark's kiln openings, like his big pots and big kilns, have proved to be generally influential, becoming markers of the Carolina tradition in its current phase. At Sid Luck's, the opening happens, literally, when the kiln is opened. For others, for Mark,

The barn on the night before Mark Hewitt's kiln opening in December 2014

Daniel, and David, it takes place a short time later, after the new pots have been evaluated and arranged for sale.

Early on the morning of a kiln opening in December of 2014, Mark and I are having a quiet breakfast. Outside it is dark, pitch black, but there are already four cars parked in a line on the narrow country lane that leads to the Hewitts' home. Soon there are ten, and by eight in the morning as the light lifts, fifty people are standing in the lane under umbrellas in a chilly drizzle. Mark goes out to welcome them and explain the rules. People must enter in the order they arrived. They take numbers, and at nine sharp they follow Carol in an orderly line, past the house, where beautiful big pots by Mark and Daniel stand on the porch, and then turn down the path that leads between the workshop and the kiln shed. Many of them previewed the pots before the sale, and they head straight, walking, but walking swiftly, toward the pots they want.

Beside the path to their left, a table holds plates. Big pots stand in a majestic crowd in the yard to their right, like silent, extravagant ambassadors from some other world. Before them, in the farm's old barn, Carol has arranged the new pots into five sections, the first on the left is crowded with mugs. In the middle, in a nook to one side, stand classics by Mark. On a table opposite, Mark's colorful new departures gather into an artful display. A table of inexpensive seconds, soon to be swept clean, stands outside in the rain.

Customers waiting in the rain before the kiln opening at Mark and Carol Hewitt's home,
December 2014

Customers among the big pots at Mark's kiln opening, December 2014

People entered at nine. Fifteen minutes later a woman groused that she was "getting a late pick." By ten most of the buying is done, and the customers are standing under a tarp in eight lines to pay their bills. Carol says the crowd is small for a December opening, but the weather is bad, buying was brisk, and she is not at all disappointed. An end of sorts has been reached, though many remain to eat, drink, and take a second look through the stock. In fact, people moved so quickly that some quiet but excellent pots are left. Their buying done, people mingle in pottery talk or snatch a chance to chat with Mark who is always pleasant and informative. They linger, but others left quickly because there is also a sale at Jugtown and kiln openings at Joseph Sand's shop and at Daniel's. That day, Daniel sold two-thirds of the works he had set out for sale.

When Daniel got back from Thailand, he built his shop and kiln in a fevered fit of energy. Then, needing money, he hastily made many pots, and, with Mark as his model, he held his first kiln opening on December 6, 2003, amazingly enough, a bit less than a year after the day he left for Thailand.

Daniel alerted all his friends. Mark Hewitt came and slept in his car so he could stand first in line and buy the first pot. "The first kiln opening was a success," Daniel says. "I'd had, you know, only three weeks to make pots for it, and I was absolutely full of myself, proud of myself." He goes on:

"I had that great success. Then I had, like, four months to make pots for the next kiln opening. And, man, I tore it up. I tore it up, and I made so many pots, and I had them priced. And I knew how much money I was going to make. It was going to be, like, thirty-five thousand dollars. I had thirty-five, forty thousand dollars of inventory made. And I sold out my first kiln opening. And the second one was, like, I'm going over the moon, you know.

"Oh God. I sat out there by myself all weekend long. And I sold, I think, six thousand dollars of stuff.

"And it was bad. The only thing worse than sitting out there by myself was when somebody did show up. Because it pointed out that there was nobody there buying. And it was a painful, painful lesson."

Daniel sat among the unsold pots and uneaten cookies, understanding that he had made many friends when he apprenticed with Mark —"my customers loved him," Mark told me — and they wanted to buy something from his first kiln opening. "And they came and they spent a shitload of money to support me. But the second kiln opening — they had done it. What I realized is that I have many friends, but I don't have customers. They weren't my customers. That was the first lesson where I realized that I've got generous friends, but I don't have any customers."

For a few days, Daniel says, he found it hard to get out of bed, and it was "salt in the wounds that you've got to clean it all up. You've got two hundred cookies. You've got everything arranged and you've got to go out there and drag it all back into the workshop." Two weeks later, he got himself together and went into action, making numberless phone calls — it was long before he had an internet connection — to learn about craft shows where he could exhibit and sell his work. Then for three years, he made pots as quickly as he could and he "hit the road" to sell them wherever he could. Looking back on that time, he says:

"I would go to the shows, and I can't hardly stand to even say it now, but every person that passed by, I stopped them and shook their hand and told them I was firing a wood kiln and everything was made by local clay. And I told them my pedigree, and, you know. I always did very well, sold a lot of pots. But it was hard work.

"I'm talking about the business end of things now, but I also got really good. I started getting really good. I had to make a lot of pots, and I started pushing hard, and I started being exposed."

However exhausting and demeaning the experience, Daniel was becoming known. Crowds now showed up for every kiln opening and, Daniel says, "Life was really good there for a few years. It was really great, and I was making more money than I ever thought I would make." Daniel's successful bid for wider recognition and increased profit was made at the right moment in an auspicious environment.

In 2005, the North Carolina Museum of Art held its first major exhibition of North Carolina pottery. Curated by Mark Hewitt and Nancy Sweezy — and accompanied by a brilliant catalogue they wrote — the magnificent exhibition brought pots from Asia, Europe, and the northern United States into comparison with nineteenth-century masterpieces from North and South Carolina and with the new creations by the contemporary Carolina core: Kim Ellington, Mark Hewitt, Ben Owen, Pam Owens, Vernon Owens, and David Stuempfle. The show closed in March of 2006. When I talked at the time with Vernon Owens, he said that before the exhibition he had not thought of himself as an artist. Having a show in an art museum, though, caused him to think again about his own work, and he felt the exhibition would lead to more general appreciation, helping to shape a better future for his son, Travis, who was already making pots with sharp and beautiful forms.

The exhibition fed the enthusiasm at the Catawba Valley show in Hickory, where Daniel was already selling his work every year. In 2008, a big pot with

Kate Johnston, 2018

a luscious glaze sold for a thousand dollars. By the next day, he had sold out, his booth was empty, a sure sign of success, and David Stuempfle said that Daniel was now clearly the leader among the younger potters. In the next year, at an exhibition of contemporary North Carolina pottery held at the Rocky Mount Arts Center, Daniel Johnston was included along with Mark Hewitt, Ben Owen, and David Stuempfle — masters whose work had been featured in the grand exhibition at the North Carolina Museum of Art four years before.

Daniel was in good company, his reputation expanding, and in that year, 2009, he was invited to teach a course on making big pots at the Penland School of Crafts in the mountains of North Carolina. "Penland was a huge turning point," Daniel says. When the course began he realized that, in trying so hard to sell his works, he had lost some of the integrity he had felt as a potter in Thailand, but it all came back when he was teaching. "In a two-week period, I took twelve people, some of them never even threw a pot before. They all threw a big pot, and I fired a kiln, all in a two-week period." Daniel was a confident teacher. Kate Waltman was one of his students. Daniel was charismatic, Kate was beautiful and talented. They fell suddenly, deliriously in love, and by the end of the course, Daniel says, he knew he would marry her.

Friendships formed at Penland endure. Remo Piracci, also a student in the class, came to help Daniel with a firing in 2012, and the next year Daniel went to help Remo build his own kiln in the mountains. Bryce Brisco, another student in the class, came to help Daniel build his new kiln in 2013. Then late in 2017, Daniel roared away on his big black bike, followed by his apprentices, Charlie Hayes and Natalie Novak, in a truck loaded with tools and lumber — all of them off to frame a workshop for Bryce in the hills of Arkansas, near Fayetteville. During the first two weeks of 2018, Daniel returned to place the windows and hang the doors for Bryce's new shop.

Earlier, in July of 2014, when Bryce Brisco, a skilled potter, had taught for three years at the Appalachian Center for Craft in Smithville, Tennessee, he invited Kate to teach a course at the Center. Attentively, in gentle control, Kate taught three women and two men her distinctive technique of ceramic decoration. Her inspiration was the Tz'u-chou ware of northern China, which is generally thought to belong to the far past, in a period ending around 1600. When Bernard Leach was in China, in 1915, he was surprised to find new Tz'u-chou ware generally available for sale at low cost. In 2000, I visited Pengcheng in northern China, where the Tz'u-chou tradition still flourishes and one of the

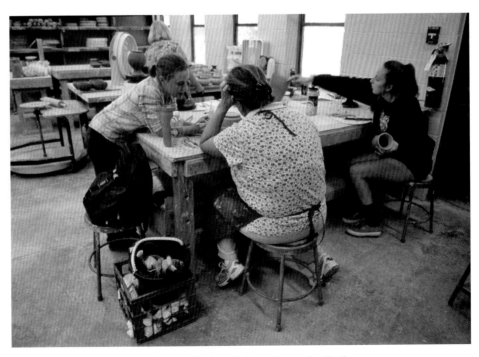

Kate teaching at the Appalachian Center for Craft, 2014

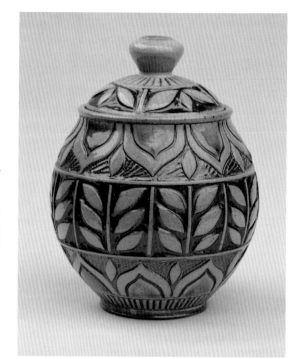

Small lidded jar by
Kate Johnston.
Manganese and tin slips,
ash glaze and salt glaze,
7 inches tall, 2013

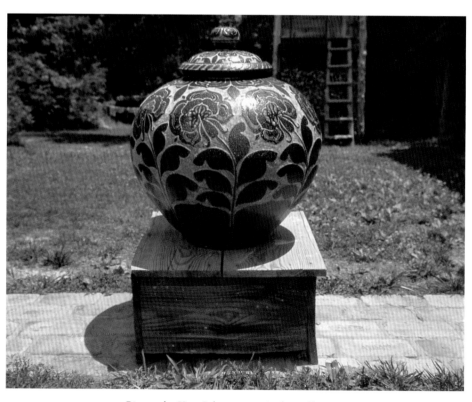

Big pot by Kate Johnston. 29 inches tall, 2017

decorative techniques in use is quite like Kate's. She carves leafy or floral motifs in a regular rising pattern that has become more curvaceous and complex over time, then scrapes away the background, usually filling it with light or dark slip to emphasize the relief. Her Chinese technique serves an Arts and Crafts sensibility; East and West meet in her work as they do differently in Daniel's.

The Appalachian Center for Craft has shops for glass-blowing, woodwork, metalwork, and weaving, as well as pottery. The students and teachers gather for convivial meals, and when we were there Kate gave an elegantly organized autobiographical talk after dinner. Knowing that new work flows from old, Kate said, she studies old pots, not to copy them, but to develop personally expressive fresh forms. She aims to appeal, she said, to people who understand William Morris's famous command to have nothing in your house that you don't know to be useful or believe to be beautiful. Kate, in the venerable modernist manner, looks back to move forward, creating useful and beautiful new pots for sale as she steadily advances.

She got a quick start. Encouraged by "two wonderful grandmothers who were both interested in art," Kate was taking lessons in painting by the age of nine in her hometown of Millville, New Jersey. At twelve, she was teaching "little, little kids" in a pottery studio, and by sixteen Kate was taking classes in ceramics at a community college, demonstrating pottery techniques at the Wheaton Arts and Cultural Center, and selling her work at craft fairs. "I was making pots in a very serious way," she says. "I hated high school. I did well, but I hated it, and I didn't identify with my peers. I had a bigger picture of what I wanted, and I knew I wanted to be a professional potter."

Kate was making more money as a potter than other teenagers were making as laborers in the fast-food industry, and she was not excited about college. But her parents and the potter who had taught her the most, Terry Plasket, thought she should pursue a university degree. Kate frightened her parents by applying only to Alfred, the leading school for ceramic study.

At Alfred University, Kate was thrilled by the room full of kilns. "It is what I pictured heaven to be like at that age. It just seemed so great." Kate found the whole spread of art classes to be interesting. She had always enjoyed drawing, a skill revealed clearly in her style of ceramic decoration, but pottery was her calling and she most loved throwing on the wheel. The classes on throwing, structured to teach, seemed odd "because I already knew how to throw, and when the other students were still centering the clay, I was finished."

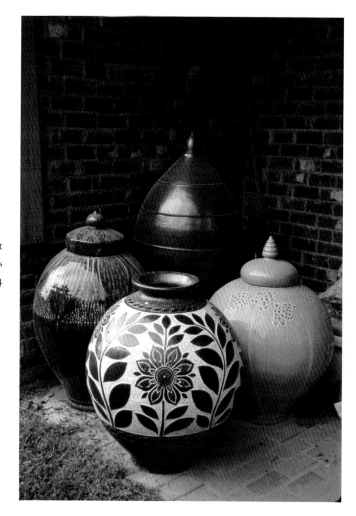

A family of pots: a big pot by Kate in front, big pots by Daniel behind, 2014

Consider the parallels in precocity. At sixteen, Daniel bought ten acres in Randolph County and was off on his own. At sixteen, Kate was making and selling pots. At eighteen, when Daniel began his apprenticeship with Mark, he already knew how to throw. At eighteen, when Kate began at Alfred, she already knew how to throw.

Since a time before Alfred, Kate had been drawn toward larger, wheel-thrown forms, and after her junior year at Alfred, she took Daniel's class at Penland, the only course offered that summer on making big pots. Daniel, listening while she talks, remarks that it was also the first time that the Thai technique had been taught in America. Daniel's technique, Kate says, provided "a skill-based way for a small female to make big pots, and big pots are impressive. They attract attention; they do that for themselves, and I wanted the attention, the recognition."

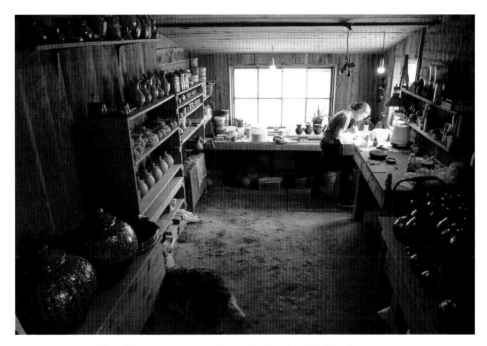

Kate Johnston in her studio in the log shop's brick wing, 2016

From Daniel, Kate learned more than an impressive method to employ in making some of her pots. "One thing," she says, "that I didn't learn at Alfred, but I did learn from Daniel, was about form, how to approach form. Everything I'd made up to that time was basically a cylinder. But form is extremely important in Daniel's work, and since then, learning about form from him and getting the curves right by looking at his pots, has been the key reason for progress in my work." Kate's words prompt me to comment that Chester Hewell said, "Ain't got form, ain't got nothing." And that leads Daniel to say that the forms flowing out of the Hewells' factory in Gillsville, Georgia, are as true and beautiful as Svend Bayer's, the results of deep skill and steady, repetitive practice.

When Kate returned to Alfred for her senior year, she began working in the studio "to prove that a five-foot-tall woman can make big pots." For Kate as well as for Daniel, for the two of them together, Penland was a major turning point. Kate had gained a vision of the potter's life. She had no intention of becoming a supportive spouse, helping Daniel with commerce as Carol helps Mark — a pattern among couples, husband to make, wife to sell, that I've also found in Japan and Brazil. She would be like Pam, who works beside Vernon at Jugtown where selling is managed by a pleasant lady in the sales cabin. Kate's goal, as she said, was to be a professional potter, and that would mean to be generally useful in the workshop while making, like Pam, fine pots of her own.

"I'm really fortunate to have Kate in the workshop," Daniel said later, once things had settled into a pattern. "I'm really glad that Kate understands that I care about my work a whole lot, and I care about her work a little bit less.

"She's surrounded by Mark Hewitt's apprentices, and the next generation of Mark Hewitt apprentices, and the next generation of Mark Hewitt apprentices, and all she hears about is Michael Cardew. And she still wants to do what she wants to do, which is Kate saying to me, I care about my work a whole lot, and I care about yours a little bit less.

"She's done this very strong thing by being engulfed in it all and staying true to who she is. It's a really brilliant thing to do, and I respect it."

After the turning point at Penland in 2009, some things held steady. In the catalogue of the exhibition mounted that year, when Daniel's pots stood with Mark's, Ben's, and David's, Daniel affirms that he belongs to "the Leach, Cardew, and Hewitt school of making pots," and that the local clay he uses "culturally offers a connection to the many potters that dug that clay in the Seagrove area before me." That remained the same.

Other things changed. Some old connections stretched and snapped painfully. New ones tightened. Terry Childress was staying with Daniel and working beside him in the shop. Every three or four weeks, Daniel hopped in his truck and sped to upstate New York where Kate was studying in her last year at Alfred.

Then after Kate had finished at Alfred and was free to help, after John Vigeland had come to begin his apprenticeship, and while Terry was still there, skilled and willing as always, Daniel was ready to take on the Big Pot Project. He had been thinking about it for years, and in time it would become another turning point, confirming Daniel's positon in North Carolina's tradition, bringing him a rush of cash, and setting the course for his future career.

Daniel had told me, in March of 2007, that he was planning to test himself and sharpen his skills by making a hundred big pots to the same basic design. In his autobiography, Michael Cardew describes the difficulty of making many pots in series; when you can do that, he wrote, you are a real potter, a professional. That's what Daniel intended to do and to be. During the long process, he would work quickly as he had when he was a production potter in J.B. Cole's shop, trading plans for action, leaving the fretful mind behind and letting the able body take over. His vision was so clear that I thought he would manage it during the coming summer, but when we talked the next year he was still planning. It was not until the time was right that Daniel could set to

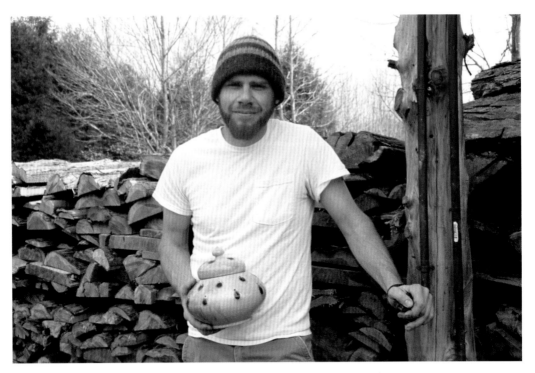

Daniel Johnston, 2007

work. The time was right in 2010, when he had Kate, John, and Terry beside him, and Daniel says:

"It was a wild time, and I was happy. It was popping, things were happening, and it just came to life. There were people in and out of here. Alex Matisse was in and out. Terry was here almost all the time. Kate was here. And that's what I wanted. It really is a way of life. And so we started working on the Big Pot Project.

"The Big Pot Project — the trouble is that I had conceived it years ago, and when it came down to doing the project, I was already over it, conceptually. I hadn't done the work for it, but conceptually I was already done with it.

"And the Big Pot Project just beat me to death, you know, and not because of the pots and not because of the work, but because of psychology.

"It really forced me to look at myself in a lot of ways, and look at my work, and look at my technique, and my grand ideas.

"When I was making a pot a day and making it beautiful — that's one thing. But when you're going to make two pots a day and you have to be faster, and your technique has to be really good to achieve that, then you're really putting yourself to the test.

"And in the beginning, I wasn't up to it; I just wasn't up to it. And the boredom was tremendous, you know, of making that many pots. The beginning was just hell. It was hot.

"And I began making a couple of pots a day, and then, Henry, what happened was I'd get really depressed, and I couldn't do anything.

"The deadline was coming, and I wasn't doing anything. I was running out of money, and I just couldn't do anything, you know. The work didn't have any soul or power.

"I counted up the days, and it was just about impossible for me to actually pull the Big Pot Project off. It was almost impossible.

"And only then, when the challenge had come to that level, was it interesting enough for me to move forward. And I went from making one or two pots a day into making four, five, six big pots a day."

In a frenzy of coordinated competence, Kate and John were rolling the coils and mixing the glazes, Daniel was compressing and shaping the pots, Terry was mixing mud, cutting wood, and wielding the blowtorch. The torch was not enough; the pots were drying too slowly. Then Daniel remembered that, in Thailand, they dried the pots on their sides in the sun, and that helped.

As the momentum increased, so did Daniel's workforce. Remo Piracci showed up, a team from Texas arrived to help, and with many busy hands in the shop, Daniel felt he was back in Thailand:

"That is how it was in Thailand. I realized that everyone was being forced into roles. It was the first time I had to be a boss. And I started realizing that I had a Thai studio. This is the studio I learned in.

"And when I started remembering that, then I started remembering everything I'd learned there. And the shapes of the pots started coming beautifully."

Working swiftly as he had in Thailand, Daniel abandoned decorative elaborations and bore down, trusting that glazed form alone could carry the message of excellence. "I was wide open," Daniel says, "and on the last day of the project, I made ten big pots in one day." Ten big pots in one day: at three in the morning he e-mailed Louise Cort with news of his triumph.

With five firings behind him, Daniel had met his deadline. On the day before the sale, he had a hundred pots, some still warm from the kiln, each one numbered and standing on a plank platform in a line along the rural road that runs past Daniel's place. That evening when customers gathered to preview the pots, Daniel told them it was his idea, the pots were his, but he couldn't have done it alone, and he called Kate and John to his side to thank them.

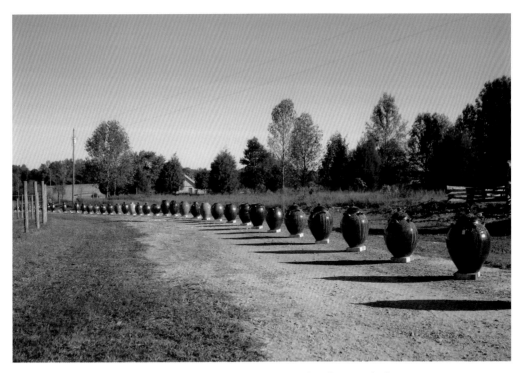

The Big Pot Project on the road, 2010. *Photo by Daniel Johnston*

Jay Yager documented Daniel's project in a film titled *4000 Gallons*. The film catches snatches of action and shows the long line of pots, curving gently amid the green fields of Randolph County. Some of them have lids; others don't. Some are decorated in loopy swoops; many are not. Some have coats of black manganese slip; most don't. All are of a size and generously robust. To visitors in the film, Daniel explains that, with a hundred big pots, his intention is to create an installation, and during the period before him, Daniel would turn his creative attention to installations.

Terry Zug was there. He is the leading scholar of North Carolina's ceramic tradition; he and I were graduate students together at the University of Pennsylvania, along with John Burrison, the leading scholar of Georgia's pottery. After dinner one night in our house, I set up the recorder and asked Terry to describe what he saw. He says:

"That large jar project that Daniel did several years ago was one of the most amazing projects I've ever seen a potter take on.

"We went down to his place while he was working on it, and the evening before he sold the pots, he put them down the road in front of his house on wooden pedestals. And it must have been three hundred yards — it was a long walk to the end of the line.

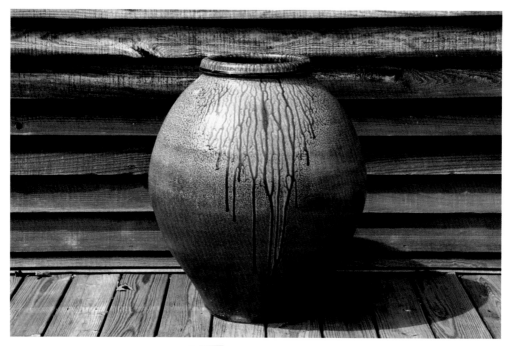

A pot from the Big Pot Project made by Daniel Johnston and standing
on the porch of Mark and Carol Hewitt's home, 2011

"There were a hundred of these large jars, and one of the interesting things about them was to see the shapes as you walked down the line, because at the beginning he made one jar the first day, and then he made several jars a day, and then he realized the time was running out, and he threw ten jars on the last day.

"And also, the decoration disappeared when he got to the end of the line, and probably numbers ninety to a hundred were the most beautiful pots because they had no slip decoration, no manganese. They looked like nineteenth-century North Carolina pots: very beautiful ovoid forms and lots of salt flowing down the sides of them.

"But the whole procedure: it was really the most ambitious project I've ever seen any North Carolina potter undertake."

Terry Zug's memory and Jay Yager's film run in accord, reinforcing each other to provide a feel for the day of the sale. Terry says it was like a kiln opening and sixty or seventy people were there. Some of them had slept in their cars to stand early in line. Daniel explained that people had to enter in the order they arrived; they could buy as many pots as they wished and all the pots were priced, too low Terry says, at four hundred and fifty dollars. Jay's film shows that Carol Hewitt was second in line and that buyers who had previewed the

pots dashed toward the ones they wanted. Terry says that a dealer was first in line and he grabbed ten pots. Terry came late and he bought the last two. Buying was over in twenty minutes. Daniel promised that people who waited in line but got no pot could make orders. He got seventy orders.

Daphne, Terry's wife, was listening while he described Daniel's project. An astute and sensitive observer, Daphne characterizes Daniel as a Samurai, a warrior who follows an inner, heroic code — a commitment Daniel would say. He began, she says, in pride, then coming to understand that he needed help, he gathered people around him and his project became "a community effort." Daniel, Daphne continues, "had the confidence that he could complete the project. Of all the potters, of all the young potters, Daniel is the most thoughtful. There is a spiritual quality in Daniel."

In Daphne's view, the project was a spiritual and social success for Daniel. For Terry, it was a sign of Daniel's industry and ambition, and an artistic success within the North Carolina tradition. For Daniel, it was all of that — and it was a financial victory. Before the disappointment of his second kiln opening, Daniel had hoped for thirty-five thousand dollars. He made six thousand. On the day of this sale, he sold one hundred and seventy pots at four hundred and fifty dollars apiece, making a touch more than twice the amount he had dreamed about before that dismal weekend six years earlier.

Two years later, after his tremendous accomplishment, Daniel looked back to generalize eloquently about his work:

"It was nothing like I thought it was going to be, the Big Pot Project, and it taught me a lot more than I ever thought it would.

"The big pots I make now, I can really see them. They bother me more; it's a much more painful endeavor. And it's a much more emotional endeavor, making the big pots now, because I expect more out of myself. And the level of concentration, and the level of skill when I sit down at the wheel, is greater than it used to be.

"This job is exhausting because when you are at the wheel, you're physically giving yourself over, and you're psychologically giving yourself over. You have to physically give yourself; your muscles have to do the work. Your mind has to be able to understand the work. And you have to have the intellect to concentrate on it. And the spirit. You have to understand yourself.

"So, there's no wonder that I would rather take a beating sometimes than to go and stand at the wheel. Because it is excruciating on every level, you know.

"While I crave it, and it's what I do — and sometimes I get to the point where everything's working well, and I've accepted my fate, and I'm progressing forward, and it sort of happens. And then you're on a roll, and you don't want to ever stop.

"But it's a horrendous profession, making pots.

"Head, heart, and hand is a very easy way of saying it. But that makes it sound very cute. And it's not cute.

"You know, psychologically, you have to be mature, to be really mature to put yourself on the line that thoroughly.

"Mentally, you have to know so much about the technical aspects of what you're doing. And you have to be confident about the technical aspects of what you're doing to be able to do it.

"And physically, you have to be in pretty damn good shape to do it.

"And I don't know how many other professions there are that you've got to have all of those things, you know, happening at one time."

Having reached a good conclusion, Daniel pauses in thought. Then he says that carpenters work like potters when they are able to plan and build their own homes and big beautiful barns. That thought carries his mind back

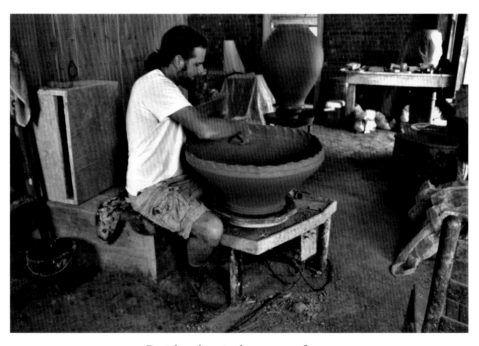

Daniel working in the summer of 2012

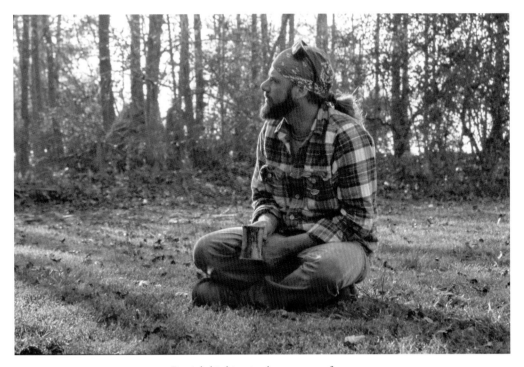

Daniel thinking in the autumn of 2012

to childhood on the farm. He recalls how he worked in the fields, how he left school behind, went off on his own, and survival became his aim. Survival, he says, "is the most fulfilling life because all you have to do is concentrate on getting to the next meal, you know. So, after that obstacle's been removed, then you have all this openness, and you can fill it up with purpose." Then remembering the flop of his second kiln opening and the smash hit of the Big Pot Project, Daniel says:

"When it comes to this level of exhibitions, I know it's going to have to come from my gut. But I feel confident enough to do it. And I will. I have faith in myself, but each step gets harder, and it's more complicated. And more sophisticated.

"And each step I take, I'm closer to that sophisticated guy I learned from."

He means Mark Hewitt, of course, and at about the same time, following the Big Pot Project, Mark told me how he and Daniel were now partners in advancing North Carolina's tradition. Daniel said he was getting closer to Mark. Mark said:

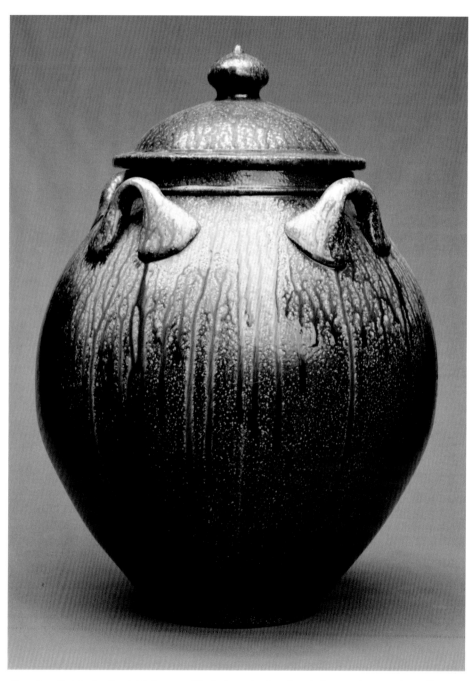

Four-handled jar by Daniel Johnston. Black slip, salt-glazed with flying ash, 22 inches tall, 2012

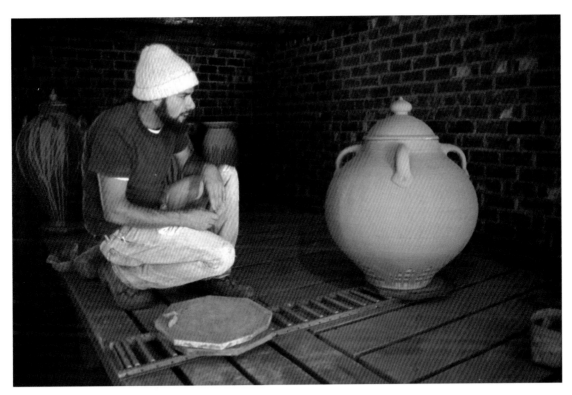

Daniel with a four-handled jar in progress, 2012

"Daniel's now nipping at my heels, and I can't rest on my laurels. We are borrowing from each other. I'm really delighted that there is now a little of Cardew and Leach down there in Seagrove. And I like to think that other potters look at what Daniel and I are doing, and it inspires them to do good work too." Chad Brown was Mark's example of a skilled young potter who was making excellent pots in the atmosphere Mark and Daniel helped to create.

Then, with the poor farmboy's need to survive at the back of his mind, and at the front, the artist's need to be an entrepreneur in order to advance, Daniels says:

"When it comes to exhibitions, it goes back to business. I understand it's about art, and I've always understood it's about the society we live in, and how we react and respond.

"You see, it's not possible for me to stay down here and create work that is brilliant. It has to be sold, and you are elevated by how it is perceived.

"If I make four-handled jars that are really brilliant and really beautiful, I can sell them, and right now I'm selling a load of them. And that's fine and they are beautiful. There's nothing negative about them.

Daniel Johnston, visiting professor, with a plate he made in Michigan, 2014

"But if I want my work to go further, you know, I need new exhibitions where I'm allowed to push the work further."

Daniel was already looking toward the installations that would set a new standard for his exhibitions, but before his ideas came to full fruition, Daniel's success, artistically and commercially, brought him an invitation to be a visiting professor for the spring semester in 2014 at Eastern Michigan University in Ypsilanti. "Pretty damn good for a high school dropout," he said. Daniel was tasked to demonstrate his craft in the ceramics studio and to teach a course on the establishment of a small business.

University life surprised him: the paucity of intellectual conversation, the cumbersome bureaucratic procedures, the immorality of taking money from talentless students who had no chance of success — why academics who fancied themselves artists would do goofy things like projecting bad amateur videos on the floor — it was all beyond him.

The ceramics studio didn't meet his needs. There was no wood-fired kiln, the materials were unfamiliar. Still, gallant in northern exile, Daniel adapted

Miniature lidded jar by
Daniel Johnston. Earthenware
clay, white slip, clear glaze,
3½ inches tall, Michigan, 2014

Tea bowl by Daniel Johnston.
Stoneware clay, iron
brushwork, Shino glaze, 3¼
inches tall, Michigan, 2014

gracefully. He and Kate turned to making slip-decorated earthenware. On diverse forms, different in materials and size, Daniel concentrated on swirling and snarled, free and angry, decorative gestures, inspired, he said, by Clive Bowen, but looking to me more like Japanese Oribe ware. To my eye, Daniel's masterpieces from the period were the tiny demonstration pieces he sold to the students for five or ten dollars. Few artists can work comfortably at radically different scales. Daniel can. Known for his monumental big pots, he made exquisite miniatures in Michigan.

In Michigan: Terry Childress, John Vigeland, Kate and Daniel Johnston, Bill Jones, April 17, 2014

At the end of the semester, his students arranged an exhibition of Daniel's work. Lectures and a party were scheduled. John Vigeland drove up from the East Fork Pottery where he was working in the mountains with Alex Matisse. Bill Jones and Terry Childress drove for fourteen hours from Seagrove. Pravina and I gave lectures, hers on commercial transactions in India, mine on Daniel's work back home. Then during his lecture, in summarizing the conclusions of his course on how to build a small business, Daniel improvised a personal manifesto.

To begin, Daniel declares himself a capitalist. Not reliant on government support, he makes his own products and he has built his own business. Like the other potters in North Carolina he brings "independent creativity together with independent enterprise."

As an artist, he says, he remains open to all influences, to historical influences from Leach and Cardew in England, from Daniel Seagle and Burlon Craig in North Carolina, and he is equally open to contemporary influences from his teacher, Mark Hewitt, and the current art market. His purpose during creation, though, is not to make references, not to seem traditional or fashionable, but "to make the best work possible."

His responsibility in business is not to lower his goals to meet market demands, but to educate his customers, lifting them — through examples and explanations — up to an understanding of true quality. Mutual understanding is "the missing component" in business theory. It is hard to develop at a distance, but not hard to achieve through direct exchange. Artists must work to bring their customers into a communicative union of comprehension, so they will know that "the objects they buy are works of art and culturally symbolic," the supreme yield of historical forces and individual effort. Commercial success in a small business like Daniel's unfolds from connections, from the maker's ability to create art and then to teach consumers about art.

Porcelain tea caddy by Daniel Johnston.
4 inches tall, 2012

Daniel and Kate on their wedding day, 2013

7

NEW DIRECTIONS

DANIEL AND KATE WERE MARRIED ON MAY 18, 2013. The bride wore a lacy white gown, elegantly crafted by her mother, a skilled seamstress. The groom, feeling that his commitment to craft required fine handmade attire, wore a trimly tailored three-piece gray suit and beautiful shoes. We chanced to be there when they arrived in a box from England, and the shoes, Daniel said, have the quality of a saddle made for the queen.

On a soft, overcast day, the ceremony took place in the Fairgrove Methodist Church, not far from Seagrove, a plain, white framed building, emblematic of the old culture of the South. We all sang "Amazing Grace." Jay Yager, who filmed the Big Pot Project, officiated. He had not done it before, but he managed it handsomely, marrying Daniel and Kate.

People left the church in a long line to congratulate the young couple. Then they stood around in clusters of conversation before driving to the place where Daniel and Kate live and work. There, between the kiln shed and the road, a floor had been laid for dancing and a white tent had been raised to shelter the revelers from the rain that threatened, then came. Welcoming the guests in front of the tent, two big pots stood, one by Kate, one by Daniel. Under the tent, the tables were set with plates that Daniel slipped to a design of Clive Bowen's, showing two yearning forms sweeping toward interlocked union.

During the dinner of roast pork, smoked salmon, and pizzas baked on the spot, John Vigeland began the toasts, praising "the generosity and heroic daring of love." Then Kate's father, Eric, and Daniel's father, Wayne, wished the

Daniel and Kate are married, May 18, 2013

Daniel and Kate arrive at the reception, 2013

Wedding plate by Daniel Johnston. 10½ inches in diameter, 2013

best for their newly married children. Mark Hewitt followed with a toast to the women, recalling how Carol served as "a surrogate mother" during Daniel's apprenticeship, and ending, "Here's to beautiful, wonderful Kate. Here's to Daniel and to the women in his life." Last came Harris Brown, steady in his friendship with Daniel, who had gone to the workshop at Penland so he was present "when Daniel first laid his eyes on this lovely young lady." Addressing Daniel and Kate, Harris said, "You both have talent, and if you stay as dedicated as you are today, you'll have a perfect marriage."

Bill Jones did DJ duty, mixing a sonic stew of rock, country, and hip-hop. The unmarried potters found partners among Kate's friends from Alfred, and we danced the night away.

Mark and the apprentices. In front: Louise Cort, Kate and Daniel, Mark and Carol, Dwight Holland. In back: Joseph Sand, Bill Jones, Hallie and Nate Evans, Matt Jones, Eric Smith, John Vigeland, Alex Matisse, 2013

On the afternoon before the dinner and dance, Daniel and Kate arrived in a carriage, drawn by a matched team, and it became a time for photography. At the rehearsal dinner on the night before, Louise Cort said that we have all been drawn together by pottery, and the afternoon's photos record the social ties that bind North Carolina's tradition in its current phase.

Mark Hewitt sits at the center with Carol and the newlyweds. Around him gather his apprentices: Nate Evans and Eric Smith, who apprenticed when Daniel did; Matt Jones, who came before; Alex Matisse and Joseph Sand, who came after. Then here in the pictures stand Daniel's apprentices, John Vigeland and Bill Jones. Ben Owen and Vernon Owens had other obligations; Vernon's daughter would be married the next day. But David Stuempfle and Chad Brown are here, and Bryce Brisco drove over the mountains to be here

In front with the Evans, Jones, and Smith children: Hallie Evans, Daniel, Carol, Mark, Kate. In back: Dwight Holland, Erin O'Toole, Bryce Brisco, Chad Brown, Bill Jones, Nate Evans, Terry Childress, David McClelland, Louise Cort, Matt and Christine Jones, Jill Figlozzi, Mei-Ling Hom, Eric Smith, John Vigeland, Daphne and Terry Zug, Connie Coady, Alex Matisse, Pravina Shukla, 2013

too. The potters are not alone in their movement. Takuro Shibata has come up from Star, where he blends local clays to the potter's specifications and saves them much time by supplying the materials they need. Dwight Holland and Harris Brown represent the supportive collectors who provide the movement's economic base. Others through their own arts bring essential attention to the potters' creative effort: the filmmaker Jay Yager and the scholars Louise Cort and Terry Zug. Pravina, a scholar too, stands with them, and when Daniel shows these photos during his lectures, he comments that the only one missing is Henry, missing because he took the pictures. The many who are drawn into participation within Carolina's art movement are the potters and their spouses, the supplier of materials, the collectors, the filmmaker, and the scholarly writers, curators, and teachers.

Alex Matisse and Connie Coady at Daniel and Kate's wedding, 2013

Bill Jones, Daniel Johnston, and John Vigeland at Alex and Connie's wedding, 2016

To locate a pattern in the relentless flow of time, I will borrow the date of Daniel and Kate's wedding — May 18, 2013 — to mark the beginning of a particular period of consolidation and change in North Carolina's tradition, and I will borrow the date of Alex and Connie's wedding — September 24, 2016 — to mark the period's end.

Alex Matisse and Connie Coady were married on the lovely grounds surrounding a fine old farmhouse near Asheville in the mountains of southwestern North Carolina. We went with Daniel and Kate. Mark Hewitt was there for the rehearsal dinner the night before. Work on behalf of the North Carolina Pottery Center called him away on the day of the wedding, but Carol Hewitt, Matt Jones, Joseph Sand, John Vigeland, and Bill Jones were there to join us for the feast in the tent. Vases on the tables made by Alex were — like the plates on the tables at Daniel and Kate's wedding — gifts to the guests.

It was, I repeat, a time for consolidation, for coherent stability, and coherence was manifest during this period at an exhibition of southern pottery, subtitled "A Living Tradition" and held at the Museum of International Folk Art in Santa Fe, New Mexico. Karen Duffy, who got her doctorate with an excellent dissertation on the pottery of Acoma Pueblo, bought a collection of southern pottery for the museum's permanent collection and arranged the exhibition. Its opening was timed to coincide with the annual meeting of the American Folklore Society, and two panels on pottery were held during the Society's meeting on November 6, 2014.

I offered the closing comment. Terry Zug and John Burrison provided compact and informative summaries of scholarly research. Four of North Carolina's potters spoke, displaying the eloquence and clarity of practiced public speakers, a requisite skill for artists who are, of necessity, also entrepreneurs.

Ben Owen III spoke first, explaining the potter's need for connection and cooperation, the artist's need to go outside for new experience and then to return home for creation. Ben praised the work of Mark Hewitt and David Stuempfle, saying the potter's forms must be strong, clean, and generous to bring joy into the lives of other people.

Kim Ellington walked the audience out of his shop and onto his landscape to stress that his work is grounded in the natural materials of his rural place: clay to turn, wood to burn. Confirming a connection to his local tradition, Kim says he uses the glaze recipe he learned from Burlon Craig, but he is also attracted to Asian glazes and forms. Burlon Craig, he says, made many face jugs and Kim followed him, but eventually finding them tiresome, he makes

Face jugs: *left* by Burlon Craig, c.1975; *right* by Kim Ellington, c.1995. The face jugs made by Lanier Meaders, then Chester Hewell in Georgia, by Burlon Craig, then Kim Ellington in North Carolina helped to sustain the southern pottery tradition during hard times in the seventies and eighties.

only a few for his Christmas sale, and feels face jugs get more attention than they deserve. Kim's kiln is based on Burlon's, though he has added the holes for side-stoking he saw on kilns built by Mark Hewitt and David Stuempfle. Kim uses the usual country terms for throwing and firing, shared with many of the world's potters, when he says he loves to turn, but most loves burning.

Mark Hewitt says his work demands manifold mastery: mastery of materials, mastery of the athletic skill it takes to make excellent pots in volume, and then mastery of business procedures. Potters are also shopkeepers who must sell to live. In North Carolina, he says, potters create within a world-class tradition, like jazz, making things that are at once old and very modern. Potters must be dedicated since their work is neglected by the art world, but that is to their advantage, Mark says, because it keeps them battling with the establishment. Mark closes with praise for some of his comrades in the fight: Matt Jones, Joseph Sand, Alex Matisse, Donna Craven, and Daniel Johnston.

Daniel Johnston begins by thanking Ben, Kim, and Mark for leading the way and making it possible for the potters of his generation. Then he sketch-

es his life, telling how he quit school, apprenticed with Mark for four years, learned from Clive Bowen in Devon, and then went to Thailand to learn the technique he uses to make as many as ten big pots in a day. Back home, he built a Thai kiln, and when he made a hundred pots in one span, he was propelled forward. Grateful for his time with Mark, he wanted to pass it on, so he began training apprentices of his own. Then he married Kate, who developed, Daniel says, a new aesthetic all her own. After their honeymoon, he leveled his old kiln and built a new one that brings sculptural energy up from the ground. And then, twenty years after he dropped out of high school, he was a visiting professor at Eastern Michigan University. Daniel ends by saying, "We are the luckiest people in the world."

They all spoke of connections, connections backward to a tradition that unifies the native and foreign, the old and the new, and connections outward to colleagues; all of them acknowledged artists not present. Speaking before a large audience, the potters shared a vision of their tradition and the shape of their artistic community; Mark and Daniel both call it a tribe. Explicitly in their words, and implicitly in the pots chosen for the exhibition, it seemed to be a time for cultural and social consolidation, a moment of clear, collective

In Santa Fe: LoriAnn and Ben Owen, John Burrison, Mark Hewitt, Kate and Daniel Johnston, Betsy and Kim Ellington, Terry Zug, Karen Duffy, 2014

victory. The potters might have been satisfied, a future before them of steady, incremental progress. But their actions contradicted contentment. Individually, having achieved success, they were already welcoming the turmoil of radical departures and exciting new directions. The period I marked out with the dates of the weddings, events of coherence, was, as I remarked on the way here, a time for change as well as consolidation. Successful consolidation provided a base for change.

Mark Hewitt had previously explored the possibilities of form in his extravagant big pots. Now he turned to color. On his website before his last firing of 2014, shortly after the exhibition in Santa Fe, Mark wrote, "Our new colors continue to excite us with their giddy exuberance, while the old colors remain mysterious and profound. These dual threads lead us onward." When the crowd gathered in the rain for the kiln opening, Mark told them that everyone could buy only one pot with the new colors. Every serious collector had to have one of these historic pots with their bright red and yellow slashes, like flashes of lightning in a dark storm. A year later, Mark was experimenting with glazes of crushed local stone that gave him a quiet, grayish or greenish celadon tone. His options tripled. Mark didn't abandon the mysterious profundity of salt and ash, but his palette widened to include electric flashes and celadon subtlety.

While Mark was experimenting with color, Joseph Sand was experimenting with form. Joseph collects old local pottery, and he uses old pots to inspire new forms, but during this period he also created forms that were not hollow pots, but tapering slabs, like megalithic standing stones, abstract shapes of clay, dressed with the energetic local glazes.

Up in the mountains of Madison County, at the East Fork Pottery in the year Daniel and Kate were married, 2013, Alex Matisse and John Vigeland were throwing, slipping, and glazing pots to feed the big wood-fired kiln that stood up the slope in a beautifully framed shed. But before Alex and Connie's wedding in 2016, they had installed a large gas-fired kiln, hired skilled workers, and they were producing diner mugs and clean, elegant tableware for sale to restaurants. Soon, the waitress in a fine restaurant in Asheville will proudly tell you that your fashionable food is being served in plates handmade by Alex Matisse who is, yes, a direct descendent of the French master Henri Matisse. And shortly after that, Alex, Connie, and John will open a stylish shop for sales in downtown Asheville.

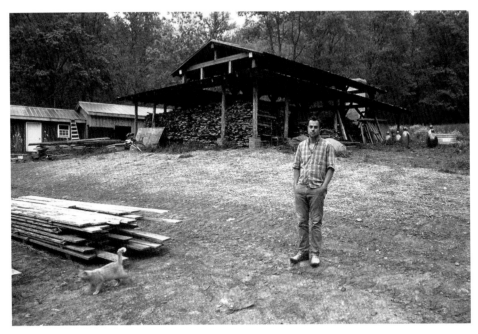

Alex Matisse standing before his big kiln, East Fork Pottery, 2012

John Vigeland and Alex Matisse in front of the new East Fork kiln, 2016

Daniel Johnston in 2017

Mark turned to color, Joseph turned to abstract forms, Alex and John turned to upscale commercial tableware. Daniel turned to installations.

In 2017, when he was forty, Daniel and I sat down in his home to record two long interviews about his installations. He begins by saying that his "story in Carolina" had ended and "phase two" of his artistic career has begun. Daniel's Carolina story, he says, was disturbed by his feelings for Mark Hewitt, confused feelings of envy, anger, love, competition, and deep admiration, but now he feels pure gratitude, respect, and affection. His new work, he says, honors Mark, "and that's the most beautiful feeling to have. It's very liberating. And that change in my feelings had to happen before I could do these installations."

Now Daniel can look back in success. Five years earlier he was looking forward with visionary ambition:

"Right now I have all the exhibitions I want. But they're not the ones I want. They're nice enough. I mean, most people would give their arm for them, but it's not the audience I want.

"I can do it. I know I can do it, but it's difficult moving forward.

"And I've got tremendous ideas for how these big pots can fill a space, almost like an installation to where — almost to give you the same feeling as walking through the woods, from the height of the pots and where they're placed.

"So, not only do you get to see all the curves — it really comes down to the curves — but you get to see the curves from the angles and perspectives in which I laid them out. So, you really could see these objects, and they would really have an impact on you.

"And in being able to walk through them, you would get the experience of them. And it would be like architecture, and the space would radiate out beyond the pot, which you control to a certain extent by making the pot.

"If those spaces overlapped in a gallery, then there would be nowhere you could go and not be in that space. And you'd be dealing with external space in an internal setting.

"And if I have these ideas, I have to make them happen. But I have a hard time with the art world, you know, a really hard time conceptually with the art world. I think a lot of it is just pompous bullshit."

His vision was clear, and Daniel was soon to make it happen in a series of installations.

An installation is meaningful in itself as its author's signature, and it gathers meaning from its situation: text and context interpenetrate; art elaborates

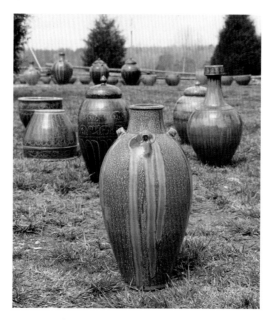

Pots by Daniel Johnston outdoors, 2007

through spatial associations. The environment matters profoundly, as it did in the ancient monuments, Stonehenge and Newgrange, set in space to track time by the rising sun, or as it does in the Statue of Liberty, located in New York harbor to welcome immigrants to the land of immigrants.

Let us now slowly assemble an environment around North Carolina's pots. When Daniel first went to Mark's, he was struck by more than the pots. The whole atmosphere put a weight on his brain: the old farmhouse, the big kiln in its long shed, the lunch in the kitchen, the opera on the radio. When Chad Brown first visited Daniel's place, the pots impressed him less than the setting: the log shop and the shed, framed to reveal the kiln from the road. Chad didn't start making pots like Daniel's, but he built a log cabin like Daniel's log shop, where he lives with his wife Erin, and later, a skilled carpenter as Daniel is, Chad framed a fine shed to shelter his kiln, something like Daniel's. When customers come to the kiln openings, they always buy, charmed by the whole scene: a remote rural spot at the end of an unpaved road, where the potter lives and works, throwing magnificent pots in a modest wooden shop and firing them in a whale of a kiln. It is like that at Mark's, at David's, at Daniel's.

At Daniel's, the pots stand outside, not only for kiln openings, but all the time, lined along the walls of the shop and standing free out in the field. Together with the aligned shop and kiln, they announce the place of a potter. It is more than an advertisement, though, for the pots standing out in the weather belong, as Daniel does, to the land, glistening in the rain, gleaming in the sun, and casting cadenced shadows, long at dawn, short at noon.

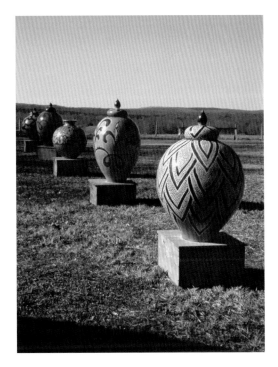

Big pots by Daniel Johnston outdoors, 2014

Big pot by Kate Johnston outdoors, 2018

Big pot by Daniel Johnston outdoors, 2012

Randolph County, the view from Daniel and Kate's place, 2018

At the time of the Big Pot Project, when a hundred pots stood in a line, the shop where the clay was shaped and the kiln where oak and pine were burned stood to one side. To the other, the fields fanned away over the red clay ground, sliding toward the stands of oak and pine. The sun circled above, sinking to leave a black sky spread with a brilliant multitude of stars, visible only in country places like this. That's the environment: the source of the materials and the setting for creation. In 2010, the Big Pot Project gathered the environment and inspired Daniel's installations that followed. He recalls:

"I would say that the idea for the installations started when I got back from Thailand. I'd learned to make these big jars, but I wondered what I was doing. Mark obviously does what he does so well. Wondering what I was doing led to this big jar project.

"And I lined the pots up and down the road. And I thought about this project in a bunch of different ways. I thought about it in ways that would help me technically, help me creatively.

"But what happened is — what happened in a three-hour period when I lined the pots along the road, before they sold — I got to really look at them, and I experienced all the pots as a whole."

That, Daniel says, was "the first installation," and it taught him to see many pots as a unit, learning that individually meaningful pots, when placed together, make contexts for each other — as stories told in the same session do, or as works gathered in a museum's exhibition do — creating together additional meaning in an aggregated array.

For Daniel, the individual pot is like an infant. "It is pure potential. It gives you that feeling you get when you go into a nursery and you see the newborn babies. And you understand that they have so much potential, that their entire life is ahead of them." Put many together, and they suggest the possibilities of existence.

When he viewed a hundred pots in a line, Daniel says, "I realized that some of those jars would break before they even got them home. Some of those jars will break in two years. And some of them will break in a hundred years.

"They represent the vitality of humans, but yet, in and of themselves, these objects have lives that will be shortened or prolonged, and that interests me.

"And I don't know if the feeling is longing for the ones that will break before they get home, or for the ones that will be in a museum in two thousand years. I don't know which one I feel for.

"So, all together that line of pots represents an entire lifetime, you know. Or what we perceive to be a lifetime, and maybe for these jars that's two thousand years.

"But, you see, it is a recording, a recording of the future that we don't know. It's a recording before it has happened.

"And what you're experiencing, you're experiencing nostalgia before it exists. You're experiencing the future, and you're experiencing hope.

"You're experiencing longing, and you're experiencing all of what life is made of, compressed into the singular moment of seeing the pots lined up. It is potent; I think that's it."

In creating the first of his installations to be built indoors — in the Green-Hill Center for North Carolina Art in Greensboro, in May of 2015 — Daniel adjusted what he had learned in the Big Pot Project to meet new conditions. In the middle, he still arranged a curving line of pots. Outside, in the wideness of space, the pots stood on separate bases and the line curved slowly along the road. Indoors now, Daniel lifts the pots onto a tall, connected frame and compresses the curve into half a circle.

Years before he had imagined an "external space in an internal setting." Now Daniel invades the art world's territory, claims a space, and shapes his

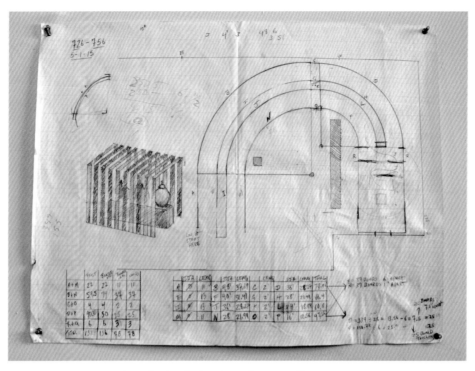

Daniel's plan for his Greensboro installation, 2015

The Greensboro frame during construction, 2015. *Photo by Daniel Johnston*

own setting. In the Big Pot Project, Daniel exhibited his works among the fields and trees in the sun's slanting and shifting light. Indoors now, he imposes an architectural frame between his pots and the gallery. Along his curling line of pots, Daniel runs walls of pine boards, fresh with scars from the sawmill and spaced apart like the slats in a corn crib to filter the light. His frame, a "tunnel" constructed like the out building on a farm, evokes the rural environment in which the pots were made.

Daniel has brought his environment into the gallery, creating an indoor space with outdoor methods, and the materials of his installation, the clay of the pots and the pine of the frame, are nature's partners in production, clay to turn and pine to burn, brought together to separate Daniel's art from the sleek, chic interior of the gallery.

When installations are created in museums or galleries of art, the setting raises the question of art. Picture the floor of a fine gallery strewn with laundry or lined with neat piles of gravel. Some viewers accept such assemblages as art, believing that works of art are, by definition, the things exhibited in art spaces. Others will read them as evidence of a tacit conspiracy between credentialed curators and their rich patrons to make art into a restricted realm of education and wealth, ruled by a privileged few. Daniel's purpose was to raise the question of art with his installation. He says:

"I had intellectually created a story that was about art and craft. I built a seventy-five-foot tunnel. There's thirty pots inside the tunnel. And then a single pot in a white room at the end, set up on a pedestal.

"My aim, I will say very unhumbly, was to fuck over the argument about what's art and craft. It was to say that the thirty pots in the seventy-five-foot tunnel represent art, and to say the single object on the pedestal did both art and craft. And it fit everyone's definition, and defied everyone's definition.

"And without words I was able to do that. And actually when people walked through the installation, what happens is: they felt the poignant spirit of life, and it didn't matter that there was a thirty-first pot on a pedestal in the white room."

The hundred pots lined on the road beside Daniel's shop and kiln were alike in size and price, but they differed in decoration, differed enough to appeal to the different people who raced in to choose and buy. In making the pots for his Greensboro installation, though, Daniel intended all of them to be precisely the same. They clustered into a meaningful unit; all were born of craft to stand as art. One viewer can call them all craft, another can see them all as

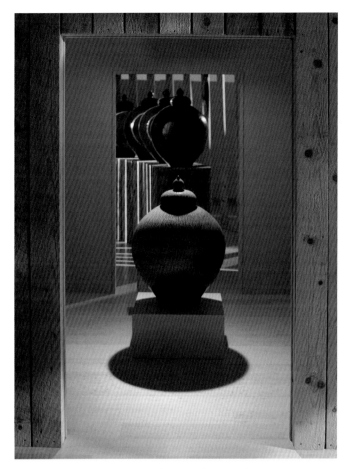

The pot at the end of the tunnel, Greensboro, 2015.
Photo by Kate Johnston

art, but Daniel disrupts any simple response by placing one pot on a pedestal in the light at the end of the tunnel, implying by its setting alone, that it is art while the others, lined in a group, represent craft. The unit's meaning complicates, but Daniel's point is that they are all the same and that the distinction between art and craft is lost, rendered trivial in the experiential moment of direct encounter.

Then Daniel undermines all intellectual assumptions by isolating and elevating on a pedestal the pot that is, in fact, the best of them all. He didn't notice its particular excellence when he was at work. It was just one of the apparently identical pots. But when Daniel lined all of the pots out in the yard and took the time to inspect them in the light of day, he came to feel that this was not only the best of the batch, it was the best pot he had yet made, a key creation in the course of his career, a masterpiece of skill-based beauty.

When I ask Daniel to explain why that was the best of the pots, he says he needs a minute to gather his thoughts. Then he offers, from within, a rich account of the creative process, beginning like this:

"Everything in craft is calculated. Everything in the craft I practice is calculated, intentionally. I learned from others, then I continued to train myself.

"And the only way you can train yourself is through calculation. So, it's all calculated when you make a series of jars. That was the first series of jars that I had ever attempted to make exactly the same. Okay.

"So, it begins with that mathematical calculation: the weighing of the coils, the weighing of the clay, the measuring of each section, you know.

"But then you stop using a yardstick to measure the width of the jar. And you start recognizing the distance the jar is from your chest. And then you start doing the same thing a cello player does when he holds the bow, or when she holds the bow. And you're measuring the distance with your mind and body. And not your eyes. Your eyes are kind of like lying little whores," he laughs and says:

"It's your body that tells you the truth.

"And at that point, when you don't know when it happens, then something slips over, and that's when that jar was created.

"And I don't know when that pot was created. It's like a newborn child that's perfect. And every day there's something that's not good, and there's something that's great.

"To say it simply, there's a moment of purity that happens, but it's only recognizable in hindsight.

"And in that moment, you know, it's not me. It's not mathematical calculation. But that's the moment that somewhere in there it happens. I think maybe it comes from the subconscious.

"Some people may call it God, and some people may call it talent. And some people may say that your body is fully in touch with what you are doing. And people will recognize a connection between your body and that object, seeing that you have physically manifested yourself momentarily.

"It's like telling the truth. We can do that accidently, you know, occasionally," Daniel says with a laugh, and concludes:

"And then it exists. That pot represents to me everything that I believe in, everything that I believe in, in art. I've created this object. And it's truth, you know. It's truth.

"Everything has run through me into that object."

In repetitive action, calculation disappears, the subconscious takes command, the eyes yield to the hands, the body flows through time, and the truth appears when the self is incarnated in a sensate object. Along that course of pure commitment, craft abides, quality holds, and art emerges as the goal and certain end.

Now the master pot, as yet unrecognized for its superiority, stands on the wheel, awaiting the flame. The installation required three firings. Through one of them, the pot stood in the right place in the kiln, accumulating the right amount of ashy salt. Then it stood in the sun to be chosen for the pedestal because, Daniel says, "it embodied all that I had done prior to that time." He goes on:

"That jar is an archetypical pot. The beauty of that jar is art and craft. The shape is beautiful, the glaze is beautiful. The beauty is physical.

"But that jar fools everyone, you know. It's not a North Carolina jar. It's not a Thai jar. The runs are too gaudy for North Carolina. The lid is too gross for Thailand. The mouth is too small to get anything in it, except for a handkerchief," he laughs.

"Those lids I don't even think existed in Thailand, those overshot lids. But everyone thinks that jar is a North Carolina and Thai combination, because I have done what an artist does.

"I understand what the public sees, and then I create something so they will understand what I'm doing, you know. So, people say, This is the woodfired, North Carolina, Thai tradition. But that jar is none of those things."

Then Daniel refers to the readymade porcelain — clay — urinal, entitled *Fountain*, that Marcel Duchamp submitted, in 1917, to the exhibition of the Society for Independent Artists in New York. Duchamp's *Fountain*, in fact, was not exhibited, but the problem it raised endures. That was, Daniel says, "a pivotal moment in art," revealing the tension between intellectual and visual judgments. By intellectual category, Daniel's jar is craft. By visual experience, it is art. To the creator, it is both. Daniel's work, exhibited in an art gallery, is intended to challenge the art world, just as Duchamp's was a century ago. Daniel concludes by saying:

"I call that jar my Fountain. It's an archetype. It's an archetypical thing, you know. And so, yeah. That jar. I don't know what else to say."

With that jar, with that installation in May of 2015, Daniel was picking up speed. Looking back now, he sees that the following two installations were preparation for something grander. Both took place in a time of quick and steady change. His second indoor installation was held in the Center for Craft, Creativity, and Design in Asheville, North Carolina, in October of 2015. The

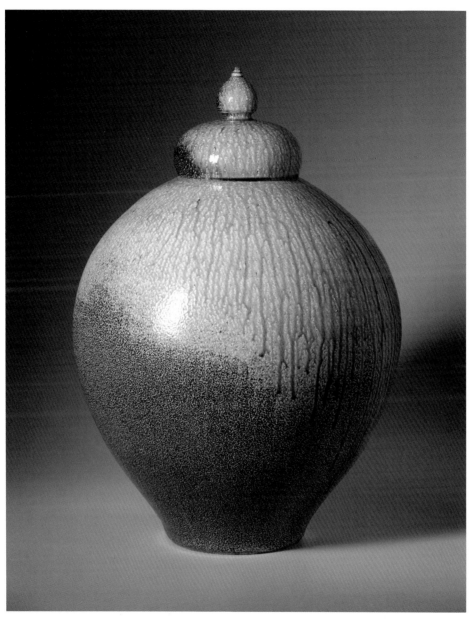

The master pot. Black slip, salt-glazed with flying ash, 38 inches tall, 2015.
Photo by Jason Dowdle

third occurred at Mahler Fine Art in Raleigh, North Carolina, in September of 2016. Through those installations, Daniel refined a personal tradition of exhibition that had its origin in the Big Pot Project and reached full maturity in his fourth indoor exhibition, built in an elegant gallery in Santa Fe, New Mexico, in 2017.

Before his first indoor exhibition, Daniel had imagined confining you, the viewer, in a radiant space. From the first to the last he has accomplished that by framing you in with the pots. In motion through that space, he hoped, you would experience the pots as you do the trees in a walk through the woods. During his first installation, you walked half a circle toward the grand pot at the end. For his second and third installations, Daniel completed the circle by building a cylinder like a silo. Upon entering, you leave the gallery and walk into a copse of pots. Your path twists tightly. Close up, you fix on the surface of a pot as you might on the mossy rough bark of a tree. At a distance, you watch the pots gather and rise like a forest. Space shifts and shapes with your motion: your body blocks the light, you bend to see, your gaze lifts with the pots.

In Daniel's first indoor installation, the pots, forty inches tall, stood on a frame forty-two inches tall. You had to cock back to see them. In his second installation, Daniel placed a second row of pots above the first. For his third — in a circle tighter than his second — he piled the pots three rows high, putting them above you, he says, "in a position of power." Daniel wants you to notice the effort it takes to see, straining, he says, "so you actually have to look to see the pots." He asks you to move, to experience the pots with your body, just as he does in creation. Confined, moving among shadows and flashes, you watch the ash run and the curves repeat on the circular course of your walk.

While Daniel was preparing himself with exhibitional experimentation, he was also preparing himself by attending to decoration. In the old tradition of the northern United States, decoration was common. The gray, salt-glazed pots regularly display representational ornament in blue, a flower, a bird, maybe a leaping deer. But in the southern tradition, a middle phase for decoration was rare. As befits the region's old-time religion and its ethical demands, the pots issue straight from two phases of labor: from work at the wheel to create useful forms, from work with the kiln to create useful glazes. Their beauty rises from necessity and abides in forms and glazes, not in applied ornament. Daniel's masterpiece from his first indoor installation was, in this light, a perfect southern pot, undecorated, but as he said, beautiful in shape and glaze.

Settled in North Carolina, Mark Hewitt advances the regional tradition — as Kim Ellington, Ben Owen, and Daniel Johnston also do — by creating generous and graceful forms sheathed with vivid, ornamental glazes. But the masters in Mark's English tradition, Bernard Leach and Michael Cardew, generally decorated their pots — Leach was truly more of a decorator than a potter — and Mark searched through the southern repertory to find the rare master who was also a decorator. From Thomas Chandler, who worked in South Carolina during the first half of the nineteenth century, Mark borrowed slipped designs, in particular swoopy, loopy swags. In Georgia, the Hewells were also attracted to Chandler's work, and before the stroke that ended his potting days, Chester decorated some of his ash-glazed jugs with Chandler's floral designs. Mark feels that North Carolina's potters would also be wise to add decoration to their pots, already handsome in form and glaze.

In the generation following Mark in Carolina, several of the potters are skilled in decoration — Matt Jones and Kate Johnston, Alex Matisse and John Vigeland — and Mark told me that when Daniel was his apprentice he displayed a great innate talent for decoration. Mark delights in decoration, and

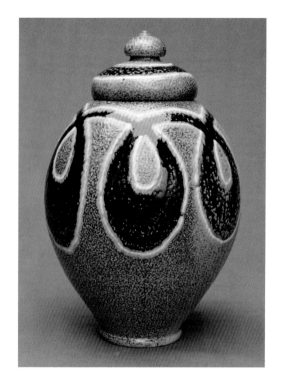

Lidded jar with geometric decoration by
Daniel Johnston. Red slip base, white slip
decoration with celadon dots, salt-glazed
with flying ash, 10 inches tall, 2014

Lidded jar with looped decoration by Daniel
Johnston. Red slip base, manganese loops outlined
with tin slip, salt-glazed, 12 inches tall, 2014

wishing for others to join him, he was disappointed that Daniel didn't concentrate on decoration as he developed.

It was, though, always in his mind, planted there during his early experience at Clive Bowen's in England. Shortly after he returned from Thailand, Daniel took me to see flamboyantly decorated pots that he had hidden, like something naughty, in the shack downhill from his shop. He said he was thinking about Picasso when he made them. Daniel kept right on decorating some of his pots, usually the smaller ones, and he decorated many of the large jars for the Big Pot Project. Now, during the period of his installations, he experimented with decorations of three kinds, all of them with prior precedent, all of them taking on new character.

In one of his decorative moves, Daniel made looping gestures, reminiscent of Mark's Chandlerian swags and inspired by Clive Bowen's free swings of slip. But he tightened them more than his mentors did. Working like a Muslim calligrapher who writes a holy text quickly, then returns to sharpen the forms of the letters with care, Daniel refined his initial gestures in dark slip by outlining them in white.

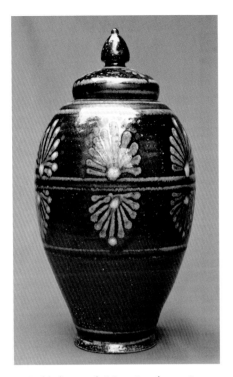

Lidded jar with Moravian decoration
by Daniel Johnston. Red slip base,
manganese, celadon, and tin slip
decoration, salt-glazed, 14 inches tall, 2016

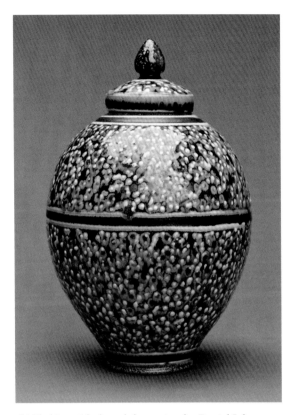

Lidded jar with dotted decoration by Daniel Johnston.
Red slip base, manganese, celadon, and tin slip dots,
salt-glazed, 16 inches tall, 2016

In another, Daniel continued to make geometric designs with lines, arcs, circles, and lattices of white slip. Then he added a new pattern when Andrew Dutcher, his apprentice at the time, asked for help in decoration. Daniel gave him a book with photos of slip-decorated earthenware made by Moravian potters in North Carolina, late in the eighteenth century and early in the nineteenth. Andrew began using Moravian designs on his pots. Daniel liked them and began using them too, slipping bands and feathery sprays.

In his third decorative move, Daniel coated pots with dots in three distinct shades of slip. The pots placed in his third indoor installation had, each of them, twenty-five thousand dots. A time-consuming process, certainly, but it saves Daniel time. All other decorative methods are his to do alone. For a dotted pot, though, Daniel fills a sample space with dots, then passes it to an apprentice for completion.

Peters Projects, Santa Fe, New Mexico, 2017

So now, having learned the virtue of curved forms for installations as well as for pots, having learned the flexibility and speed of dotted decoration, Daniel was ready to create the exhibition that would end his series of indoor installations. It opened on June 2, 2017, at the Peters Projects gallery in Santa Fe.

Daniel set his task in a proposal he wrote and submitted to the gallery. His new exhibition, he writes, will follow the pattern of the installations he built after he had challenged himself to make and display a hundred pots "in a single line, spanning a quarter of a mile." The pots will be "large storage jars" with "archetypical forms that transcend their historical function." They will be placed in a wooden structure that references "the vernacular architecture of the American South." In that setting, the pots will manifest "the relationships between the maker and the viewer, the workshop and the gallery, and the actual and the perceived." Daniel's aim is to collapse the definitions of art and craft, so that he can operate simultaneously in both realms without the "psychological restrictions" those labels, artist or craftsman, imply.

To get the job done, Daniel will need fifty pots, alike in form and dotted so that one is black, one is white, and the others are transitional between them. Daniel tells me:

"I started thinking about those dots changing in value. There's twenty-five thousand dots on each one. So, I figured that up. In a three-and-a-half-inch square box, there's a hundred dots. So, we dropped the value of the dots by two percent on each pot. So, the first pot is one hundred percent black dots. The second pot is ninety-eight percent black dots. The third is ninety-six percent black dots.

"So, when you get to the very center, where the lines of pots grip each other, then you have two neutral pots. And then the pots increase in white dots by two percent, you know, as two percent of the black dots drop to where you have a white pot."

Daniel goes on to say, "The interesting thing about the dots is that I don't really like them. They're ugly, you know.

"And that starts to speak to an interesting thing about transition, because the pot is becoming an object in space that does a job. It's part of a sequence. So, the dots are important in that sequence." The dots don't enhance the beauty of the lone pot; they make connections between the pots, bringing them into unity — and recall Daniel saying that one of the lessons he learned from the Big Pot Project was to see individual pots as parts of a larger, potent whole.

Then, saying, "I am not a big fan of dots on pots," Daniel refers to that master jar, the rotund beauty with its waterfall of glaze, which was illustrated in his proposal to Peters Projects and which ended the sequence of apparently identical pots in his first indoor installation. "That run of pots," Daniel says, "was for aesthetic value. This one is conceptual."

"And it's interesting to see that, as the work moves, there is more obligation to speak of something other than the object in and of itself, and the object becomes deprived of individual beauty."

"That's something I'm well aware of. Now the pot is part of something. It's not an entity anymore. It's becoming part of something grander. It's a building block rather than something in and of itself."

The aesthetic value of the lone pot is overridden by the conceptual goal that unifies the pots in a transitional sequence from black to white. The drama of that sequence will arrive in conjunction with the wooden frame that Daniel will build to shape the curved route along which the pots will run.

Daniel paced the gallery where his installation would be built, found it to be 126 feet wide, with a door in the front wall and a door in the back wall. His idea was to frame a tunnel from one door to the other so visitors could walk through it, moving along with the pots, without entering or even seeing the

INSTALLATION 902 - 951

CENTER - GRADATION OF POTS 50% WHITE / 50% BLACK — WALKWAY 3 FEET WIDE

ENTRANCE / EXIT

TOTAL LENGTH OF TUNNEL 216 FFET

ENTRANCE / EXIT

POTS 24 INCHES WIDE

Daniel's plan, from his proposal to Peters Projects, 2017

gallery. His last two installations were circular. They provided the experience Daniel wanted the visitors to have, and Daniel made it hard for himself and interesting for the visitor by planning his tunnel for circular motion. He says:

"So, how do I get a person from the entrance to the exit in a circle? I drew circle after circle. Circles are repetitive, to say the least.

"So, you have to have two circles, one connected to the entrance, one connected to the exit, with a connection between them.

"So, I made two huge spirals that intersect in the middle. The spirals wrap around one another until they hit the center, and then you transfer to the other spiral. This allows the inside of one wall to be the outside of the other wall.

"And to create a double spiral that wraps around itself and accelerates and expands at the exact same speed — that mathematical problem is phenomenal.

"And what I got to do was spend hours to figure that out.

"What I would say the installations are really about — it's about my brain learning, moving forward. And I did it. I worked my brain and did it.

"And some people work a week, you know, bagging groceries or something. But I spent a week of my life to figure out how to put two spirals together."

Daniel drew the plan for his double spiral with such precision that he could use it to measure and cut the lumber in North Carolina that would be screwed together in New Mexico. "I had to trust every measurement on that blueprint," Daniel says. "I had to trust my math perfectly, because I didn't have the space to build it here, nor the time to cut it out there. Every bit of the wood was pre-engineered and pre-cut before it got to the gallery, you know."

The pre-cut boards of Carolina pine will lift vertically along the walls and make a ceiling above, all of them spaced apart to admit, block, then admit the gallery's lighting in an alternating rhythm. Once they had been cut to size, the boards were treated to create the right backdrop, one side black to rise behind the dark pots, the other side white to rise behind the light pots. Daniel explains:

"For the half of the tunnel that has the predominant black dots, we burned the wood with a torch. So, all the pine has been burnt. On the back side of that wood, we whitewashed it with proper whitewash: lime and egg and salt.

"And so the beauty of it all is: without paying attention, you enter into the tunnel that is dark with a black pot. And you exit the tunnel with a white pot. But truly, you don't know how you got from black to white. It happened so slowly.

"It was an adventure. You don't know how you got from having a black pot on your left to having a white pot on your right."

Daniel's heroic code, his commitment to humanity and himself, requires him to deliver what he promises. He had the fifty pots that the gallery commissioned and all the parts for his wooden framework done on time. Heroic is an apt word for Daniel, but he is less like the driven hero out of an epic than he is like the hero of a romantic novel who identifies with Hamlet and knows moments of stasis, melancholy, and indecision. As it was with the Big Pot Project, Daniel got a late start, battled through lethargy and depression, and then when his task seemed nearly impossible, he gathered helpers and finished in a frenzy.

He had the capable Kate beside him and three apprentices to help too: Andrew Dutcher, Charlie Hayes, and Natalie Novak. "And then," he says, "I hired two other people. There were seven of us cutting wood and painting it and burning it for a week. Seven people sawing, you know, for a solid week."

Daniel flew away to give a lecture at Haystack, and a couple of hours after his return, "the truck driver pulled up with the truck. And we started loading the wood and the pots, and it took us three solid days, three twelve-hour days, thirty-six hours.

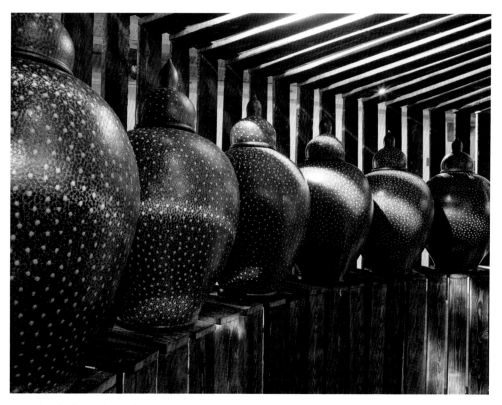

Inside the dark spiral at Peters Projects, 2017. *Peters Projects photo, courtesy Daniel Johnston*

"Every single pot had to have specially-cut wood screwed around it to keep if from bouncing.

"So, a year after I went to see the gallery, I show up in New Mexico with an eighteen-wheeler with three thousand board feet of lumber on it."

I am here at Peters Projects, standing at the entry of Daniel's creation. Before me, a dark tunnel, a yard wide, runs straight for two yards, then sweeps to my left where a recessed shelf appears, carrying twenty-five pots — the first of them black — as it curls around to my right. The shelf is forty-three inches from the floor. I have to stand back and look up to see the tops of the pots, just as visitors had to do in Daniel's previous indoor installations. The pots are round, the same in form and set in a tight line, so as Daniel wants me to do, I don't focus on the individually fine pot; all of them are fine. I understand them as parts of a whole.

Daniel wants my walk to be a surprising adventure. The sequence from black to gray — as the white dots increase in the blackened first spiral — is contradicted by the dark finials on all of the pots and interrupted by the light that streaks through the slatted ceiling. The first four pots stand in the dark. The next six are brightly lit. Then seven stand in the dark, and the remainder,

gray in tone, stand in a gray half-light. I have to squint and concentrate to follow the dots into the decorative sequence.

Around the corner in a sudden reversal, the spiral swings to my left while the pots curve in a tight line on my right. The boards are all white, the finials are all white, and the pots, dotted toward whiteness, stand first in a gray half-light. Then seven stand in the dark, seven in the light, and the line ends with four in the dark, the last of them purely white. Along the course of the whitening pots, it becomes clear to my eye that the pots were decorated by different hands. On some the dots are large and loose; on others they are small and tight. In applying the dots that Daniel dislikes, his apprentices differ.

For all its precision in planning, in carpentry, in throwing and decorating the pots, Daniel's installation is handmade, everywhere enriched by natural materials and invigorated by the human touch. With a white pot on my right, a straight tunnel before me, I leave.

I leave, pass through a door, enter a second gallery, and encounter a second installation. No mention of it was made in Daniel's proposal. He never told the people at Peters Projects about it. The idea hit him late when he was throwing fifty pots, five or six a day, in a wild burst of work, and here it is before me.

Daniel's secondary installation, Peters Projects, 2017

In the middle of the room stands a hollow wooden rectangle with rounded corners. Slatted and lit from within, forty-two inches high, the frame carries a tight, continuous sequence of thirty-one tall white cylinders, handmade and wood-fired. Daniel calls them pillars, but columns more often.

Daniel will tell me that he intended the frame to represent the boxcars in which Jewish people were shipped to death during the Holocaust. The silent, anonymous columns "feel like people," Daniel said, and his installation is a memorial to the victims of violence, to the Jews who were murdered in the gas chambers, to the black men who were lynched in the South, to the Vietnamese peasants who were bombed during the war in which Daniel's father served, to the women who are beaten by drunken husbands.

Much as I respect Daniel's intent and share his values — we disagree about nothing that matters — thoughts of the sort don't enter my mind when I pass through the opening in the rectangle, the door of Daniel's boxcar, and stand surrounded by the columns. They were slipped white by hand, given a white Shino glaze, then fired to be, Daniel says, "two-sided." Turned to have the dark, scorched side facing in — the side Daniel calls more interesting and beautiful — they have been arranged to swing around me from light to dark and back to light. Earlier that summer, I had seen Daniel's installation at the conference on wood-firing in Star, North Carolina. There his frame was round, not rectangular, but the columns, viewed from within the circle, also swept from light to dark and back to light.

The columns repeat the idea behind the dotted decoration, so at Peters Projects the smaller installation can be read as a clarifying comment on the larger installation that preceded it. In the double spiral, the dots ran in a transitional sequence from dark to light. The columns came from the flame with irregular surfaces, so even on their dark sides some were lighter, others darker, and they could be set into a transitional pattern, expanding from a dark center toward lightness in both directions.

The dots, though unlovely in Daniel's view, serve to bring beautifully curvaceous and individually desirable pots into a continuous line. The columns don't reach for beauty with swelling curves; they don't call attention to themselves as individuals. Their virtue is to form, like dutiful uniformed soldiers, a coherent line.

Applied by the apprentices, the dots added an amateur touch of variability to pots that were professionally shaped to a single design. The columns were

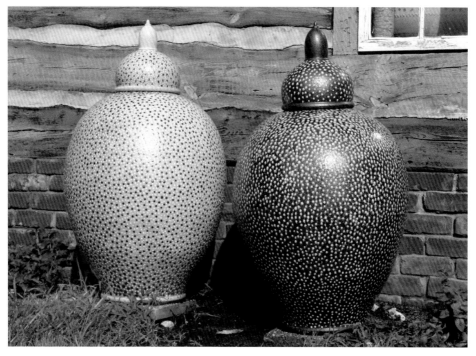

Dotted pots by Daniel Johnston from the Peters Projects installation, bought before the exhibition and awaiting their owners outside Daniel's shop, 2018

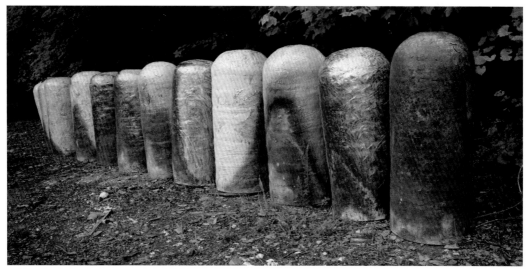

Columns left over from Daniel's installations in 2017, one in Star, the other in Santa Fe, lined up near Daniel's kiln, 2018

made entirely by the apprentices to be intentionally and vitally ungainly. Daniel made none of them.

"I've actually never built one," Daniel says. "I couldn't build one, you know. Every time I put a coil — if I wanted to make one of those, every time I would put on a coil, I would question every aspect of it.

"They have to be built by someone who doesn't know what they're doing," Daniel laughs. "The beautiful part of them is that the person who built them doesn't understand what they're doing.

"So, these columns were built by my apprentices. And they touch the clay in a very unconscious way. And because of that the columns are beautiful. Because the apprentices don't have a choice. They have to make them because I told them to make them, right?

"I'm orchestrating it. It's very orchestrated by me, for sure. No one of these apprentices could have made them by themselves." The method they use in making the columns is the Thai technique Daniel taught them; he continues, "It takes all of them, and me, to produce them. Which also gets rid of the ego. It gets rid of the individuality of each individual piece. So, no one can claim any of those pots.

"And that allows me to build what I want out of those pots, because I don't have a personal attachment to any of them."

Daniel's ability to build what he wants with the columns will carry us a year into the future. But now it is July 19, 2017, in Santa Fe. I leave the box of columns behind, pass through the gallery's back door and enter a third gallery. A monumental decorated jar stands to my right and its mate stands to my left, flanking the doorway that provides an alternative entry to Daniel's sequence. You can go either way, but Daniel planned it, and thinks about it, along the route I took. Here's his summary:

"There were three showrooms, three galleries. The first gallery held the first installation. The second gallery held the secondary installation. And the third gallery held two large jars.

"They are phenomenal. I made them without thinking. They have beautiful big loop patterns on them. And I just made them without thinking. Put them in the kiln.

"But people see them because they've seen the others. They're fantastic. And ultimately, you know, the last two pots do as much as the first fifty."

While Daniel's show was up and running, Mark Del Vecchio, the delightful director at Peters Projects, told me the exhibition was a great success. People

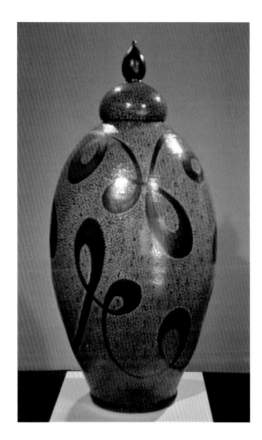

One of the pair of big pots by
Daniel Johnston that flanked
the rear entry at Peters
Projects, 2017

The back door to Daniel's installation at Peters Projects, Santa Fe, 2017

stayed longer than he thought they would. Some returned for a second visit, bringing their kids to see it too. Mark thought all the pots would sell. Daniel's prices are low, too low Mark said, and buyers in Santa Fe want big works to place outdoors, ornamenting their homes. Most ceramic pieces weather badly, but Daniel's pots are so well made, Mark said, that they can survive without damage through the shifts of the seasons.

With his partner, Garth Clark, Mark Del Vecchio has built a comprehensive collection of contemporary ceramics and arranged a multitude of exhibitions for artists. Garth Clark, collector, dealer, and critic, is a central figure in the world of ceramics. Recipient of the College Art Association's award for art journalism, Garth has published many important books, including an early study of Michael Cardew. At a dinner in Santa Fe with Mark, Garth, and two of their friends, Pravina and I had a grand time; the chat was pleasant, the laughter constant. We all signed a card of congratulation to send to Daniel.

Garth had gone to North Carolina to see what was happening, and he warmly recalled an elegant dinner at Daniel's. Garth and Mark both thought the columns pointed Daniel's way into the future because, lacking utilitarian functions, they hold appeal for sophisticated consumers.

At the time Daniel agreed that the columns pointed the way, but his reasoning was different. His thought was caught in the description of his pots in his proposal for Peters Projects. They are storage jars that transcend their historical functions. In transcendence, Daniel's pots have become idealized representations of utilitarian vessels, much as Greek statues are idealized representations of human beings. Now they are decorative in function, like the works that Garth and Mark collect and display in their beautiful home, but their past as storage jars endures to evoke the traditions of North Carolina and Thailand, in which Daniel learned and out of which his pots arise.

Daniel's useful forms are more about meaning and beauty, more about tradition than utility. All art is in some measure traditional, the natural consequence of a lifetime's experience, so the effort to escape tradition and achieve deracination eventuates in desperate convulsions or swoons into mere fashion. Through tradition, in reference to the past, a layer of significance is added to Daniel's creations, even in the case of the innovative abstract columns. They were made out of Carolina clay, using a Thai technique, coated with a Japanese glaze, and fired with Carolina pine in a Thai kiln. They point the way because Daniel can install the columns in units to attract the attention of others, making them aware of their bodies in motion, stimulating their vision, and engaging their minds.

That is, like all works of art, Daniel's installations are communicative in function. The creator has altered nature, combining traditions and personal desires into an artful embodiment of the self. The work is his. The viewer encounters the work as the materialized manifestation of its human creator. Somebody made it. The humanity shared by the creator and viewer forms the base on which messages transmitted and received mesh logically, though never completely, never perfectly, leading ideally to some degree of mutual understanding — and mutual understanding, Daniel feels, is foundational to successful exchange. Through the work, the viewer understands something about the creator. The creator's work displays some understanding of the viewer's interests, values, and needs.

All artifacts are multi-functional, at once aesthetic and pragmatic, and through their communicative potential, in alliance with the promotional efforts made at their venues, Daniel's installations have functioned to expand his reputation, slowly but surely, causing his prices to rise and — this is what is most important for Daniel — bringing him opportunities for new exhibitions that will force him to work his brain.

One clear and patently utilitarian function of art is to provide the artist with a livelihood, and the immediate benefit of Daniel's installations is that all the pots get sold. Daniel has numbered his big pots in sequence, using the numbers to subtitle his exhibits. His first indoor installation in Greensboro offered pots numbered 726 to 756. His second in Asheville had numbers 783 to 804. The third in Raleigh had numbers 866 to 885. His fourth in Santa Fe had numbers 906 to 955. He had, with that exhibition, sold nearly a thousand big pots at healthy prices.

When Pravina and I showed up near the midpoint of Daniel's exhibition in Santa Fe, which opened in June and ended in August, both of the largest jars, the ones that flanked the rear entry, had sold for five thousand dollars apiece. Twelve of the pots in the dark spiral and eight of the pots in the light spiral had sold for three thousand dollars apiece. Nineteen of the columns had sold for fifteen hundred apiece, and one man bought five, the best ones from the dark middle, to make a little installation on his place. Any that didn't sell during the exhibition, Mark Del Vecchio told me, would be kept in stock and eventually sold. As it turned out, some were shipped to New York City and sold there.

Daniel says, when I ask, that the pots placed in the spirals near the entry and exit — those that were predominantly dark or light — sold most quickly. The middle pots, balanced between black and white, also sold quickly. Slowest

to go were the "saturated" two, one purely black, one purely white, and the ones that contributed to the sequence but were individually unresolved and off balance in their dots.

At Peters Projects in Santa Fe, the fullness of Daniel's art lay not in the lone pot but in the installation as a whole. Yet, he says:

"People bought those individual pots and carried them away" — after the exhibition was over. "I love that the greed in our culture will destroy a piece of art. And I love that art lovers are the guilty ones. And I love putting them in that position.

"It points out the flaws in capitalism, and it points out the flaws in ourselves as well.

"The installation says, All of you art lovers, come and tear me apart. I love that they will buy a pot for themselves and destroy a work of art."

In September when Daniel got home, after dismantling his exhibition's framework in Santa Fe, he gave me a call. He designed the primary installation, he said, so that by the time the visitors got to the white pot, they would have been so completely absorbed by the repetitions and variations that they would be thinking of nothing but their journey from black to white.

That one pleased him but now he was looking forward to creating more and better installations, and he got hints in Santa Fe about future possibilities in Philadelphia and New York. Daniel ended by saying:

"I've been paying my dues for years without a break. Sometimes that's depressing. Even workers at Walmart get fifteen-minute breaks.

"But I'm going to keep working hard, and if I can make people see through the neon bullshit, if I can take craft and integrity into the art world, then I'll be satisfied."

With his four indoor installations, created between 2015 and 2017, Daniel had opened the door into the art world. In the next year, he walked through it in triumph. The columns had pointed the way.

When Daniel decided to add a stand of columns to his exhibition in Santa Fe, he had been talking about the columns with me for two years.

A local precedent for the columns might be found in the ceramic grave markers made around Seagrove in the nineteenth century and described in a catalogue by Terry Zug. Like the columns, they are not open vessels for storage, but closed sculptural forms. The grave markers remember the dead, and Daniel intended the columns in Santa Fe to be memorials to the victims of violence.

Marker by
Daniel Johnston, 2012

Marker by Daniel at
the dogs' graves, 2018

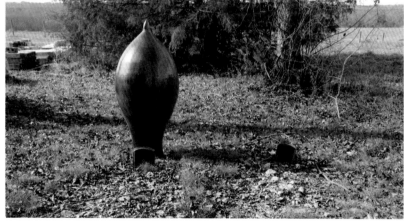

Mark Hewitt was inspired by the grave markers to make tall, solemn, stoneware forms, glazed like his pots. One of them commemorated a friend who had passed, though most of them stand as splendid and mysterious works of art. Mark calls them sentinels. Daniel and Alex Matisse followed Mark in the creation of slender, closed forms that range in height from a masterwork by Daniel, taller than a tall man, to the miniatures made after Alex's bold models by his apprentice Corey Sizemore.

Daniel calls them markers, and he has placed a quiet, dark marker beneath the trees at the edge of his land where two dogs, Sam and Gus, lie buried. Three live and lively dogs frolic around Daniel and Kate's place.

But Daniel says his idea for the columns didn't come from the grave markers. It came from the squared limestone posts that anchored barbed wire fences in the American Midwest and then stood in isolation after the wire had rusted away. The limestone posts are, like the columns, pale and rough in texture. Spaced far apart, with no physical connection between them, the stone posts, Daniel says, "make a dotted line along the landscape, and you feel the entirety of those spaces and the weight of life that happened in those spaces. And who knows what was in and what was out?"

Inspired by the limestone posts, Daniel first imagined placing his columns in a long straight line on the undulating landscape of the Great Plains. Rising and falling with the heave, the columns would record the contours of the topography and disappear over the horizon into the vastness of space. In line, they would imply a division, a boundary that thwarts motion like a fence. But set apart and unconnected, the columns would strike a line easily crossed, symbolizing the harmful falsity of categorical divisions — the social distinctions that divide the rich from the poor, the black from the white, and the intellectual distinctions that divide art from craft. When the American political atmosphere soured with biased blather, Daniel thought of positioning a loose and open span of columns in Texas along the Mexican border to welcome the immigrants as they crossed the political divide without hindrance and entered a space that was originally theirs.

After his exhibition in New Mexico, Daniel told me that using the columns in an indoor installation was "immature." They belong outdoors. When I visited him in January of 2018, Daniel was making plans and experimental pots with a new open-air installation in mind.

If he made columns in different heights, he could arrange them in a line so their tops maintained a straight horizon while they descended a grassy slope and then rose again with the land's ascent. Placed too close to permit passage through them, yet just far enough apart for the land beyond to be glimpsed, the columns would make a wall or represent a line of people on the march. Wall or marchers, the line would steadily cross uneven ground, vanish into a hillock, then emerge to persist on course, maybe breaking courteously at a path, maybe driving relentlessly across it, going on and on, casting shadows while the sun rises, sets, and rises again. The installation would insistently remind us that we are not alone. Others before us made a wall, altering the land we walk. Others today are proceeding on their way across the land, caring nothing about us. Our arrogance is checked: whatever we might think, we share with others a world scaled beyond our control or comprehension.

Daniel worked hard during the spring to turn that idea into a plan of action, and on the last day of May, when we were in Brazil, Daniel left a message on our answering machine, saying, "I just wanted to give you guys a call to let you know that today I signed a contract with the North Carolina Museum of Art, and they purchased an installation that's four hundred foot long and has two hundred big pots. It's a big day, and I'm having a beer now. It's my way to celebrate, and I really wanted to let you guys know that I got the planning done and it's really crazy; they purchased it for the permanent collection. Things are going quickly, but good. I love you guys and thank you for everything. Give me a call when you get back from your trip."

When we got back in June, having given copies of our book on Brazilian art to all the artists in it, we called Daniel and before the month was out we drove to Seagrove. Daniel hoped to have the installation finished by Thanksgiving. With only five months to get the job done, things were rolling. The shop was crowded with columns waiting to be glazed and fired; big stacks of wood surrounded the kiln. A victory for art lay ahead, since this installation will not be dismembered and scattered; it will be preserved forever in the permanent collection of the North Carolina Museum of Art, where, thirteen years before, Mark Hewitt, Daniel's master, co-curated the museum's first major exhibition of North Carolina pottery.

To get the planning done, Daniel rented a small building in Seagrove. Once a bank, it is now an orderly office with a big pot in the front, a professional drafting table behind it, a colorful Central Asian carpet on the floor, and a bookcase in the back. The pictures on the wall record the process of planning, and they exhibit the skills that combine in Daniel, the skills of a thinker, an architect, an engineer, a draftsman, and a spirited, adventurous artist.

Daniel walked the spacious grounds around the North Carolina Museum of Art and found a piece of land that resembled the space he had imagined and sketched quickly for me back in January. Using detailed topographical maps, he made a series of drawings of the land's profile, viewed from the south and crossed by a tight, straight line of columns. After passing through a shallow hollow on the west, the columns disappear into a hill and then reappear to continue on their eastward course. Dipping and lifting with the land, the columns vary in height to strike a straight horizontal line with their tops. The natural hill is too low, so it will be heightened by moving tons of earth to create the illusion of a line of columns continuing underground for a short stretch.

Columns drying in the shop,
June 2018

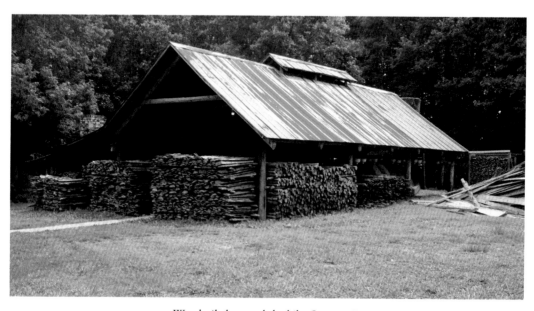

Wood piled around the kiln, June 2018

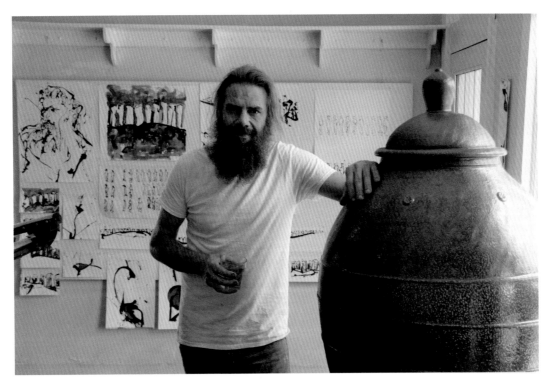

Daniel Johnston in his office, June 2018

In a long line, Daniel told me, the columns present a diagram of American society. People, though innately equal, are born into different circumstances and as they grow they get different opportunities and meet different challenges. Where the columns are tallest, where you can't see over them or get around them, they represent the challenges faced by African Americans and immigrants from Mexico. Where the columns are shortest and you can see beyond them and climb over them, they represent middle-class experience. Where the columns go underground and you can walk over them effortlessly, they represent the conditions of the rich who proceed blithely, feeling no need to acknowledge the engines of privilege that propel them. In their sweep, the columns evoke the inequity in American society. There are more tall columns than short ones and space for only a few underground. Thoughts of this kind — like those he had about the boxcar of columns in New Mexico — help to keep Daniel moving forward with his projects, and he doesn't expect the viewers to completely understand his motives.

The first segment of Daniel's measured plan for his installation
at the North Carolina Museum of Art, 2018

Daniel does think that the viewers of this installation will recognize that it is about division. The bright, light sides of the columns will be turned to face north, and the northern landscape around them will be meticulously manicured, like a golf course or suburban lawn. The dark sides of the columns, which Daniel thinks are more beautiful, will face south, and the southern landscape will be wild with native vegetation. Some visitors will prefer the smooth northern side, others will, like Daniel, prefer the rough southern side, and Daniel makes his attitude plain by arranging his installation so that the sun will always shine on the dark backs of the pots, rolling disruptive black shadows onto the tidy northern lawn.

"The northern side," Daniel says, "is conventionally beautiful, a lawn with white posts. The southern side is rough, ragged. You have to look close, and understand what you are looking at, to see the beauty in it. And if you look at it, it's much more phenomenally beautiful than the north.

"The shadows land on the northern side, and they always will until the earth spins in a different direction. The sun will always illuminate the dark beauty of the southern side that takes a long time to see. But I'm making sure that the light shines on that dark beauty constantly."

In Daniel's design, the columns cut a sharp borderline. "It has to do with the North and the South, for sure," he says. "That's the dividing line for us

The second segment of Daniel's measured plan for his installation
at the North Carolina Museum of Art, 2018

historically, from the Civil War to now." With the Civil War in mind, you look uphill toward the North. The columns standing in line, spaced four inches apart, become the men at arms waiting in the instant that endures, William Faulkner wrote, in the minds of southern boys, the instant just before Pickett's Charge. Now, Daniel says, "The border is the Mexican border. Mexico is the South, America is the North, and the southerners are poor, dark Mexicans, and wealthy white people don't want them here." As it was early in his thought, the columns form a silent, abstract presence; they can be read as doomed human beings or as the building blocks in a wall.

One of Daniel's preparatory drawings is an elevation, precisely measured like his plan for Peters Projects, so he could use it to locate each column and calculate its height. He made a list of the columns, each one numbered, so that, skipping at first the tallest most difficult ones, his apprentices could make the columns in order, all of them the same in diameter, each one the right height. Needing help to get it all done, Daniel took on a third apprentice, so he had Jacob Craig, called Jake, as well as Natalie Novak and Charlie Hayes coiling the pots, Thai-style, on low wheels. Charlie told me he was getting so much practice with Daniel's technique that his columns were smoothing toward perfection, and when Daniel walked by he sometimes decentered Charlie's pot to make the work more challenging and the column appropriately rough.

Daniel Johnston's technical drawing to guide the installation of the columns, 2018

The young potters can make the pots. Engineering is Daniel's job, and he made an exacting technical drawing to guide construction. A deep trench will be dug along the straight line of the march of the columns and filled with concrete. Rods of rebar will stand out of the concrete where the columns will be placed. Concrete poured into each column will be held at the top by a rubber diaphragm, so when the column is lifted and slid into place, the rebar will pierce the diaphragm, releasing the concrete that will run down to unite with the concrete in the trench. Doing that two hundred times will be a long, tough task, but permanence will result. The columns will be anchored into a firm foundation. Being "solid, bottom-heavy forms" Daniel says, they will stand through an earthquake.

While Daniel was making the technical drawings requisite in planning, he was also making drawings to fire his imagination and keep him going. He made drawings to ally the columns with the human form. He made free and lively renderings of the columns in line, moving black and brown ink on paper

A fancy of dancing columns by Daniel Johnston, 2018

Daniel's first scroll, depicting part of his installation, 2018

like slip on a pot, reminding me of Japanese brushwork and the paintings of Adolph Gottlieb and his talented student Larry Marty. The energy of all of these drawings, the tight and the loose, flowed into a scroll, forty feet long, one foot for every ten of the installation it pictured in profile. Daniel refused to write an elaborate, explanatory proposal. The scroll was his proposal, and he unrolled it during a meeting with the museum's curators. At the time he was promised a quick decision, but the signs were already good, for Daniel heard one of the curators comment that it would be a good idea to display the scroll at the opening, and it wasn't long before Daniel signed the contract on the last day of May in 2018.

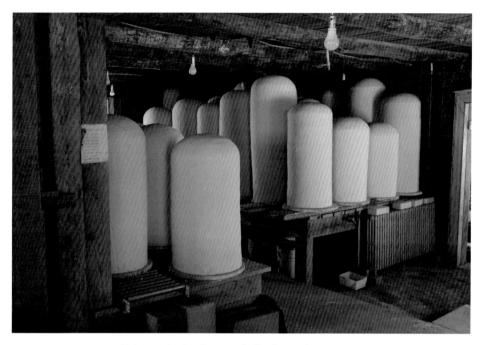

Columns in the shop, ready for firing, August 2018

Wood piled around the kiln, August 2018

When we returned at the beginning of August, sixty of the two hundred columns were slipped, glazed, and ready for the kiln. The apprentices began with the shorter columns, and their familiar techniques met their needs, but as the columns passed five and a half feet and rose toward the maximum height of seven feet, difficult problems of height, weight, and space demanded creative solutions.

Daniel began solving his problems by expanding his operation to incorporate his father's old barn. Certain that his grand project was about to provide stimulating tests for his skills as a carpenter and mechanic, he set up a woodworking shop on one side of the barn. The columns awaiting the kiln filled his log shop, leaving slight space for work, so he moved his apprentices into the barn. Work space matters. Kate told me that when she throws a big pot in her small studio, it always comes out smaller than she thought it would. Big pots need big spaces, room to breathe, to spread and rise. The wide and lofty barn offered the right environment for creating the tallest columns. "The apprentices," Daniel says, "changed as soon as I moved them into the barn. They were oppressed by that space in the shop; they couldn't see bigger because they were already making things as big as the shop could hold. Then I moved them down there and they started seeing bigger and making bigger, so easy and quick."

The columns they were making at the time weighed four hundred pounds, and Daniel estimated that when the columns reached seven feet in height, they would weigh six hundred pounds. (Dried during firing, he says, their weight will decrease by a bit more than twenty percent.) Already too heavy for people to carry, they have to be lifted and shifted on the fork of a Bobcat, so Daniel removed the posts on one side of the barn's runway and framed a swing beam above, clearing the floor for the Bobcat's motion.

When I asked Daniel for a progress report in August, he led us into his sequence of solutions. "The last time you guys were here, I was on top of it. But shortly after you-all left, things started falling apart.

"And not in a bad way. It's just that the wheels started to give way underneath the weight of the biggest columns, pillars.

"And the apprentices started making the pots a lot heavier. And I really liked it, but they were using twice the clay that we had anticipated. So, it makes the pots too heavy for the wheels we had.

"The apprentices had been incredibly stoic, and they didn't bother me. They had put up with a lot of shit, which is in a way a fault, you know.

Daniel and his Bobcat, August 2018

"They'll ask me some piddily little question, which they shouldn't, but then when there's a real problem, like the wheels not working right, they'll work on for a week before they'll tell me, and that slowed production down by half.

"But that's what I need to know about. So, finally they told me that the wheels weren't working right, and they were giving way. Then I realized that we could build the wheels a lot more massively."

Daniel made three stout wheels that bore the weight and spun easily, one for each of the apprentices, Natalie, Charlie, and Jake. But the apprentices had to climb ladders to coil the tops, so Daniel began building an elaborate scaffold on which they could stand to finish the tallest columns. Designed to solve a problem of the moment and to be useful in future projects, the scaffold was framed as a unit so it could be lifted with the Bobcat and loaded onto a truck.

The foundational frame of Daniel's portable scaffold carries six potters' wheels, three on each side, so the apprentices have nine wheels and they can work on nine columns at once, letting some dry while they turn to others. The wheels are thick, bolted together, and mounted on spindle and hub units from used mobile homes. They spin freely when the potters simultaneously add coils and turn the columns by hand. A tripartite bat placed on each wheel enables Daniel to lift and move the columns with his Bobcat.

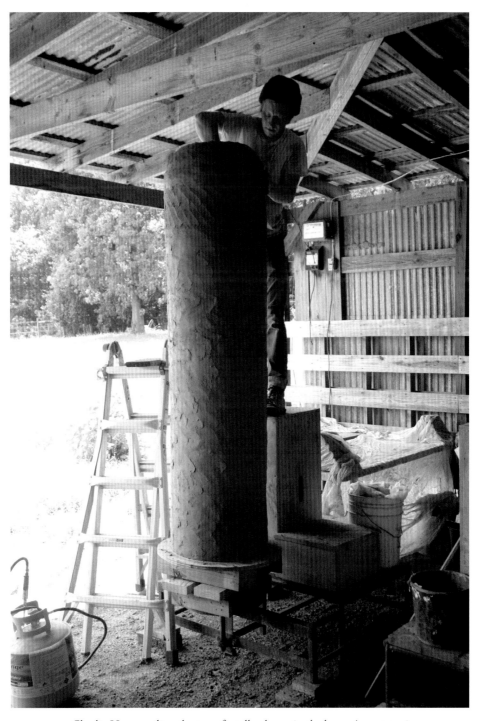

Charlie Hayes coiling the top of a tall column in the barn, August 2018

Daniel's portable scaffold,
August 2018

Then the frame's second level supports two jacks that can lift the scaffold's platform by twenty-five inches. "It doesn't need to jack up and down," Daniel says, "but my brain wanted that engineering problem." On the level above the jacks, a wide platform provides a place to stand and finish the tallest columns. A table on the platform, the frame's fourth level, holds the coils so the apprentices don't have to stoop down to pick them up while they are working on the tops of the columns. When we arrived, the apprentices were climbing ladders. A week later, Daniel had finished his clever contraption, and all three of his apprentices were working on it together, comfortably and efficiently.

The weight of the columns caused Daniel to build a new glazing wheel, mounted on a jack so the column could be lowered for glazing and lifted for moving. Their height raised the problem of firing. Daniel's kiln gracefully accommodates the shorter columns, like the ones three feet tall that stood in his installations the year before. The tallest columns — "undeniably phallic," he calls them — were another matter. On the morning of one day in August, Daniel told me he would have to break the brick floor of his kiln, deepening it to hold the tallest columns. By that afternoon, having experimented with the Bobcat, he thought that, given the trouble and time it takes to move the big columns from the barn to the kiln, he would probably have to build a new and taller kiln next to the barn.

The barn, August 2018

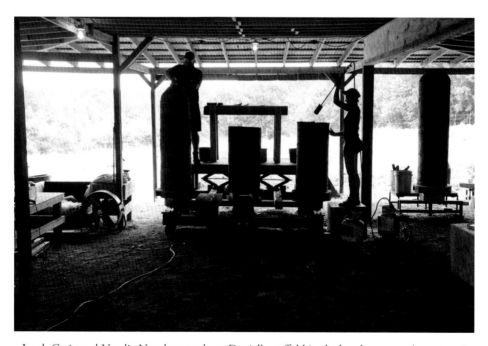

Jacob Craig and Natalie Novak at work on Daniel's scaffold in the barn's runway, August 2018

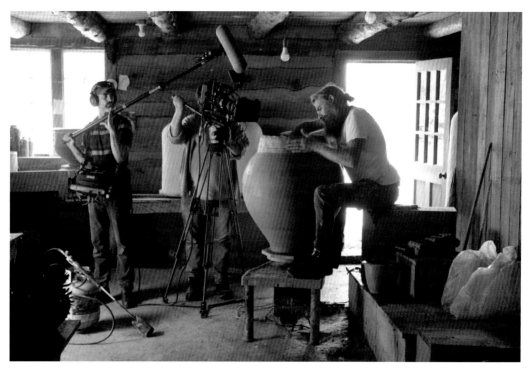

Bob Brennan recording and Colm Hogan filming Daniel making a big pot, August 2018

Amid this quick and difficult series of solutions, Daniel was interrupted by visitors as he had been, back in 2013, when he was building his new kiln. Then they came from Sweden; this time they came from Ireland, and I was to blame. Thinking it would be good for the permanent record to have patient, professional footage of North Carolina's potters in action, I brought our friend, the noted film director Pat Collins, and his crew: his cameraman Colm Hogan, fresh from work on a big-time Hollywood flick, Colm's assistant, Tom Reynolds, and Bob Brennan, the soundman. They filmed a firing at Mark Hewitt's. They filmed Kate making and decorating an elegant ewer. They filmed, without a break, the entire process of Daniel making a beautiful big pot. Daniel said he hadn't worked on the wheel for six months, he needed to be making pots again, and he felt the disruption was productive. It made him think about what he was doing.

And what he was doing became the subject of a meditative soliloquy when we were alone and the recorder was running:

"Right now I'm feeling a little bit uncomfortably disconnected from the work that is being produced. I don't see it sometimes because I'm so focused on the engineering that's got to get done.

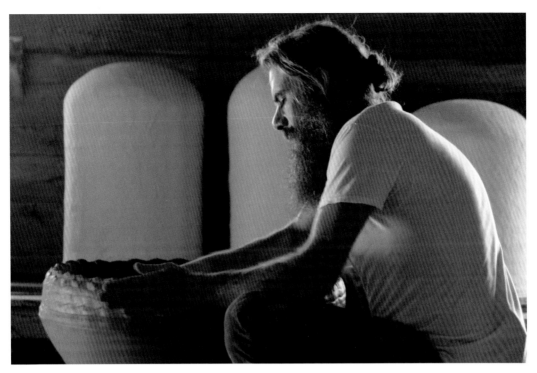

Daniel Johnston making a big pot for the film, August 2018

"But when I feel that way, I go into the barn at night and look at all the work. And I'm blown away by being able to create that work — and not to even touch it. I realize that I've created a learning situation, that the people understand my aesthetic. The people who are making the work, they understand my aesthetic perfectly.

"They understand my aesthetic, and I've taught them how to do it. I created this project months ago, and I created the mindset of the people who make the work. And I don't have to be connected to the pots right now.

"I know enough about myself, and about life, to know there's nothing wrong or right about it. If that's what I'm doing, then that's what I need to do right now. And the answer will come later about why I did it."

Daniel does the planning; he designs and builds the equipment. Charlie, Natalie, and Jake throw the pots. The link between them is the educational process that is Daniel's topic now. With firing as his example, he says the apprentices begin learning by working beside him, then they advance when he surrenders command and they teach themselves while working:

"You have to trust them to take control of the kiln. You can't stand out there and control it. If you take control away from people, they stop using their intuition and things don't work.

"You have to allow them to have control. Then people grow as their intuitions change, so" — out in the barn, with the apprentices in control — "the pillars are getting better. It's amazing how much better the apprentices have gotten over the last month."

That's the process, intimate and liberating, and its success depends on the commitment, the willingness to give, on both sides:

"I have given so much of myself to the apprentices, but it doesn't matter what the fuck I've given them. What's important is for them to encounter someone who will absolutely, hands down, give until they have nothing to give.

"And they don't give it back to me with gratitude. They give it back by knowing that they will absolutely not disappoint me. They give it back with the work they do for me; they give it to me there.

"I have given so much to them, and that's the price I have paid for this work to be done for me. And they will be better people for what I've given them and they've given me."

Through educational exchange and the interlocked action the work requires, Daniel intends for the apprentices to grow and become better people. By better he means more mature; by mature he means generous. The change he wants, and the apprentices have achieved, is the change from juvenile selfishness to mature, collaborative generosity. That "huge change" is, in this moment, Daniel's proudest accomplishment.

The values implicit in Daniel's words contrast sharply with the desires of those American artists who yearn to create without the need to teach, but they align clearly with the values held by masters in Asian workshops — in India, China, and Japan, though the case I know best is Turkish. In Kütahya, a city in the mountains of western Turkey, where splendid ceramics have been made for five hundred years — where I have been so often that, by the mayor's decree, I am an honorary citizen of the city — there were, at the beginning of the twenty-first century, twenty-three large ateliers and close to two hundred small ones, supplying the livelihood for ten thousand people.

Within the rumbling workshops, rising from *çırak* to *kalfa*, from *kalfa* to *usta* — to master — men and women become fully competent in craft and they also gain the name *sanatkâr* — artist. But the greatest masters rise still higher in local esteem by taking on social responsibilities. Knowledgeable, they manage shops that provide employment to others. Generous, they teach, transferring techniques and aesthetic principles to their apprentices, just as

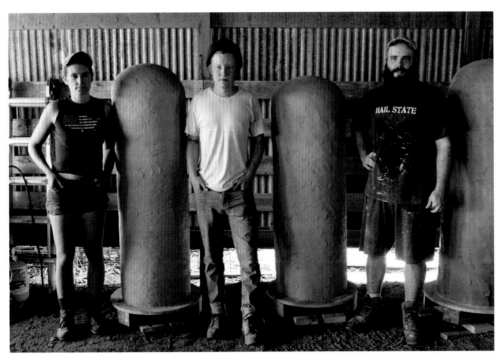

Natalie Novak, Charlie Hayes, and Jacob Craig in the barn, August 2018

Daniel has done. The best of them teach so well that they no longer have to touch the excellent works that issue from their ateliers. And, complete in commitment, they guide the moral development of their students, shaping intense and affectionate relationships that last a lifetime. Toward that pinnacle of mastery Daniel has come.

When I tell that to Daniel, at greater length, with more specificity, he responds:

"The things I know now, other people have known them before, but I've had to figure it out for myself. But, yeah. How can you really believe in loving people, and not do it? How can you not do it?

"Why are these people around me? Why can't you — it's like the song, isn't it? Why not love the people you're with? I mean, what else are you going to do with your life? Like, what else is there?

"I'm constantly thinking about Natalie and Charlie and Jake. How do I, like, disappear so they have to fend for themselves at the right moment?

"They need to know I care about them.

"If I wanted a business, it would be fucking easy. But I want art, you know."

Daniel pauses, then laughs, realizing he has reached a perfect conclusion. "Exclamation point," he says, and the conversation is over.

Terry Childress, 2018

On the last night, Daniel gathered his apprentices and the Irish film crew around the wood-fired oven that he and Charlie built behind the kiln shed. Kate, just back from teaching at Alfred and about to leave for Denmark, rolled the dough for pizzas. Daniel baked them in the oven and served them to his guests. We sat in the dark beneath the trees, the night sounds around us, eating pizzas and drinking the delicious, indigenous moonshine. Pat Collins told me he couldn't imagine a more perfect setting for a film on the virtues of work by hand.

By early September, half of the columns have been made. "The barn looks like a forest of pillars," Daniel says on the phone. From the first firing, he learned that the columns were heavier than he thought they were, harder to move. He remains uncertain, but it seems increasingly likely that a tall temporary kiln will have to be built down by the barn. Terry Childress has gathered enough old blocks and bricks. Terry, a competent mason, could direct the construction, and there are always people around, Daniel says, who want to learn how to build a kiln. The apprentices have been loyally productive and he is about to give them a day of rest at the beach. It is, Daniel says, "a worrisome time full of stress," but things are in motion.

Five weeks later, in the middle of October, nearly three-quarters of the columns have been made and half of them have been fired. To fire the tallest columns, Daniel has designed a "funky" new kiln. With Terry Childress directing the work, the brick arch is nearly complete. The chimney has yet to be built,

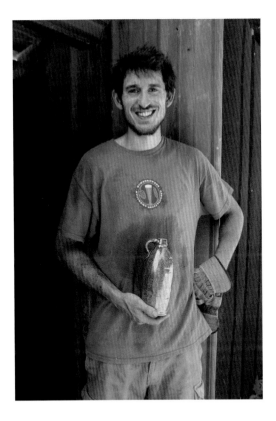

Hamish Jackson at Mark
Hewitt's kiln, 2018

but Daniel hopes the kiln will be ready for firing in December. Urgency is in the air, the weather is cooling, and if the temperature drops below freezing, the damp columns in the barn will freeze, crumble, and collapse. Meanwhile, windy wet storms have disrupted the firing of the old kiln. Problem upon problem: Daniel's project is taking on the dramatic intensity of Benvenuto Cellini's vivid description of casting his bronze *Perseus*.

Everyone is worn out, Daniel says, morale at the moment is low, but the difficulties have made him a better man. Like an athlete in training, he is eating better, drinking less, and testing his body to the limit of its capacity.

As it was with the Big Pot Project, Daniel is in the lead, his team is expanding. He hired two laborers. One asked for an advance, got it, and disappeared. The other is a reliable fireball of energy. Mark Hewitt generously released his apprentice Hamish Jackson for two weeks. Hamish, a pleasant upbeat man from England and a skilled potter, wanted to learn Daniel's technique for making big pots. He came, learned, and turned columns for a fortnight. On the weekends, Hamish and Mark's other apprentice, Stillman Browning-Howe, come to help. Julie Rose Hinson, who usually works with Sid Luck, appears occasionally to roll piles of coils. Paying for help is expensive, Daniel says, but worth it.

Earlier in October, when Linda Dougherty, Chief Curator at the North Carolina Museum of Art, came for a visit, she was, Daniel says, "blown away" by what was happening. He boldly told her, "This is something that's real, that's really art. This is a big deal, not just another sculpture for your garden." She agreed, Daniel says, calling the project epic and saying that Daniel's installation will "alter things from now on in the world of ceramic art."

When I asked Linda Dougherty for her opinion in her own words, she wrote that the "determined line of columns, marching across the meadow, reveals questions of walls, borders, and boundaries, and how we move through the world, both literally and metaphorically. Pushing the conventional boundaries of craft and pottery, Johnston has expanded his practice into large-scale installations that transform familiar forms into unexpected and awe-inspiring experiences for the viewer."

Now, in the middle of October, the museum's curators — leniently and generously, Daniel says — have agreed to a new schedule. In the beginning, Daniel planned to finish by Thanksgiving. Then he talked about December. Completion is now set for March, the right time for landscaping the space around the line of columns.

The new schedule has relieved some of the pressure, and, Daniel says, "Things are weaving together." A month later, in the middle of November, we are back with Daniel in Seagrove.

Charlie and Natalie are repairing the old kiln's chimney. The new kiln's shed has been framed next to the sawmill on the lane leading down to the barn. Along that lane, in front of the log shop, eighty columns, all of them finished and fired, run in a cluster. The tallest columns have all been made and they stand, dry enough to resist the frost, inside the barn.

"We've got about a week's worth of work to finish the kiln, the new kiln," Daniel says. "Hopefully we'll be done next week and we'll be able to fire it a couple of weeks later.

"And we'll fire it with eight big pillars to begin with. And if that works, if I can see how the kiln works, then maybe I can expand the number up to sixteen pots. The truth is we only have about forty of the largest pillars to do, so even if we sneak in ten that's only four firings.

"So if we get a firing in December, we should have no problem finishing on time."

Eighty finished, the tallest forty ready. Of the remaining columns, all are shorter, less than four feet tall, some as low as eight inches. Some of these have

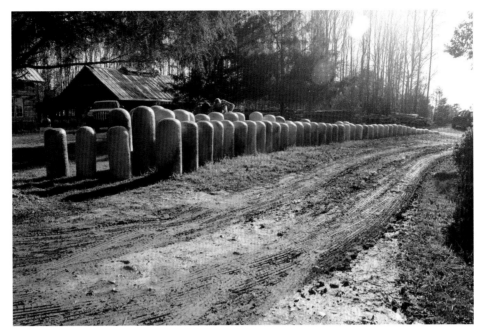

Fired and finished columns line along the lane, November 2018

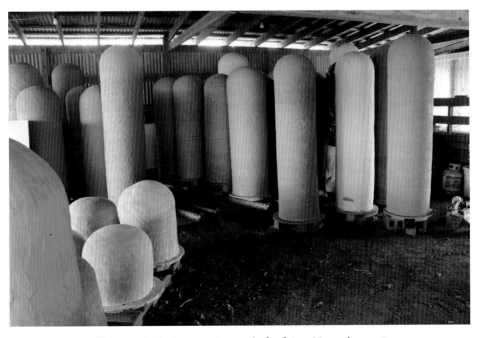

Columns in the barn getting ready for firing, November 2018

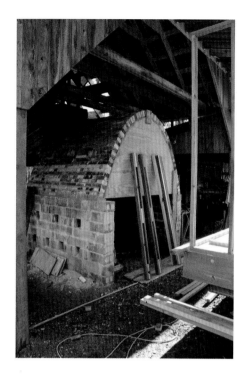
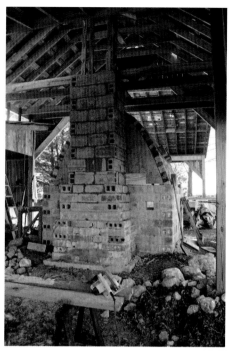
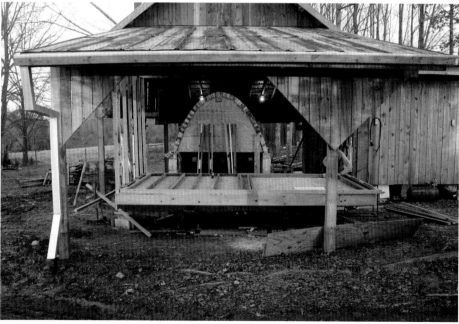

The new kiln under construction, November 2018

already been made and they wait in the barn. For the last thirty or so, Daniel will move his apprentices back into the warm log shop where these shorter pillars can be comfortably made. The apprentices can make about five a day, and all will be fired in the big old kiln.

"It's all weather-dictated," Daniel says. "The timing is tricky, but by the new year, I hope to have made and fired all the small pillars, and to have fired the new kiln at least once.

"In December and January we'll be firing the kilns a lot, which is really fantastic because cold weather is perfect for firing."

Beneath these technical considerations, there lies a deeper aesthetic concern. Planning demands numbers. Initially, the installation was said to be four hundred feet in length, then the number went down to three hundred and fifty. The plan calls for two hundred columns spaced four inches apart. But, as made, the columns are heavier, wider than intended, so to preserve the look of Daniel's artistic composition, the number of columns or the width of the negative space between them will have to change. Numbers must yield to visual affect, and for that reason, Daniel says, he remains intentionally vague about the numbers:

"I've not told anyone about it, because I haven't wanted to explain the aesthetic quandary I'm in. I have to make a personal decision about the work; it's not a committee decision, you know.

"But that's why when anyone asks about the numbers, I seem vague. I haven't quite decided yet.

"The pillars are wider, and I don't know if the space between them needs to be four inches, or if it should be more or less.

"That space between them is more important than the damn pillars themselves.

"And think about this. If you see a picture of Tiananmen Square in China, you see thousands of people bunched together really tightly. Okay. It has an impact.

"But if you see a single line of people standing in a food line during the Depression, the separation between them is way more emotional. And it's the space around them that allows you to see them as individuals.

"And when you see thousands of people gathered and pushed together, you see them as a whole, and it loses that impact.

"And that space between the people in food lines has always struck me by how devastating it is. You're able to see the individuals.

"And when this project is done, then you'll recognize how phenomenal each of these pillars are. They will not become individuals until they are all together in a line.

"And they will make a powerful statement about humanity. Individualism is explored through community, through union."

To represent humanity is the goal. The columns have to stand close enough to represent community, yet far enough apart to represent individuals. Daniel's problem now is to fix the number of columns and set the space between them before the contractor digs the trench for the foundation and fills it with concrete, establishing the locations of the columns with rods of rebar. That work is scheduled to begin in the middle of December before all the firing is done. Then Daniel and his apprentices can install the columns during February, at the rate of a dozen a day, and the job should be finished in March, so long as February grants them good weather.

Continuing on the course of his creative commitment, Daniel has run into problems that have left him standing alone.

"Right now," Daniel says, "I'm right on the edge of what I can do. There's been a lot of learning, and I've really come into myself.

"I've become internal. The higher you get up that mountain you're climbing, the fewer people there are to talk to.

"I feel really lonely to be honest. I'm incredibly lonely.

"To be alone in a room by yourself, you can be lonely and there's an explanation for it, a very logical one. But to be surrounded by people constantly and still to be lonely, it doesn't make sense, you know, from a human perspective.

"Both situations are difficult, I know, but it seems there's a larger difficulty in being surrounded by people and feeling so lonely.

"I'm not trying to sound heroic, and I'll get used to it, but it's surprising. Glorious is how I should feel, and I'm not disappointed with myself. I can't stop. That would kill me. I can't stop.

"But I'm feeling so fucking lonely. I just don't have anyone I can talk to about the work."

Daniel has spun himself out of the orbit of tradition. In tradition, creators find an accumulation of solutions and models that guide personally satisfying actions and enable easy communication among colleagues. When Daniel was learning and working in the tradition of Leach, Cardew, and Hewitt, he could go to Mark with questions. Once he had set up his own shop, he could talk with Mark and the other potters around him about technical and commercial

Sunset over Randolph County, November 18, 2018

matters. But now, out beyond the reach of traditional precedents, he stands alone with his problems.

One is the proper spacing of the columns, a problem that — right now as I write, a week after we talked — only Daniel and I know about. The other problem is known to the people around him, but it is Daniel's alone to solve, and that's how to lift, move, place, and fire the gigantic pillars. Daniel designed the kiln. Terry directed its construction. Mark Hewitt came, looked at the kiln, and wondered if it would work — a deeply disturbing thought, but it will certainly work, Daniel says, though he has yet to fire it. His apprentices are apprehensive, worried about the whole process, but Daniel remains courageously confident. He has no other choice.

Our talk is done and we are sitting together on a pile of lumber, watching the sun roll over the edge of the world in western Randolph County. Low on the horizon, blue fades toward lemon and above us the heavens streak with russet and scarlet in a sweep of color as magnificent as the one Frederic Church caught in *Twilight in the Wilderness* when he was watching the sky back in 1860. Slowly now, as darkness silently drops, the first stars prick the black and shine.

The "rocky road" that stretched before him into the new year took the course Daniel had imagined, but motion along it was slower than he had hoped. Cold wet weather came down. Work on the foundation, provisionally scheduled for the middle of December, started a month later on the sixteenth of January, when, in quick efficiency, eighteen men dug the trench and filled it with concrete.

Before they began, Daniel arrived early and watched the sun rise over the site. A crimson notch burned in the eastern horizon, long black shadows rolled the hills into relief, and he was struck by the beauty of the land and his duty to leave it better than he had found it. "I had to stand before God and explain myself," Daniel said. As though he were a devotee of Ogun, the fiery divine smith of the Yoruba people, Daniel accepted the inevitable collision of destructive and creative forces. He was responsible for "the scar on the land" that marked the death of the natural place and he was obliged to bring forth the birth of a new cultural place. "Art," he told me, "is a celebration of the self, but what I'm doing is bigger. It's a celebration of mankind." His task was to act honorably toward the land and to "push toward a celebration of mankind," the human presence on the land.

Finished columns wait in the rain outside Daniel's shop, March 2019

Then it rained, rained so relentlessly that the ground around Daniel's shop was trampled into the swampy muck of a muddy battlefield. Boots became cumbersome clods of sodden clay; work clothes refused to dry. It rained and it was cold, so cold that Daniel had to wrap the western face of his log shop with a sheet of plastic to cut the wind. Plans were disrupted, progress stopped.

Daniel had been there before. During the Big Pot Project and while he was working toward his exhibition in Santa Fe, he also got stuck in a perilous pause before the final dash to the finish. But this time, he said, "Maybe I've bitten off more than I can chew," and weary and worried, distressed and distracted, he was given a firm date for completion, the first of April.

Now, with only a month to go, with all of the pillars made, but the biggest ones still unfired and none of them emplaced, we are sitting at his kitchen table, the recorder is running and Daniel begins by saying:

"It's the beginning of March, and I'd hoped to fire the new kiln before now. But I started to become really worried about the quality of the firing.

"And I had to stop and give the kiln everything I had, aesthetically as well, or I would feel like I was cheating myself and it would be bad for the pillars, long term.

"So, I think everybody is panicking because of the length of time it's been since we started the kiln, but I knew that if I didn't stop and do it correctly that it would be devastating for the project. My time that I'm spending on it now is what's going to make the project good. It has to have integrity all the way from the clay through the kiln.

"I'm staying up days at a time, trying to get everything done, to get the new kiln fired, and I'm exhausted.

"I'm exhausted, but it's one of the happiest times of my life. Every waking minute, I'm dong exactly what I want to do."

What he wants to do is work his brain, to face problems and solve them. There is no time now to build another kiln, no time to make replacements for columns destroyed in faulty firings. This kiln has to work, so Daniel designed a portable firebox that can be lifted with the Bobcat and placed in front of the kiln to ensure complete control of the heat and flame. Joe, Daniel's brother, is a skilled mechanic, and Daniel borrowed Joe's tidy shop to build his firebox in two sections. To belong to this grand project, the kiln must work well and look good too. Daniel could have supported the kiln's sides with an iron frame, but that would have been ugly, so he took the time to build faceted buttresses instead. Then if the kiln works like Daniel thinks it will, he will get four firings,

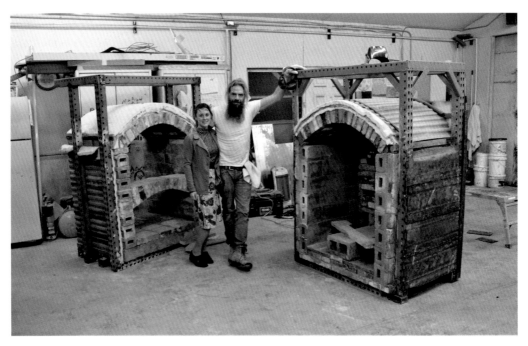
Kate and Daniel with the portable firebox near completion, March 2019

back to back, and all the tallest columns will be ready to install close to the first of April.

The time lost in perfecting the new kiln will be balanced by the time saved with the new method of installation that Daniel developed in conversation with Tom Gipson, a "feisty and fatherly" expert in construction. Daniel says:

"We decided to use a clip system for the pillars instead of my original idea, which was to pour concrete into the pillars and stand them on top of the foundation.

"So, I designed this clip system that goes into the bottom of the pot. You put it in vertically and then it folds out horizontally to catch the bottom rim of the pot. And it's bolted to a clip that slides over an eighteen-inch circular foundation. Then there's a stainless steel band that wraps around the foundation and holds the clip down in place. And the clips will vary in size and weight, depending upon the size of the pot.

"That's going to increase the speed of installation by a magnitude. What was going to take two months to install is going to take three or four days now.

"It's going to be a clean job, and I'm really pleased with that."

Let me explain. On the grounds around the North Carolina Museum of Art, across a gentle southward slope, a straight trench dips, rises, breaks at the point where a small hill will be built, and then continues eastward toward a path. Down in the trench, a concrete foundation steps along with the land.

The foundational scar on the land, looking eastward across the grounds around
the North Carolina Museum of Art, March 2019

The sequence of concrete cylinders in the trench, looking westward, March 2019

The columns destined to stand here were planned to be sixteen inches in diameter with four inches between them, but they are eighteen inches in diameter and they will be separated by two inches, so low circles of rebar poke out of the sweep of concrete on twenty-inch centers. Over these circles of rebar, Daniel placed hollow, cylindrical sonotubes of sturdy cardboard, keeping them in line with a temporary wooden frame in the trench. Filled with concrete, the cylinders in series will provide an independent circular foundation for each pillar, a stubby column beneath the lofty one. All that was done by the first of March.

Next, Daniel will insert two pierced blades through the hole, five inches in diameter, in the bottom of the column. A bolt through the clip will rise to thread through the holes in the blades, pulling them down and trapping them above the rim inside the pot. The clip is a metal strip, staple-shaped in profile and designed to straddle the cylinder and extend downward on opposite sides, like a rider on a horse. When the column is lifted into position, the clip, fixed to the pot's bottom by the bolt through the blades, will slide over the concrete cylinder, from which the cardboard skin has been stripped. A steel band, tight-

ened around the cylinder where it is clasped by the clip, will hold the clip, and the column with it, firmly in place. Attached by the clip system, the column will stand on a concrete cylinder that is anchored by rebar into the concrete foundation at the bottom of the long trench. The installation will be permanent, and Daniel has a great many blades and clips to hammer into shape.

It is "artist talk," says Daniel, to use easily remembered round numbers when describing a project, so he told folks that the installation would have two hundred columns. Now that he has worked with the land and taken exact measurements, the actual number can be revealed. There will be one hundred and seventy-eight pillars, plenty enough to make his point, and what remains to be done seems clear.

The view forward is filled with anxiety and hope. The job of the moment is filled with the pleasures of labor and learning. As Daniel flows into his creation, it takes shape, then it separates from him and teaches him how to make the next move. Now, Daniel says, "The project is starting to manifest itself, and it's starting to have its own personality.

"And it's starting to leave me, and there's a great deal of joy in being able to see that. And there's a great deal of sadness in watching it go out of myself and into the world.

"So, I'm indulging, I'm indulging myself in the beauty of this birthing process. But I'm well aware of the consequences of seeing what has gone out of me into the world.

"And there will be a joy that I've never experienced, but I fear the pain of it being gone.

"It's not that I don't want to finish it. It's an awareness that I've never pushed myself this hard, or attained such a level.

"There's a fear that I haven't faced such depression either. I've never experienced the level of depression I might feel. I'm a little worried about that.

"I've never felt — when I did the Big Pot Project, I felt it being born, and I experienced it, and all that happened in four hours. This is exhilaration on that level, but it has lasted for weeks, and I have weeks to go, and there's nothing but great things ahead when I finally see the pillars going up.

"It's crazy. Everything I've done for the past twenty years has been worth it because of the last two months of work."

During those months he wasn't alone, and, near tears, he pauses in the run of his talk to say how grateful he is to Charlie, Natalie, and Jake. Though Jake came late, Charlie and Natalie were there when the project began, and now in

the third year of their apprenticeships, they are — as Daniel was in his third year with Mark — comfortably confident in their work. Daniel is pleased that all of them have preserved the peculiarities of their personalities while collaborating generously, maturely, and smoothly.

"This is a real beautiful period," Daniel says, "because we understand each other without talking. And we work for hours together without communication or watching the clock.

"And I can tell that this thing is being born and pushed out because they feel it too.

"And it's powerful, so powerful that all of us are feeling the conclusion. It's as if you're waiting for an earthquake, and how do you get ready for an earthquake? You can see the time ticking down, but how do you prepare for the world to shake out underneath you?

"It's unanticipated, but it makes sense when I look back and see all the work that's gone into it. I'm happy to honor this thing that is being born. And I'm able to resist all the pressure from the outside world to get it done, and to protect this little thing that's being born and allow it to give me everything it has, like I've given it everything I have.

"That exchange will give me the next project. I've given it birth, and it has given me the next project. That's what it has given me.

"It has given me all the information I need about how tradition and industry meet. And I've happily absorbed it all, opening the door for projects without boundaries."

When, at the end, he spoke of the future, Daniel envisioned a method in which tradition and industry mesh. Early in his career he called himself a folk potter, and Daniel will hold to North Carolina's tradition, using the natural materials of his rural place, throwing forms on the wheel, then slipping, glazing, and firing them with wood in a cross-draft kiln. At the same time, familiar with machinery and power tools since the days of his boyhood on the farm, Daniel will employ industrial techniques as he did in building his portable scaffold with its jacks and free spinning wheels, as he did in constructing his portable firebox to increase control over the flame, and as he did in developing the clip system that speeds the process of installation. The old and the new will fuse in future works, boundless in their reach.

With creative energy roiling in his brain, Daniel, like many an artist before him, was thinking about future projects while the current project remained undone, but it had to get done, and it did.

The new kiln was fired successfully in the first week of March. "I had to believe it would work," Daniel said on the phone, "but really I didn't have a fucking clue. But the kiln was brilliant, and the firebox I designed worked absolutely superb." That was the turning point, Kate later said; the mood swung from fear to confidence. The second firing finished on the twenty-fourth of March, and as Daniel had hoped back at the beginning, he found he could burn sixteen giants at once, so there was no need for a fourth firing. The third and final firing ended on the eighth of April. Meanwhile, a hundred pillars had been trucked to the site, and the first six were installed on the twenty-ninth of March.

"This was an adventure from the start," Daniel said at the time. "Jake is on board. Natalie and Charlie are going for it, and the energy is incredible.

"This is bigger than me. I didn't do it; it exists on its own. It's bigger than we are, and I'm thrilled."

The pillars went up in April. Using the trusty old Bobcat, Daniel and his team moved the pillars and laid them in sequence next to the foundation. For each one, they placed its clip, one leg down, on top of its concrete cylinder, marked the width, and hammered the second leg down. Then they fixed the clip, single for small columns, double for large ones, to the bottom, and lifted the column into place with the Bobcat, finishing the job by tightening a steel band, single for short columns, double for tall ones, around the foundational concrete cylinder. The process, Charlie told me while I watched, is clear in concept, but, like everything in this project, stressful and difficult in execution.

Installation in progress, April 2019

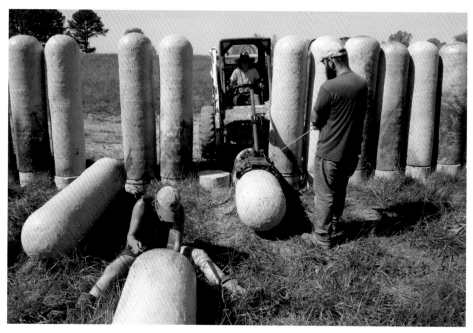

Natalie affixing a clip while Charlie, in the Bobcat, and Jake prepare to lift a column

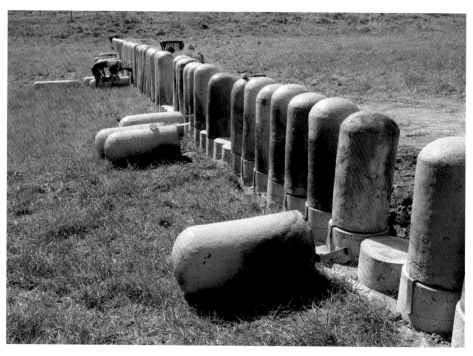

Looking westward: the line of columns with the apprentices at work, April 2019

The clip bolted through the blades in the pot's bottom

The clip in place

Steel bands around the clip and the cylindrical concrete foundation,
April 2019

With Charlie and Jake helping, Daniel places a column
with the Bobcat, April 2019

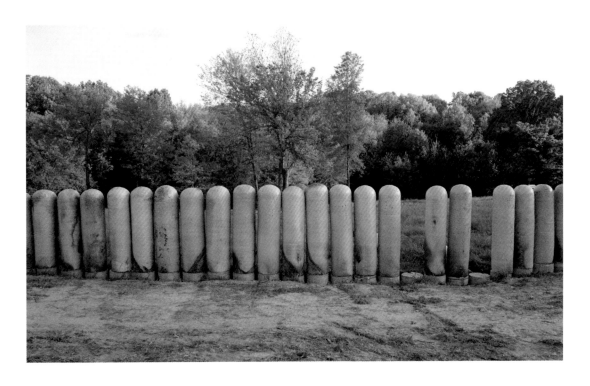

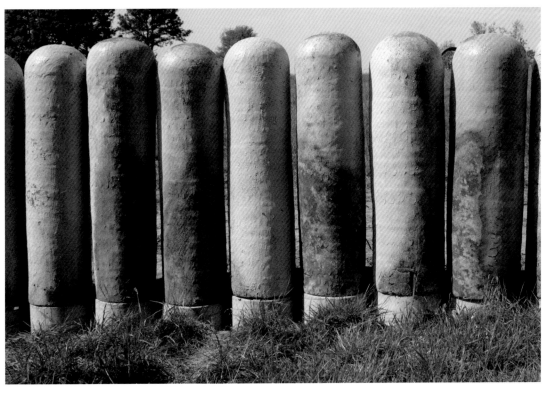

Columns installed, April 2019

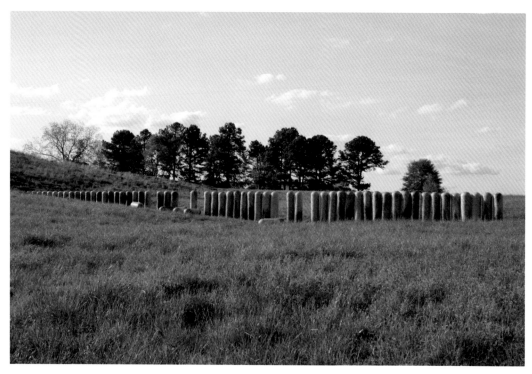

Daniel Johnston's installation, April 2019

As the pillars rise and march, one after the other across the land, they realize in three dimensions the drawings Daniel made a year before. He told me he could adjust their heights with shims, but his measured plan was so accurate that few changes were necessary, and now, before the installation has reached completion, the sweep of columns already displays the universal human duality, implicit in all great works of art: the simultaneous realities of the social order and the lone individual. Stand back, and the columns assemble into the social union of community. Go close, and every column is different, an individual. Shaped by hand and fired with wood in a free method that welcomes the accidental, each column is distinct in form and surface — tall or short, straight or swaying, blackened or bright, slick, rippling, scaly, and bubbling with life.

The last pillar was firmly in place on May 4, 2019. While Daniel, compelled by commitment, was in the midst of his exhilarating rush to completion, Mark Hewitt came, shook Daniel's hand, and warmly congratulated him. A couple of weeks earlier, Mark had written me a letter, saying, "I am in awe of Daniel's talent and drive, and especially of the way he has combined his foundational building skills with his potting prowess to create his signature installations. His magnification of scale is breathtaking."

Surface details of installed
columns, April 2019

Daniel was moved by Mark's visit. "This project is bigger than me," Daniel said, "and I share it with my teacher. I have my teacher back." Daniel was looking forward to helping with the hundredth firing of Mark's big kiln, preparing for the celebratory kiln opening on the twentieth of April when special commemorative pots will be sold, when Louise Cort, Terry Zug, Chris Benfey, and I will speak in praise of Mark's profound contribution to North Carolina's ceramic tradition, and when the apprentices trained by Mark and Daniel will gather for a good time.

On the day before Mark's grand event, on the day Daniel turned forty-two, we set up the recorder in his home so Daniel could look backward and forward to frame a conclusion.

Daniel begins by saying how touched he is that Natalie, Charlie, and Jake shared his anxieties over the course of the project. "That has changed my life. I'm a lot softer inside. I feel like more of a man, and it's quite beautiful that they were worried too.

"This project is done in my body. I feel removed now, and I have space inside me. I can look back and see how simple and easy it all was in hindsight. And I can see how creating it all was so difficult.

"It's taken a toll on my body — and on everything. In things that are hard and worthwhile, there's a payment due always.

"It's like the Big Pot Project, you know. It's a very big turning point in my life that will change me, but in magnitude there's nothing else that's been comparable so far.

"And that, that's an acknowledgment to me that I'm moving in the right direction. And I'm thinking differently about my work."

In thinking about his work in the future, Daniel feels no need to escape tradition. "I think if you understand tradition, you'll never deny it. I think if you understand it well, you'll never have to deny it. Tradition is the only thing that gives you the strength to evolve." But by solving the problems that arose during his project, Daniel gained a view that widened beyond the precedents set in his training:

"Part of what's made all of this so difficult is to have been trained for twenty-five years or so to think about moving forward in the context of craft and traditional ideas of pots.

"This project has given me a switch inside, so I can switch perspectives, and I don't have to view the world through the lens of my training.

Daniel, Charlie, Natalie, and Jake, April 2019

"And that's what has been so difficult. It's not the engineering of the wheels. It is to get rid of what I think a wheel is. To be able to actually build the one I need.

"And that shift has been thoroughly made. Why did I think the pillars couldn't be over six feet tall? It was because I was looking through the lens of my prior training. But now I have a kiln that lets me create pots nine feet tall.

"I'm ready to move on, and I'm not scared about the world. It's wide open."

Having sketched a future practice congruent with his conclusion in March when he said he intended to combine traditional and industrial techniques, Daniel pauses in thought, then looks back in gratitude to his mentors, Mark Hewitt and Louise Cort, and he says that I filled that role during the time of this grand project. Our regular visits and the questions I asked as I wrote caused Daniel to think about what he was doing and to stay on track. I will humbly deny it, he says, being, like him, a Southerner, but he tells me, "You have been the white lines on either side of the road during the movement forward." He goes on:

"You writing the book while I was doing the project was probably as important as anything that happened, as important as the placement, the funding. You hold the world to a standard because you hold yourself to a standard, and that has become part of my process."

The talk that followed deepened in emotion. The word "love" arrived without embarrassment. Then Daniel returned to the view forward, speaking of his installation's future:

"I think there's a moment that hasn't happened, and I keep telling everybody that nobody has seen this project yet. Nobody has seen what I have seen.

"And that moment's coming very quickly. And I know — we have half of the pillars up, but it's nowhere close to half of what you'll see in the end.

"I don't know what's going to happen after that. I won't care to experience it, but I've waited this whole forty-two years to experience it. And it's coming very quickly.

"I think I can estimate more than anyone else what it's going to be. I keep telling everyone it hasn't happened yet. All the physical pieces are out of me, you know, but the infant's soul is not there yet.

"I don't miss it yet. I'm glad for it to be over, but I don't miss it yet. I haven't, like, collapsed in tears and mourned its departure.

"And I don't know what it's going to be, because I don't own it anymore.

"And I don't know how many years it will take for me to tell you what it is. That's the beautiful thing about the work not really being about me.

"It has moved through me, and it has moved through a lot of people, including you and Pravina.

"There is a force and power that is moving through all of us. I'm not controlling that. I'm not trying to.

"Now I'm experiencing the first few days out of jail, after being in there for a year, and I can see the moon and the stars and taste food again.

"I've really tried not to think about it."

Tears appear in Daniel's eyes.

"It's quite difficult. It's quite difficult imagining the project not being in my life anymore."

The tears flow, the words fail, the room is quiet.

"It's quite difficult," he repeats and begins to recover his balance:

"It's going to be gone. I can feel it, and I fear that I won't have the strength to move on, and let it live its own life so I can live mine.

"But I know who I am, and I know I will have the strength to move forward, and I hope the next projects keep getting better and harder and harder.

"And this one will be somewhere out in the world, becoming itself, you know.

"And that's the point. This is the moment I've been working toward for forty-two years.

"Maybe that's it."

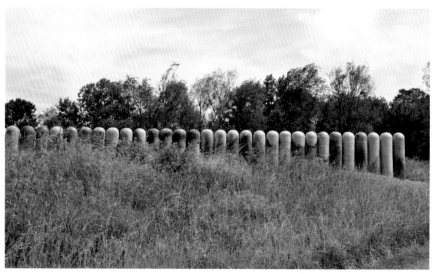

Daniel Johnston's installation, complete except for landscaping, June 2019

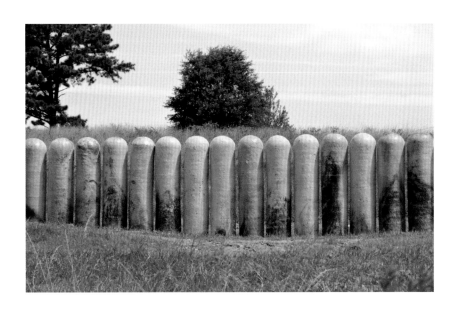

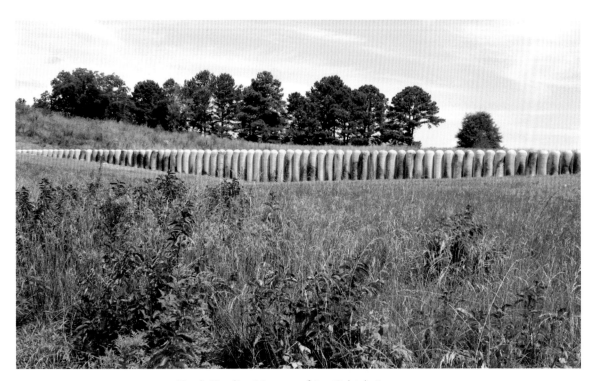

North Carolina Museum of Art, Raleigh, June 2019

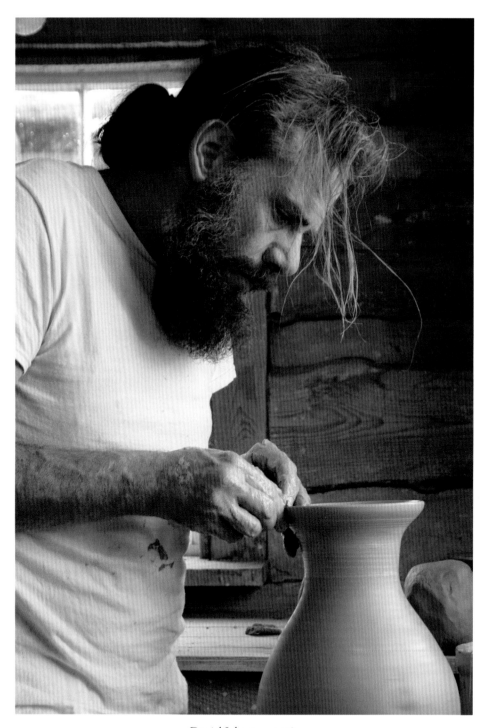

Daniel Johnston, 2018

AFTERWORD

Learning is a pleasure for me, as it is for Daniel, and I learn the most in the field. Though I have made my living in the university, I get away and into the field as often as I can. In the nineteen-sixties, I measured old buildings by day and recorded the singers of old songs at night in North Carolina, Virginia, Pennsylvania, and upstate New York. The seventies were for Ireland, for close ethnographic work in a borderland community during the time of the Troubles. In the eighties, big field projects in Turkey then Bangladesh turned my attention to ceramics and I began visiting potteries in the South, drawn by the fine books published in the eighties by my close friends and fellow folklorists Ralph Rinzler, John Burrison, and Terry Zug. The southern pottery tradition was in good hands. There was no need for me to write about it too; a little learning was enough. In the nineties, while my work in Turkey and Bangladesh continued, I also visited potters in New Mexico, Sweden, India, and Japan, Japan especially, and I was pulled southward by deepening friendships with Mark Hewitt in North Carolina and Chester and Matthew Hewell in Georgia.

At the end of the decade, when I published a small book, *The Potter's Art*, my main aim was to provide compact, updated summaries of the information on pottery from two big books published earlier in the nineties, *Turkish Traditional Art Today* and *Art and Life in Bangladesh*. I added reports of recent fieldwork from New Mexico, Sweden, and Japan, included a brief piece on Georgia, featuring the Hewells, and closed with a rhetorical flourish centered on Mark Hewitt.

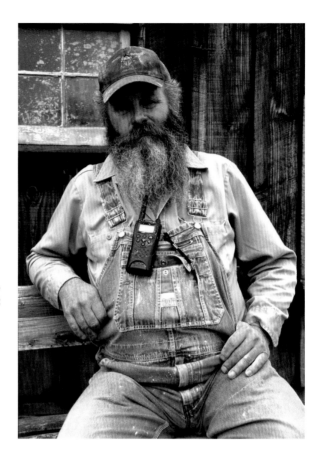

Chester Hewell, Gillsville,
Georgia, 2008

During the new century, work went on in Turkey, Bangladesh, and Japan, and I began doing fieldwork in Italy, excited by the parallels in history and production between Italian *maiolica* and Turkish *çini*. In this century's first year, I got a chance to visit potteries in northern China, and in that year, when he was still Mark's apprentice, I met Daniel Johnston. Trips to the South increased, taking me frequently to Daniel's place, and in 2012, knowing that I had written a couple of brief bits about Mark, Daniel asked me to write about him.

Immediately we started a series of recorded interviews. I watched Daniel at the wheel, and I could have quickly concocted some prose of praise. But I was in the midst of a big field project, in collaboration with my wife Pravina, on the working-class artists of northeastern Brazil, potters and sculptors, painters and smiths. Writing about Daniel would have to wait, and the delay was beneficial. I kept visiting North Carolina, usually with Pravina beside me, watching what was happening, interviewing Daniel and other potters as well (check out the list of oral sources that precedes the bibliography). My understanding deepened and broadened.

Maria Tomassini and Antonio Margaritelli with a *maiolica* plate they made
in Antonio's atelier, Deruta, Italy, 2012

Mehmet Gürsoy, Kerim Keçecigil, and Muradiye Çelik with a *çini* plate they made in Mehmet's
atelier, Kütahya, Turkey, 1995

Self-portrait by
Daniel Johnston, 2018

When in the fall of 2017 our Brazilian book was finished, I leafed through the seven thick notebooks I had filled, read over the hundreds of pages I had transcribed from recordings, reviewed the two thousand or so photos I had taken, and, though my initial intention was more modest, I thought I had enough to write a book worthy of Daniel. Coincidentally, Daniel's life had completed an arc with his installations. One phase had ended, he said, another had begun. Daniel had arrived at a point where a book could end, and I had a story to tell.

I was ready. When Daniel asked me to write about him, I had most recently published a book on the life and art of the Nigerian painter Prince Twins Seven-Seven. Twins got his book, then died in 2011, and I miss him. Twins was my pal, as Daniel is now. I recorded many long interviews, observed him at work, and traveled with him through Nigeria, meeting up with the babas in the bush and visiting the places — Ijara, Ogidi, Ibadan, Abuja, and Oṣogbo — that figured in his story.

My book about Twins, which prepared me to write about Daniel, belongs to a folkloristic tradition of writing that generally involves fieldwork and brings specific biographical facts into conjunction with general concerns about creative processes and products.

Prince Twins Seven-Seven, 2008

Taking inspiration from anthropological life histories that bring individuals into connection with cultural patterning, and from biographical writings by and about artists that bring individuals into connection with aesthetic principles, we folklorists have written about narrators, singers, and makers. The resulting works are not properly ethnographies or biographies, but integrations of the ethnographic and the biographical designed to yield understanding at once of individuals, their cultures, and their arts. To give this variety of writing a name I'll borrow Joyce's word "portrait."

I am not being tricky — Daniel would say cute — when I twist Joyce's title into a subtitle for Daniel's book, *A Portrait of the Artist as a Potter in North Carolina*. Read the long fragment of the first draft — titled *Stephen Hero* after the old English ballad "Turpin Hero" (see *Portrait*, p. 252) — and you will find that in writing *A Portrait of the Artist as a Young Man*, James Joyce jettisoned digressive biographical details to shift from the merely personal toward the place where the personal, cultural, and artistic meet — closer, that is, to the center located in folkloristic portraits like my book about Twins or this one about Daniel.

Dylan Thomas parodied Joyce's title for his own story, *Portrait of the Artist as a Young Dog*. In it, ten artfully contrived and chronologically ordered mem-

ories bring the poet to the point where artistic orientations are set but the great work lies ahead. That's the point Stephen reaches in *A Portrait of the Artist as a Young Man*. We're waiting for *Ulysses*. Daniel has gone farther, his second phase began with the installations, parallel, say, with *Dubliners*, but he is done with the columns, he says, and greater things are promised. In the far future, some biographer might do for Daniel what Ellmann did for Joyce. Meanwhile, we have this tale of the beginning and the portrait of a fully developed young artist who makes pots in the eastern Piedmont of North Carolina.

To get it done required recording and transcribing many lengthy interviews (maybe ten percent of that transcribed material appears as quotations in this book), making detailed notes during every visit and phone call, taking more than enough informational photographs (more valuable as documents than as illustrations), reading many books I'd long wanted to read, and enjoying the tasks of writing and design while crafting a book that implicitly demonstrates how I think fieldwork should be done.

And to get it done, I needed help, as Daniel does in firing, and I am grateful to many:

To the potters, to Daniel Johnston, Kate Johnston, Mark Hewitt, David Stuempfle, Chad Brown, Sid Luck, Terry Childress, Vernon and Pam Owens, Ben Owen III, Kim Ellington, Matt Jones, Alex Matisse, John Vigeland, Joseph Sand, Bill Jones, Michael Hunt, Naomi Dalglish, Natalie Novak, Charlie Hayes, and Jacob Craig in North Carolina; to Chester Hewell, Matthew Hewell, and C.J. Meaders in Georgia; to Winton and Rosa Eugéne in South Carolina; to Bryce Brisco in Tennessee; to George Johnson in Pennsylvania; to Wanda Aragon and Lilly Salvador in New Mexico; to Rosalvo Santana, José Fernando Marques da Silva, and Antônio Pimpo in Brazil; to Svend Bayer, Clive Bowen, and Magdalene Odundo in England; to Lars Andersson in Sweden; to Maria da Graça in Portugal; to Antonio Margaritelli, Gianni Marcucci, Chiara Bonini, Marino, Marzia, and Tania Pallanti in Italy; to Ahmet Şahin, Ahmet Hürriet and Nurten Şahin, Ibrahim Erdeyer, Mehmet Gürsoy, Sıtkı Olçar, Kerim Keçecigil, Ömer Cesur, Osman Kaya, and Sabri Yaşar in Turkey; to Alagar Chettiar in India; to Haripada Pal, Amulya Chandra Pal, Maran Chand Paul, and Muhammad Ali in Bangladesh; to Liu Lizhong and Sun Xiuquing in China; and to Agawa Norio, Tatcbayashi Hirohisa, Higaki Hachiro, Matsumura Takuo, Maekawa Denko, and Kato Susuma in Japan.

To the writers on pottery, to Terry Zug, John Burrison, Ralph Rinzler, Mark Hewitt, Louise Cort, Takashi Takahara, Garth Clark, Young Dong Bae,

Nancy Sweezy, Chris Benfey, and Charlotte Brown. Terry Zug generously read a draft of this book, found a few mistakes, and I am especially grateful to Terry.

To the filmmakers, to Ralph Rinzler, Tom Mould, Jay Yager, and the Irish crew: Pat Collins, Colm Hogan, Bob Brennan, Tom Reynolds, and Roman Bugovisky.

To my masters who have passed, to Fred Kniffen, Estyn Evans, Jim Deetz, Bob Armstrong, James Marston Fitch, Hugh Nolan, Roger Abrahams, and Kenny Goldstein.

To my friends and colleagues, to George and Samantha, Nazif and Maha, Bill and Mary Beth, Ray and Lorraine, Tom and Brooke, Greg and Jennifer, Brandon and Ellen, Pat and Margot, Marius and Bobbie, Daniel and Kate, Mark and Carol, Terry and Daphne, David and Nancy, Steve and Denise, Michael and Michiko, John and Pat, Dave and Jessica, Jacob and Christina, Tim and Barbara, Judah and Rebecca, Vincent, Bob, Bill, Phil, Lee, Elliott, Karen, Michael, Gabi, Rich, Cliff, Doug, Jerry, Diane, and John.

To my friends at the Indiana University Press, Gary Dunham and Jennifer Witzke. Gary, the director, is an anthropologist and friend of folklore, who cuts through the difficulties and keeps things moving smoothly. Jennifer is a dear friend, an artist, and a master of the latest technology, who is a delight to work with during the process of design.

To our family, to Judy and Mike, Polly, Harry and Tsering, Lydia, Ellen Adair and Eric, Neeru, Divya and Paul, Bobby and Chris.

And most of all to my wife Pravina, colleague and companion, dove of the dawn and queen of my soul. A Buddhist monk in Japan declared us to be "the number one couple," and with love as the force between us, it seems he was right.

Big pot by Daniel Johnston in front of his shop, 2016

NOTES

CHAPTER ONE

P. 9. Mark Hewitt: Hewitt, "The Making of a Potter"; Hewitt, "Tradition is the Future"; Hewitt, "The Poetry in North Carolina Pottery"; Hewitt, "A Few of My Favorite Things about North Carolina Pottery"; Hewitt, *Great Pots*; Hewitt and Sweezy, *The Potter's Eye*, especially pp. 189–203; Zug and Hewitt, *Stuck in the Mud*; Millard, *Mark Hewitt: Potter*; Mecham, Francis, and Zug, *The Living Tradition*, pp. 58–64; Coulter, *A Unique Likeness*, pp. 12–15; Benfey, *Red Brick, Black Mountain, White Clay*, pp. 62–72; Benfey, *At the Crossroads*; Glassie, *Mark Hewitt: Outside*; Glassie, "Mark in Place"; Harrod, "The Artist as a Young Man"; Shapiro, *500 Percent*; Summers, "Making Mega-Pots with Mark Hewitt"; Korzon, "Studio Potter Mark Hewitt"; Lebow, "Mark Hewitt: Village Potter"; White, "Artist and Residence."

P. 9. Daniel Johnston: Johnston, *Pots from an Apprenticeship*; Coulter, *A Unique Likeness*, pp. 8–11; Brown, *The Remarkable Potters of Seagrove*, pp. 100–101, 106–107; Wiedemann, *Controlled Burn*, pp. 20–27; Compton, *North Carolina Potteries*, p. 80; Compton, *Seagrove Potteries*, p. 38.

P. 12. J.B. Cole and Nell Cole Graves: Zug, *Turners and Burners*, pp. 260 (quote), 437; Sweezy, *Raised in Clay*, pp. 175–81; Perry, *North Carolina Pottery*, pp. 70–73, 77; Lock, *The Traditional Potters of Seagrove*, pp.

116–23; Brown, *The Remarkable Potters of Seagrove*, pp. 50–59; Compton, *North Carolina Pottery*, pp. 128–33; Compton, *North Carolina Potteries*, pp. 53–54; Compton, *Seagrove Potteries*, p. 68. It's interesting that, on her business card for J.B. Cole's pottery, Nell Cole Graves called herself Master Potter at the same time that the deservedly famous Ben Owen, whose shop stood not far from J.B. Cole's, was stamping his pots Master Potter.

P. 13. Burlon Craig: Zug, *Turners and Burners*, p. 438; Zug, *Burlon Craig*; Sweezy, *Raised in Clay*, pp. 87–92; Wigginton and Bennett, *Foxfire 8*, pp. 209–255; Perry, *North Carolina Pottery*, pp. 77–80; Huffman, *Catawba Clay*, pp. 15–22; Beam, Harpe, Smith, and Springs, *Two Centuries of Potters*, pp. 96–101; Harpe and Dedmond, *Valley Ablaze*, pp. 67–102.

P. 15. Ben Owen III: Kay, *Built upon Honor*; Brennan and Clark, *Ben Owen III*; Glasgow, *Rich History, Vibrant Present*; Hewitt and Sweezy, *The Potter's Eye*, pp. 204–218; Mecham, Francis, and Zug, *The Living Tradition*, pp. 82–89; Perry, *North Carolina Pottery*, pp. 150–51; Coulter, *A Unique Likeness*, pp. 16–19; Brown, *The Remarkable Potters of Seagrove*, pp. 104–105; Wiedemann, *Controlled Burn*, pp. 68–75.

P. 15. Chad Brown: Brown, *The Remarkable Potters of Seagrove*, pp. 90–100; Compton, *Seagrove Potteries*, p. 38; Wiedemann, *Con-*

trolled Burn, pp. 4–11. The past of Chad's family is described in Burrow, *Growing Up Backwoods Southern*, where Chad's ancestor, the potter William Henry Chriscoe, is treated on pp. 139–47. His surname is diversely spelled; it is Chrisco in Zug, *Turners and Burners*, p. 437, and Crisco in Perry *North Carolina Pottery*, pp. 53–54.

P. 16. Vernon, Pam, Travis, and Bayle Owens: Brown, *Pamela and Vernon Owens*; Brown, *The Remarkable Potters of Seagrove*, pp. 110–11; Hewitt and Sweezy, *The Potter's Eye*, pp. 218–48; Sweezy, *Raised in Clay*, pp. 211–17; Mecham, Francis, and Zug, *The Living Tradition*, pp. 90–99; Owen, DeNatale, and Compton, *The Busbee Legacy*, pp. 29–36; Wiedemann, *Controlled Burn*, pp. 76–89.

P. 16. Sid Luck: Wiedemann, *Controlled Burn*, pp. 44–51; Perry, *North Carolina Pottery*, pp. 130–31; Brown, *The Remarkable Potters of Seagrove*, pp. 118–19; Compton, *Seagrove Potteries*, p. 67.

P. 17. Leach, Hamada, and Cardew at St. Ives: Leach, *Beyond East and West*, pp. 119, 139–49, 213 (quote from p. 148, repeated in Leach, "Introduction," p.7); Leach, *Hamada: Potter*, pp. 106–130; Leach, *A Potter's Book*, pp. 9–10, 29–31; Rose, *Artist-Potters in England*, pp. 9–13; Peterson, *Shoji Hamada*, pp. 28–29; Cardew, *A Pioneer Potter*, pp. 22–38 (quote from p. 29); Harrod, *The Last Sane Man*, pp. 43–62; Clark, *Michael Cardew*, pp. 15–25; Edgeler, *Slipware and St. Ives*; Whybrow, *Leach Pottery St. Ives*, pp. 19–31, 90–91; Whybrow, *The Leach Legacy*, pp. 6–17, 82–88.

P. 17. Svend Bayer and Mark Hewitt, apprentices with Michael Cardew: Harrod, *The Last Sane Man*, pp. 337, 340–41, 355, 358–59, 362, 379–81 (quote from p. 381); Harrod, "The Artist as a Young Man"; Svend Bayer quoted from Herold, "Michael Cardew," pp. 23–24; Edgeler, *Michael Cardew and Stoneware*, pp. 118–21; Grant, *North Devon Pottery*, pp. 174–75; Clark, *Michael Cardew*, pp. 81–82.

P. 18. Critique and solution: Leach, *Beyond East and West*, pp. 238–41. Attitudes consistent with his critique and solution can also be found in: Leach, *The Potter's Challenge*, pp. 22, 42–43; Leach, *A Potter's Book*, p. 25; Leach, *A Potter in Japan*, pp. 230–31; and Hamada offers a consonant opinion in Sanders, *The World of Japanese Ceramics*, pp. 9–10.

P. 20. Matt Jones: Jones, *Endurance: Potting in the Twenty-first Century*; Perry, *North Carolina Pottery*, p. 118; Compton, *North Carolina Potteries*, p. 85.

P. 20. Alex Matisse: Recker, "The Potter is Present: Alex Matisse's Creative Cycle of Intention, Accident, and Community."

P. 20. Joseph Sand: Compton, *Seagrove Potteries*, p. 59.

P. 20. John Vigeland: Larson, "The Art of Repetition: North Carolina Potter John Vigeland."

P. 23. David Stuempfle: Hewitt and Sweezy, *The Potter's Eye*, pp. 248–62; Coulter, *A Unique Likeness*, pp. 20–23; Brown, *The Remarkable Potters of Seagrove*, pp. 102–103; Compton, *Seagrove Potteries*, p. 86; Wiedemann, *Controlled Burn*, pp. 114–21.

P. 23. Kim Ellington: Zug, "Entering Tradition: Kim Ellington, Catawba Valley Potter"; Hewitt and Sweezy, *The Potter's Eye*, pp. 174–89; Mecham, Francis, and Zug, *The Living Tradition*, pp. 50–57; Huffman, *Catawba Clay*, pp. 33–36; Harpe and Dedmond, *Valley Ablaze*, pp. 115–24; Beam, Harpe, Smith, and Springs, *Two Centuries*

of Potters, pp. 104–105; Perry, North Carolina Pottery, pp. 95–96.

P. 23. Donna Craven: Coulter, A Unique Likeness, pp. 4–7; Wiedemann, Controlled Burn, pp. 12–19; Compton, North Carolina Potteries, p. 78; Compton, Seagrove Potteries, p. 42.

P. 23. Michael Hunt and Naomi Dalglish: Dalglish, "Pots, Purpose, and Place"; Carter, Mastering the Potter's Wheel, pp. 50–54.

CHAPTER TWO

P. 26. Clive Bowen and Svend Bayer: When the authors of books on English pottery turn to the rural potters of the present, they include Clive Bowen and Svend Bayer: McGara, Country Pottery (a fine book, by the way), pp. 114–15; Grant, North Devon Pottery, pp. 174–76; Edgeler, Michael Cardew and Stoneware, pp. 174–76. In 5 Devon Potters, Davies presents Svend Bayer, pp. 7–23, and Clive Bowen, pp. 42–59.

P. 27. Mingei: Leach, Beyond East and West, pp. 66, 84, 128–30, 144, 162, 175, 187–90; Leach, Hamada: Potter, pp. 94, 151, 162–64, 195; Kikuchi, "Hamada and the Mingei Movement"; Yanagi, Folk-Crafts in Japan; Yanagi, The Unknown Craftsman, especially pp. 101–108, 127–57, and the introduction by Leach, pp. 87–110; Munsterberg, Mingei, pp. 16–24; Moes, Mingei, pp. 19–30; Moeran, Lost Innocence, pp. 9–27.

P. 29. Daniel's great lidded jar: see pp. 156–59.

P. 31. Clive Bowen: Waterhouse, Clive Bowen; Edgeler, The Fishleys of Fremington, pp. 118–20.

P. 31. Cardew in Braunton: Holland, Fifty Years A Potter, pp. 4, 28, 47, 51–55, 61 (quote from the preface); Cardew, A Pioneer Potter,

pp. 11–17; Harrod, The Last Sane Man, pp. 38–39; Clark, Michael Cardew, pp. 11–12; Rose, Artist-Potters in England, pp. 16–17; Edgeler, The Fishleys of Fremington, pp. 84–106, in particular p. 104; Edgeler, Michael Cardew and the West Country Slipware Tradition, pp. 50–51; Edgeler, Slipware and St. Ives, pp. 23–25, 64; Grant, North Devon Pottery, p. 174.

P. 31. Braunton: Hoskins, Devon, pp. 346–47; Glassie, Vernacular Architecture, pp. 105–112.

P. 32. Svend Bayer: In Bayer, New Pots, Mark Hewitt published a fine essay on Svend and his art, "I Want to Lie Down and Sleep in its Shadow," saying many of the things he said to me in our interviews, the quote is from p. 7.

P. 34. The pot embodies the potter: Leach, A Potter's Book, pp. 18–19; Leach, The Potter's Challenge, p. 48 (quoted, repeated in Whybrow, The Leach Legacy, p. 6); Cardew, A Pioneer Potter, p. 30; Cardew, Pioneer Pottery, pp. 246–50.

CHAPTER THREE

P. 37. Modernism: My take on modernism is elaborated in the eighteenth chapter of my book Prince Twins Seven-Seven. To my way of thinking, these are among the key modernist texts: Ruskin, The Nature of Gothic; Thoreau, Walden; Morris, Hopes and Fears for Art; Morris, Signs of Change; Morris, News from Nowhere; Morris, Architecture, Industry and Wealth; Kandinsky, Concerning the Spiritual in Art; Kandinsky and Marc, The Blaue Reiter Almanac; Coomaraswamy, The Transformation of Nature in Art; Le Corbusier, Journey to the East; Pevsner, Pioneers of the Modern Movement; Synge, The Aran Islands; Yeats, The Cutting of an Agate; Yeats, Later Poems; Joyce,

Ulysses; García Márquez, *One Hundred Years of Solitude*; Beckett, *Waiting for Godot*; Lévi-Strauss, *Tristes Tropiques*; Leiris, *Phantom Africa*; Camus, *The Rebel*; Sartre, *Between Existentialism and Marxism*; Soyinka, *Art, Dialogue, and Outrage*; Rothko, *Writings on Art*; Newman, *Selected Writings*.

P. 38. Leach's life: Leach, *Beyond East and West*; Leach, *Hamada: Potter*; Leach, *A Potter in Japan*; J.P. Hodin's introduction to Leach, *A Potter's Work*, pp. 11–30; de Waal, *Bernard Leach*; Edgeler, *Slipware and St. Ives*; Sanders, *The World of Japanese Ceramics*, pp. 55–57.

P. 38. East and West: Leach, *A Potter's Book*, pp. 9–10, 16; Leach, *A Potter in Japan*, pp. 30–31, 63, 81–82, 134, 217–25; Leach, *The Potter's Challenge*, pp. 44–45; Leach, *Beyond East and West*, pp. 134, 163, 209, 227, 241–43, 267, 279, 307. In Dobbie, *The Maker's Eye*, p. 20, Michael Cardew says, "The oriental influence brought to Britain by Bernard Leach seemed to me, and still seems, the most significant event in the history of twentieth-century pottery."

P. 39. Daniel and Mark: Quotations from Johnston, *Pots from an Apprenticeship*, pp. 1–3.

P. 39. Mark on North Carolina: Hewitt, "A Few of My Favorite Things about North Carolina Pottery." Also Hewitt, "The Poetry in North Carolina Pottery."

P. 40. Jugtown: Crawford, *Jugtown Pottery*, especially pp. 13–51, 75–83, 99–103. Doug DeNatale usefully expands on Crawford's "balanced" account in *New Ways for Old Jugs*, pp. 1–23; then he adds more in Owen, DeNatale, and Compton, *The Busbee Legacy*, pp. 6–19. Also: Zug, *Turners and Burners*, p. 446; Sweezy, *Raised in Clay*, pp. 211–17; Brown, *Family Business*; Brown, *The Remarkable Potters of Seagrove*, pp. 41–50, 69–76, 91; Lock, *The Traditional Potters*

of Seagrove, pp. 152–61; Benfey, *Red Brick, Black Mountain, White Clay*, pp. 45–53; Perry, *North Carolina Pottery*, pp. 119–27, 143–49.

P. 44. Louise Cort on ceramics: Cort, *Shigaraki*; Cort, *Seto and Mino Ceramics*; Cort, "Portrait of a Moment"; Cort, "Asian Ancestors"; Cort and Mishra, *Temple Potters of Puri*.

P. 48. Help for studio potters: Rose, *Artist-Potters in England*, pp. 1–6, 13–14, 16–18; Wheeler and Edgeler, *Sid Tustin*, pp. 8, 13–14.

CHAPTER FOUR

P. 51. Pottery Villages: Glassie and Shukla, *Sacred Art*, pp. 150–241; Glassie, *Turkish Traditional Art Today*, pp. 411–24; Güner, *Anadolu'da Yaşmakta Olan İlkel Çömlekçilik*, pp. 74–77.

P. 52. Kawai: Uchida, *We Do Not Work Alone*, pp. 10–22.

P. 61. Big pots: Cardew, *A Pioneer Potter*, p. 105. Techniques comparable to Daniel's can be seen in Sayers and Rinzler, *The Korean Onggi Potter*, and Sanders, *The World of Japanese Ceramics*, pp. 103, 107–109, 129–30. I learned the most about the process of making big pots in parts of southeastern Asia where I haven't been during many conversations with Prof. Young Dong Bae when he was a research associate at Indiana University. Prof. Bae, who teaches at Andong National University in South Korea, has written, in Korean, a large and handsome book on the *onggi* pottery in one Korean village, *Onggiwa Modumsal-i*, in which techniques quite close to Daniel's are described and illustrated in the third section. (My thanks to Angela Mini Jo for help with translation.)

P. 61. Poles in creation: Leach, *A Potter's Book*, p. 23; Leach, *The Potter's Challenge*, p. 47. Daniel's midline and silhouette bring his process of design close to that of the great Brazilian sculptor Edival Rosas; see Glassie and Shukla, *Sacred Art*, pp. 30–41.

P. 70. Melodic geometry: Leach, *The Potter's Challenge*, pp. 33, 39, 110. Also Leach, *A Potter's Book*, p. 101.

P. 72. Salt glaze: Zug, "The Salt Glaze"; Zug, *Turners and Burners*, chapter 2; Hewitt and Sweezy, *The Potter's Eye*, pp. 57–101; Burrison, *Brothers in Clay*, pp. 57–58; Sweezy, *Raised in Clay*, pp. 52–54; Shaw, *History of the Staffordshire Potteries*, pp. 108–113; Rhead and Rhead, *Staffordshire Pots and Potters*, pp. 148–50; Barton, *Pottery in England*, pp. 49, 119.

P. 73. Alkaline glaze: Zug, "The Alkaline Glaze"; Zug, *Turners and Burners*, chapter 3; Hewitt and Sweezy, *The Potter's Eye*, pp. 103–163; Burrison, *Brothers in Clay*, pp. 53–62; Sweezy, *Raised in Clay*, pp. 54–56; Baldwin, *Great and Noble Jar*, pp. 16–20; Brackner, *Alabama Folk Pottery*, pp. 43–47; Benfey, *Red Brick, Black Mountain, White Clay*, pp. 204–205. In an early essay, "Alkaline-Glazed Stoneware," pp. 386–88, John Burrison succinctly argues that Landrum got the idea of ash glaze from letters written by Pere d'Entrecolles in 1712 and 1722. Those letters are presented in full by Tichane in *Ching-te-chen*, pp. 49–128. Burrison's idea, now generally accepted, gains support from the fact that Simeon Shaw, Landrum's contemporary in England, knew those letters, as he reports in his marvelous *History of the Staffordshire Potteries* (1829), pp. 85, 195.

P. 75. The Hewells: Burrison, *Brothers in Clay*, pp. 43–49, 224–39; Burrison, *From Mud to Jug*, pp. 36–41, 44–46, 51–53, 64–73, 103–126; Sweezy, *Raised in Clay*, pp. 139–44; Wigginton and Bennett, *Foxfire 8*, pp. 320–45; Mack, *Talking with the Turners*, pp. 99–100, 130–31, 194; Glassie, *The Potter's Art*, pp. 41–47.

P. 75. Daniel Seagle: Hewitt, *Great Pots*, pp. 103–114; Hewitt and Sweezy, *The Potter's Eye*, pp. 130–31, 136–49; Beam, Harpe, Smith, and Springs, *Two Centuries of Potters*, pp. 14–19; Harpe and Dedmond, *Valley Ablaze*, pp. 11–18; Perry, *North Carolina Pottery*, pp. 175–76; Zug, *Turners and Burners*, p. 444.

P. 77. Trouble with salt glaze: Leach, *A Potter's Book*, p. 204 (quoted); Leach, *Hamada: Potter*, pp. 198–203.

CHAPTER FIVE

P. 81. English updraft kilns: McGarva, *Country Pottery*, pp. 90–105; Brears, *The English Country Pottery*, pp. 146–51.

P. 81. The groundhog kiln: Zug, *Turners and Burners*, pp. 175–77, 202–234 (features Burlon Craig); Olsen, *The Kiln Book*, pp. 59–69 (features Kim Ellington); Rinzler and Sayers, *The Meaders Family*, pp. 119–29; Burrison, *Brothers in Clay*, pp. 91–97; Burrison, *From Mud to Jug*, pp. 51–53; Baldwin, *Great and Noble Jar*, pp. 20–21; Brackner, *Alabama Folk Pottery*, pp. 62–67; Sweezy, *Raised in Clay*, pp. 60–70; Mack, *Talking with the Turners*, pp. 157–64.

P. 85. The Japanese climbing kiln: In the excellent diagrams of kilns she provides in *Seto and Mino Ceramics*, chapters 1, 5, and 7, Louise Cort labels the last chamber, highest up the hill, a chimney. When Bernard Leach describes climbing kilns in *A Potter in Japan*, pp. 57, 62–64, 107–115, 206–210, he remarks that they lack chimneys — vertically rising vents, that is, though, in fact, some do have them — and the kiln at Leach's pottery in St. Ives, patterned on

the climbing kiln, has a vertical chimney, as does the similar kiln Mark Hewitt recently built behind his older big kiln. For more on the climbing kiln: Cort, *Shigaraki*, pp. 256–60; Leach, *Beyond East and West*, pp. 183–84; Wilson, *Inside Japanese Ceramics*, pp. 143–49; Sanders, *The World of Japanese Ceramics*, pp. 79–85, 92–94; Faulkner and Impey, *Shino and Oribe Kiln Sites*, pp. 33–37; Olsen, *The Kiln Book*, pp. 75–87.

P. 93. Art and craft: I have most explicitly and at greatest length treated the problems of art and craft, folk art and fine art — problems easily solved if you begin with the creators themselves — in *The Spirit of Folk Art*, and with more local nuance in *Turkish Traditional Art Today* and *Art and Life in Bangladesh*.

P. 93. Bernini in clay: Wardropper, *Bernini's Rome*, especially pp. 30–41.

P. 93. Cardew on art: Cardew, *Pioneer Pottery*, pp. 234–37, 244–50; Cardew, *A Pioneer Potter*, p. 192; and Cardew in Clark, *Michael Cardew*, pp. 215–24.

P. 93. Affecting presence: Armstrong, *The Affecting Presence*; Armstrong, *Wellspring*; Armstrong, *The Powers of Presence*.

P. 93. The pot is the potter: Leach, *A Potter's Book*, pp. 18–19; Leach, *The Potter's Challenge*, p. 48.

P. 93. Signature: On p.115 of *Finnegans Wake*, James Joyce writes, "So why, pray, sign anything as long as every word, letter, penstroke, paperspace is a perfect signature of its own?" Joyce is the ultimate writer, but other writers have also come close to his thought; see Rushdie, *Imaginary Homelands*, pp. 425–26. The thought, of course, precisely parallels Leach's conviction that, in seeing the pot, you're seeing the potter. As for actual signatures: East Fork uses a company stamp as Jugtown does. When Ben Owen left Jugtown, his stamp read: Ben Owen, Master Potter. Jugtown still uses a company stamp, but the individual potters generally add personal signatures. Ben Owen III and Sid Luck sign their work with their names. So does Chad Brown, though Chad often uses his initials, CB, just as Kim Ellington often uses GKE. Matt Jones uses a stamp with his whole name. Mark Hewitt has two stamps with his initials, WMH, one for his own work, the other to accompany the stamped initials of his apprentices; so today an S means the pot was made by Stillman in Mark's shop. Off on their own, Mark's apprentices continue to use stamped initials, so Daniel's pots have a D. Then Daniel's apprentices also use initials, so Andrew's pots have an A. Kate has followed with a K. All of these marks appear unobtrusively on the pot's bottom, and for people in the know they are hardly necessary. You don't have to pick up a big pot by David Stuempfle and look at the bottom to know it is by David. Most of the world's pots are not signed. The local people glance at them and know who made them. Signatures are necessary only when pots are destined for distant consumers.

P. 94. Tradition: Cashman, Mould, and Shukla, *The Individual and Tradition*; pp. 2–4; Glassie, "Tradition"; Glassie and Mahmud, *Living Traditions*, pp. 25–108.

P. 94. Carpets: Glassie, *Turkish Traditional Art Today*, pp. 199–230, 571–776.

P. 97. Art from within: Kandinsky, "On the Question of Form," *The Blaue Reiter Almanac*, especially p. 153 (in the 1974 edition — p. 77 in the original); Suzuki, *Zen and Japanese Culture*, p. 226; Cardew, *Pioneer Pottery*, p. 250; Leach, *The Potter's Challenge*, p. 19. Rabindranath Tagore shapes a frame and finds the center with the expression of

deep unity in "What is Art?," *Lectures and Addresses*, pp. 77–100.

P. 98. Cubism: Gertrude Stein was there with Picasso in Paris; she saw cubism come in 1909 and go in 1917, and in 1938 she presented a cubistic report on cubistic form in *Picasso*, pp. 8–19, 23–25, 35–36.

P. 99. Ephebism: Thompson, *Black Gods and Kings*, chapter 3, p. 3 (the information and pagination are the same in the Los Angeles edition of 1971 and the Bloomington edition of 1976); Thompson, "Aesthetics in Traditional Africa," p. 378; Thompson, "Yoruba Artistic Criticism," p. 56; Thompson, *African Art in Motion*, pp. 5, 7; Armstrong, *Wellspring,* p.34.

P. 107. The merchant's values disrupt artistic success: Leach, *Beyond East and West*, p. 163.

CHAPTER SIX

P. 109. Hard to sell: Holland, *Fifty Years a Potter*, pp. 34–36, 46, 91. The potter's scramble to adjust to a diminishing market is compassionately portrayed in José Saramago's superb novel *The Cave*.

P. 109. Bangladesh: Glassie, *Art and Life in Bangladesh*, pp. 61–96, 169–90, 204–305; Shah Jalal, *Traditional Pottery in Bangladesh*.

P. 111. Collectors: From the angle of performance theory, most richly articulated by Dell Hymes in *Foundations in Sociolinguistics* and the key to best practices among contemporary folklorists (me, for example), it is important to know how artists understand consumers and respond to them, lead them, or ignore them. The consumers, in this case the collectors, deserve study on their own as the creators of collections and the arrangers of domestic environments. Terry Zug wrote a fine paper, "Consuming

Pots," on Mark Hewitt's customers. Mark and Daniel both express special gratitude to Monty and Ann Busick, and Monty appears in the first of the catalogues that the North Carolina Pottery Center published on collectors, titled *The Collector's Eye* and featuring seven collectors and selections from their collections. In it, p. 1, Monty says he has bought pots by all of Mark Hewitt's apprentices, and he chose, pp. 3–4, pots by Mark and Daniel, as well as by Vernon, Pam, and Travis Owens, Matt Jones, Joseph Sand, and Donna Craven. In the second in *The Collector's Eye* series, Patricia Hyman, pp. 1, 7–8, also chose pots by Mark and Daniel, as well as by Pam and Travis Owens, Ben Owen III, and David Stuempfle. Steve Compton, who appears in the first book in the series, wrote a guide for collectors of old pieces, *North Carolina Pottery*, and he is given the second chapter in the excellent dissertation Stacy Tidmore wrote on collecting, "The Art of Collection."

P. 115. The exhibition at the North Carolina Museum of Art in 2005: Hewitt and Sweezy, *The Potter's Eye.*

P. 116. The Rocky Mount exhibition in 2009: Coulter, *A Unique Likeness.*

P. 117. Bryce Brisco: Brisco, *Bryce Brisco*; Sekino-Bove, "Bryce Brisco: The Art of Serving"; Brisco, "Working Potter."

P. 117. Tz'u-chou ware: Mino, *Freedom of Clay and Brush through Seven Centuries in Northern China*; Medley, *The Chinese Potter*, pp. 123–35; Li, *Chinese Ceramics*, pp. 139–40, 167–69; Leach, *Beyond East and West*, p. 95.

P. 119. Useful and beautiful: William Morris's command — "Have nothing in your houses that you do not know to be useful, or believe to be beautiful" — comes from his lecture of 1880 "The Beauty of Life," published in *Hopes and Fears for Art* in 1882.

In the 1898 edition, the quote comes on p. 108, not long after Morris had set the goal on p. 103: "Art made by the people and for the people as a joy to the maker and the user." In May Morris, *The Collected Works of William Morris*, the essay comes in vol. 22, pp. 51–80, the quote on p. 76.

P. 119. Kate Johnston: Compton, *North Carolina Potteries*, p. 80; Wiedemann, *Controlled Burn*, pp. 36–43; Johnston, "Kate and Daniel Johnston."

P. 122. Daniel quoted: Coulter, *A Unique Likeness*, p. 11.

P. 122. Pots in series: Cardew, *A Pioneer Potter*, p. 82.

P. 135. The artist's responsibility in commerce: Daniel's conclusion comes close to Michael Cardew's when he wrote, in *Pioneer Pottery*, p. 236, "the potter does not merely follow what his public wants but leads it, so that in the end they want what he wants."

CHAPTER SEVEN

P. 141. Takuro Shibata: Wiedemann, *Controlled Burn*, pp. 106–113.

P. 143. Exhibition of southern pottery at the Museum of International Folk Art: Duffy, "Pouring What the Vessel Holds," and Marjorie Hunt's review in the *Journal of American Folklore* in 2016.

P. 143. Face jugs: Vlach, *The Afro-American Tradition in Decorative Arts*, pp. 81–94; Baldwin, *Great and Noble Jar*, pp. 79–88; Rinzler and Sayers, *The Meaders Family*, pp. 101 105; Burrison, *Brothers in Clay*, pp. 74–76, 226–36, 269–73; Burrison, *From Mud to Jug*, pp. 68–73, 105–151; Burrison, *Roots of a Region*, pp. 128–33; Burrison, *Global Clay*, pp. 99–105, 122–38; Glassie, *The Potter's Art*,

pp. 36–47; Zug, *Turners and Burners*, pp. 129–64, 202–234; Huffman, *Catawba Clay*; Huffman, *Hand-in-Hand*, pp. 36–45; Beam, Harpe, Smith, and Springs, *Two Centuries of Potters*, pp. 96–106; Koverman, *Making Faces*.

P. 158. Fountain: Mink, *Marcel Duchamp*, pp. 63, 66–67.

P. 161. Thomas Chandler: Hewitt, *Great Pots*, pp. 32–51; Wingard, *Swag and Tassel: The Innovative Stoneware of Thomas Chandler*; Baldwin, *Great and Noble Jar*, pp. 51–55, 154–59; Hewitt and Sweezy, *The Potter's Eye*, pp. 116–21.

P. 163. The book with Moravian designs: Bivins, *The Moravian Potters of North Carolina*.

P. 164. Daniel's proposal: I quote from Daniel's proposal to Peters Projects, which Mark Del Vecchio generously shared with me.

P. 170. Pots in Daniel's Santa Fe exhibition: It happens that the piece on Daniel Johnston in Wiedemann, *Controlled Burn*, pp. 20–27, was composed when Daniel was preparing for the Peters Projects installations, and the photos show both the dotted pots and the columns.

P. 174. Collection: Strauss and Clark, *Shifting Paradigms in Contemporary Ceramics: The Garth Clark and Mark Del Vecchio Collection*.

P. 174. Columns: Garth Clark and Mark Del Vecchio, who know the art market, feel that the columns point Daniel's way forward. My dear friend George Jevremović, the owner of Material Culture in Philadelphia who runs a successful art auction, looked at Daniel's work in 2018 and said the big pot, pictured on page 159 of this book,

was truly beautiful but the strong and un-expected columns are what rich, hip buyers want today.

P. 174. Function: Through here, I follow social-scientific usage as set forth with characteristic clarity by Robert K. Merton in *On Theoretical Sociology*, chapter 3.

P. 174. Tradition: Morris, "Making the Best of It," in *Hopes and Fears for Art*, especially pp. 157–59; Yeats, "Poetry and Tradition," in *The Cutting of an Agate*, pp. 36–57; Eliot, "Tradition and the Individual Talent," in *Selected Essays*, pp. 3–11; Ben-Amos, "The Seven Strands of Tradition"; Glassie, "Tradition"; Glassie and Mahmud, *Living Traditions*, pp. 25–70.

P. 176. Grave markers: Zug, *"Remember Me as You Pass By": North Carolina's Ceramic Grave Markers*, and Zug, *Turners and Burners*, pp. 355–62. Sentinels, Mark Hewitt's take on the grave markers, can be seen in the kiln on p.84 in this book.

P. 183. Gettysburg remembered: Faulkner, *Intruder in the Dust*, p. 194.

P. 185. Gottlieb: Alloway and MacNaughton, *Adolph Gottlieb*; Friedman, *Adolph Gottlieb*.

P. 194. Kütahya: Glassie, *Turkish Traditional Art Today*, pp. 427–562; Çini, *Ateşin Yarattığı Sanat: Kütahya Çiniliği*; Kolhan, *Çini: Sır Altındaki Aşk*. The ware — painted underglaze with tinted slips on a composite white body, rich in kaolin and quartz, and until recently wood-fired — is called *çini*, cognate with "china." It was taken by Armenians from Kütahya to Jerusalem: Kenaan-Kedar, *The Armenian Ceramics of Jerusalem*. Made since the fifteenth century in several Turkish locations, it is now generally named for one of them, Iznik, where the tradition, vital into the eighteenth

century, was dead until it was introduced from Kütahya in the later twentieth century. In Kütahya, the ware was made in the early days — the oldest dated piece was made there in 1529 — and, though there have been many changes, it has continued, uninterrupted, to the present. For more see: Akalın and Bilgi, *Yadigâr-i Kütahya*; Lane, *Later Islamic Pottery*, chapter 5; Carswell, *Iznik Pottery*; Denny, *Iznik: The Artistry of Ottoman Ceramics*.

P. 197. Perseus: Cellini, *The Life of Benvenuto Cellini*, II, pp. 210–311. The statue still stands in the open Loggia dei Lanzi, in the Piazza della Signoria, the civic center of Florence.

P. 202. Individualism is explored through community: Daniel's idea, important in my opinion, is demonstrated in an excellent recent book, Waiboer's *Vermeer and the Masters of Genre Painting*, in which Vermeer, placed among other artists who shared his times and topics, becomes clearly distinct; see in particular Wheelock's essay, pp. 22–35; Gifford and Glinsman's essay, pp. 65–83; and Ducos's essay, pp. 193–98. That has been my goal in the past — in *The Stars of Ballymenone*, for instance — and in this book I have brought Daniel's colleagues around him to sketch his community and clarify his individuality.

P. 203. Sunset: Huntington, *The Landscapes of Frederic Edwin Church*, pp. 78–83, plate VI.

P. 204. Ogun: Soyinka, *Art, Dialogue, and Outrage*, pp. 27–29, 47–48; Soyinka, *Of Africa*, pp. 152–63; Bascom, *The Yoruba*, pp. 82–83.

P. 211. The process of installation: In his diaries, which are profoundly important for an understanding of modernism, the great Paul Klee complained, in 1909, that writers

on art provide biographical facts about artists, but neglect the mundane processes of making; see Klee, *The Diaries of Paul Klee*, pp. 238–39. Throughout Daniel's book I've scattered biographical facts, but, in response to Klee's complaint and in line with folkloristic practice, I've worked to provide detailed descriptions of processes, from throwing a pot to building an installation.

AFTERWORD

P. 225. Whenever possible: You will note from the dates in the list of oral sources that most of the work got done when we had no obligations to the university, during spring break or the summer.

P. 225. Excellent books from the eighties on southern pottery: Rinzler and Sayers, *The Meaders Family* (1980); Burrison, *Brothers in Clay* (1983); Zug, *Turners and Burners* (1986).

P. 225. Turkey: Glassie, *Turkish Traditional Art Today*, pp. 339–48, 397–532; Glassie, *The Potter's Art*, pp. 56–90; Glassie, *Günümüzde Geleneksel Türk Sanatı*, pp. 42–59; Güner, *Anaadolu'da Yaşmakta Olan İlkel Çömlekçilik*; Çini, *Ateşein Yarattığı Sanat*; Atasoy and Raby, *İznik Seramikleri*.

P. 225. Bangladesh: Glassie, *Art and Life in Bangladesh*, pp. 61–366; Glassie, *The Potter's Art*, pp. 19–34; Glassie and Mahmud, *Contemporary Traditional Art of Bangladesh*, pp. 4–14; Shah Jalal, *Traditional Pottery in Bangladesh*.

P. 225. New Mexico: Glassie, *The Potter's Art*, pp. 48–56; Dillingham, *Acoma and Laguna Pottery*; Duffy, "Carry It On for Me"; Peterson, *Lucy M. Lewis*; Bunzel, *The Pueblo Potter*.

P. 225. Sweden: Glassie, *The Potter's Art*, pp. 34–36; von Friesen, *Krukan från Raus*; Anagrius, *Keramik från Kvidinge*.

P. 225. Japan: Glassie, *The Potter's Art*, pp. 91–116; Kawano and Enomoto, *Hagi*; Nagatake, *Kakiemon*; Empey, *Fourteenth Red*; Wilson, *Inside Japanese Ceramics*.

P. 226. Italy: De Mauri, *Le Maioliche di Deruta*, pp. 47–50; Busti and Cocchi, *Museo della Fabbrica di Maioliche Grazia di Deruta*; Busti and Cocchi, *Fatto in Deruta*; Minchilli, *Deruta*; Berti, *Il Museo della Ceramica di Montelupo*; Sani, *Italian Renaissance Maiolica*; Piccolpasso, *The Three Books of the Potter's Art*.

P. 226. Brazil: Glassie and Shukla, *Sacred Art*, pp. 150–241, 344–53; Martins, Luz, and Belchior, *Nova Fase da Lua*, pp. 58–79, 106–157. Portuguese antecedents: Vermelho, *Barros de Estremoz*; Fernandes, *Figurado Português*. African antecedents: Griaule, *Folk Art of Black Africa*; Abiọdun, Drewal, and Pemberton, *The Yoruba Artist*; Thompson, *Flash of the Spirit*.

P. 228. Twins: Glassie, *Prince Twins Seven-Seven: His Art, His Life in Nigeria, His Exile in America*; Glassie, "Prince Twins Seven-Seven: 1944–2011"; Beier, *A Dreaming Life*.

P. 229. Classic anthropological lives: Simmons, *Sun Chief*; Lewis, *Pedro Martinez*.

P. 229. By and about artists: We begin in sixteenth-century Italy with the painter Vasari's rich biographies in *Lives of the Most Eminent Painters* (1568) and the goldsmith Cellini's wild and wonderful, egotistical and culturally revealing autobiography, *The Life of Benvenuto Cellini Written by Himself* (c. 1559). For direct use in Daniel's book, we have a model biography in Tanya Harrod's *The Last Sane Man: Michael Cardew*, and numerous biographies of the profoundly influential William Morris, notably E.P. Thompson's *William Morris* and Fiona MacCarthy's *William Morris*. And we have useful autobiographical writing in Leach's

Beyond East and West, Cardew's *A Pioneer Potter*, and Holland's *Fifty Years a Potter*.

P. 229. Portraits: Some books read like a series of portraits: Vasari, *Lives of the Most Eminent Painters*; Cashman, Mould, and Shukla, *The Individual and Tradition*; Kociejowski, *God's Zoo: Artists, Exiles, Londoners*, Kimmelman, *Portraits*. Joyce's word "portrait" fits biographies of artists: Garth Clark subtitled his book on Michael Cardew, *A Portrait*; Charles Mee titled his fine biography of Rembrandt, *Rembrandt's Portrait*; and in the introduction to her excellent biography of Jackson Pollock, pp. xiv–xv, Evelyn Toynton poses Pollock in "a portrait of the artist as America." Now, Daniel is saner and more articulate than Pollock, but he is also masculine and sensitive, ambitious and inventive, and Daniel's story can also be read as a particularly American life. In March 2019, Daniel, in the midst of his difficult project, said that he is crazy in the same way that Pollock was.

P. 229. Portraits of narrators: Hyde, *Mayo Stories Told by Thomas Casey*; Ó Duilearga, *Seán Ó Conaill's Book*; Glassie, *The Stars of Ballymenone*, pp. 115–87, 361–73; Cashman, *Packy Jim*; Campbell, *Stories from South Uist Told by Angus MacLellan*; Ferris, *"You Live and Learn, Then You Die and Forget It All": Ray Lum's Tales of Horses, Mules, and Men*; Hurston, *Barracoon;* Dégh, *Hungarian Folktales: The Art of Zsuzsanna Palkó*.

P. 229. Portraits of singers and musicians: Ives, *Joe Scott*; Abrahams, *A Singer and Her Songs*; Glassie, Murphy, and Peach, *Ola Belle Reed and Southern Mountain Music on the Mason-Dixon Line*; Sawin, *Listening for a Life*; Pearson, *Virginia Piedmont Bluesmen*; Morton, *Come Day, Go Day, God Send Sunday*; Williams and Ó Laoire, *Bright Star of the West: Joe Heaney, Irish Song Man*; Bird, *The Songs of Seydou Camara*; Chowdhury, *Abdul Halim Bayati: Jiban o Sangit*; Hansen, *A Florida Fiddler*; Rosenberg and Wolfe, *The*

Music of Bill Monroe; Szwed, *So What: The Life of Miles Davis*.

P. 229. Portraits of makers: Jones, *Craftsman of the Cumberlands*; Vlach, *Charleston Blacksmith*; Cort and Nakamura, *A Basketmaker in Japan*; Joyce, *A Bearer of Tradition: Dwight Stump, Basketmaker*; Glassie, "William Houck, Maker of Pounded Ash Adirondack Pack-Baskets"; Glassie, "A Master of the Art of Carpet Repair: The Life of Hagop Barın" (revised in *Material Culture*, pp. 87–141); Glassie, *Prince Twins Seven-Seven*; Goldstein, "William Robbie"; Serin, *Kemal Batanay*; Kirshenblatt and Kirshenblatt-Gimblett, *They Called Me Mayer July*; Holm, *Smoky-Top*; Marriott, *María: The Potter of San Idefonso*; Kramer, *Nampeyo and her Pottery*; Ferris, *James "Son Ford" Thomas*; Duffy, "The Work of Virgil Boruff"; Holtzberg, "Place Matters: A Wooden Boat Builder in the Twenty-First Century"; Burrison, "Georgia Decoy Maker Ernie Mills"; Evans, *King of the Western Saddle*; Alvey, *Dulcimer Maker*.

P. 230. Phases: Joyce, *Stephen Hero*; Joyce, *A Portrait of the Artist as a Young Man*; Joyce, *Dubliners*; Joyce, *Ulysses*; Joyce, *Finnegans Wake*; Ellmann, *James Joyce*; Thomas, *Portrait of the Artist as a Young Dog*. Often enough, autobiographical writings divide into a preparatory first phase that is coherent and engaging, and a second phase of accomplishment that trades coherence for sketches of notable people and accounts of achievements. In 1914, two years before Joyce's *Portrait* was published, W.B. Yeats wrote *Reveries Over Childhood and Youth*, a marvelous preparatory tale, detailing the development of his interest in poetry, narrative, mysticism, and the Irish tradition; in it he brings himself to a point close to Stephen's in Joyce's *Portrait*. Then in 1922, Yeats wrote *The Trembling of the Veil*, filled with personalities — including William Morris, pp. 172–84, John Synge, pp. 423–27, and Lady Gregory, pp. 463–69. Morris, his chief

of men, was his inspiration. John Synge and Lady Gregory were his collaborators in developing a modernist theatre in Dublin at the same time that modernist painting was taking shape in Paris. The two books, describing a young artist moving toward greatness at the turn of the century, were published together as *Autobiographies* in 1927. The first phase is foundational, and writers often end autobiographies, as Yeats did in *Reveries* and Thomas did in *Young Dog*, before the creation of their masterworks. Some examples: Wright, *Black Boy* (though see the critical essay "How 'Bigger' was Born" appended, pp. 433–64, to the 2005 edition of *Native Son*); Naipaul, *Finding the Center* (in which pp. 1–6, 52–60, 70–72 make a beginning for the author of *A House for Mr. Biswas*); García Márquez, *Living to Tell the Tale* (though the early information is arranged to explain his masterpiece *One Hundred Years of Solitude*); Saramago, *Small Memories* (in which pp. 67–68 point toward *Baltasar and Blimunda*). That is, with this book, preparation is over, and Daniel's future, however complexly, will unfold from the past that he and I have collaboratively described in this portrait.

ORAL SOURCES

NORTH CAROLINA

Brown, Chad: March 22, 2008; March 27, 2009; March 25, 2011; March 23, 2012; March 22, May 11, 12, July 14, 27, 2013; May 25, 2014; March 17, 2016; June 8, 2017; November 18, 2018.

Childress, Terry: July 7, November 10, 2012; August 11, November 17, 2018.

Dalglish, Naomi: December 1, 2012; December 9, 2017.

Dutcher, Andrew: June 8, 12, 2017.

Ellington, Kim: March 24, 2007; March 22, July 18, 2013; November 6, 2014; March 25, June 10, 2017; April 20, 2019.

Hayes, Charlie: June 27, August 4, 2018; April 18, 2019.

Hewitt, Mark: April 6, 2000; March 23, July 11, 2002; February 2, 2003; May 17, 2004; March 20, 22, 2008; March 16, 27, 2009; March 15, 2010; March 14, 2011; March 24, 2012; May 16, July 3, 8, 9, 17, 23, 26, December 17, 2013; August 31, November 6, December 6, 7, 2014; March 15, 2016; June 9, 10, November 6, 2017; August 6, November 18, 2018; April 20, 2019.

Hunt, Michael: December 1, 2012; June 10, 2017.

Johnston, Daniel: March 22, 2007; March 20, 22, 2008; March 15, 27, 2009; March 25, 2011; March 23, 24, July 5, 6, 7, 8, 2012; March 22, May 13, July 5, 9, 16, 24, 27, 29, 2013; March 28, April 17, May 23, 24, July 16, November 6, December 7, 2014; March 14, 16, 17, September 10, 23, 2016; March 24, June 9, 12, 13, 14, 17, September 7, November 29, December 17, 2017; January 13, 14, June 13, 27, August 4, 7, 10, September 3, October 14, 24, November 17, 18, 2018; January 11, 19, February 12, March 1, 2, 28, April 18, 19, June 25, 2019.

Johnston, Kate: November 10, 2012; May 13, July 27, 2013; May 23, July 15, August 29, 2014; March 15, 2016; June 14, 2017; April 21, August 7, November 17, 2018; March 1, April 18, 2019.

Jones, Bill: May 13, 2013; June 8, 2017.

Jones, Matt: March 23, 2007; March 22, 2008; April 30, 2012; March 23, July 20, 2013.

Luck, Sid: April 8, 2000; February 2, 2003; March 16, 2010; March 23, May 11, July 15, 2013; June 15, 2017.

Matisse, Alex: March 15, 27, 2009; March 25, 2011; April 30, 2012; July 19, 20, 2013; May 22, 2014; March 11, 2016.

Novak, Natalie: August 10, 2018.

Owen, Ben: April 8, 2000; March 22, 2002; November 6, 2014; September 10, 2016; June 10, 13, 2017.

Owens, Pam: May 13, July 24, 28, 2013; September 10, 2016.

Owens, Travis: September 10, 2016; June 9, 2017.

Owens, Vernon: July 11, 2002; May 18, 2004; March 11, 2006; May 13, July 24, 28, 2013.

Sand, Joseph: March 15, 2009; July 11, 25, 2013; March 25, 2017.

Stuempfle, David: May 18, 2004; March 28, 2008; March 16, 2010; March 14, May 11, 14, July 13, 2013; March 28, May 6, 2014; March 18, December 10, 2016.

Vigeland, John: May 22, June 17, 2014; March 11, 2016.

Zug, Charles G. (Terry): March 15, 2011; December 2, 2012; May 19, 2014.

SOUTH CAROLINA

Bayne, Michel: March 22, 2008; March 20, 2009.

Eugéne, Winton and Rosa: March 24, 2007; March 27, 2009; March 29, 2014; September 10, 2016; June 16, 2017.

GEORGIA

Hewell, Chester: April 26, 1991; March 27, June 7, 19, 1999; October 6, 2001; May 14, 2004; October 1, 2005; October 6, 2007; October 4, March 10, 11, 2008; April 29, 2012.

Hewell, Grace Nell: March 10, 2008.

Hewell, Harold: March 11, 2008.

Hewell, Matthew: March 27, 1999; May 14, 2004; October 1, 19, 2005; October 7, 2006; March 10, 11, 12, 2008; August 31, 2009; October 1, 2011; April 29, 2012; December 28, 2017; September 14, 2018.

Hewell, Nathaniel: March 10, 11, 2008; October 1, 2011.

TENNESSEE

Brisco, Bryce: May 18, 2013; July 15, 2014.

ALABAMA

Brown, Jerry: May 12, 2004.

ENGLAND

Bayer, Svend: March 17, 2015.

Bowen, Clive and Rosie: March 16, 2015.

BIBLIOGRAPHY

Abiọdun, Rowland, Henry J. Drewal, and John Pemberton III, eds. *The Yoruba Artist: New Theoretical Perspectives on African Arts*. Washington: Smithsonian Institution Press, 1994.

Abrahams, Roger D. *A Singer and Her Songs: Almeda Riddle's Book of Ballads*. Baton Rouge: Louisiana State University Press, 1970.

Akalın, Şebnem, and Hülya Yılmaz Bilgi. *Yadigâr-i Kütahya*: *Suna ve İnan Kıraç Kolesionunda Kütahya Seramikleri*. Istanbul: Vehbi Koç Vakfı, 1997.

Alloway, Lawrence, and Mary Davis Mac-Naughton. *Adolph Gottlieb: A Retrospective*. New York: The Arts Publisher, 1981.

Alvey, R. Gerald. *Dulcimer Maker: The Craft of Homer Ledford*. Lexington: University Press of Kentucky, 1984.

Anagrius, Tomas. *Keramik från Kvidinge: Om Krukmakerierna i Kvidingebygden*. Kvidinge: Anagrius, 2007.

Armstrong, Robert Plant. *The Affecting Presence: An Essay in Humanistic Anthropology*. Urbana: University of Illinois Press, 1971.

———. *Wellspring: On the Myth and Source of Culture*. Berkeley: University of California Press, 1975.

———. *The Powers of Presence: Consciousness, Myth, and Affecting Presence*. Philadelphia: University of Pennsylvania Press, 1981.

Atasoy, Nurhan, and Julian Raby. *İznik Seramikleri*. London: Alexandria Press, 1989.

Bae, Young Dong. *Onggiwa Modumsal-i: Oegosan Onggimaeul*. Seoul: National Research Institute, 2011.

Baldwin, Cinda K. *Great and Noble Jar: Traditional Stoneware of South Carolina*. Athens: University of Georgia Press, 1995.

Barker, David, and Steve Crompton. *Slipware in the Collection of the Potteries Museum and Art Gallery*. London: A&C Black, 2007.

Barton, K. J. *Pottery in England: From 3500BC — AD 1750*. Newton Abbot: David & Charles, 1975.

Bascom, William. *The Yoruba of Southwestern Nigeria*. New York: Holt, Rinehurt and Winston, 1969.

Baxandall, Michael. *Patterns of Intention: On the Historical Explanation of Pictures*. New Haven: Yale University Press, 1985.

Bayer, Svend. "The Kiln as Tool," *The Studio Potter* 28:2 (2000): 19–20.

———. *New Pots*. Uppingham: Goldmark Gallery, 2007.

Beam, Bill, Jason Harpe, Scott Smith, and David Springs. *Two Centuries of Potters: A Catawba Valley Tradition*. Lincolnton: Lincoln County Historical Association, 1999.

Beck, Horace P., ed. *Folklore in Action: Essays for Discussion in Honor of MacEdward Leach*. Philadelphia: American Folklore Society, 1962.

Beckett, Samuel. *Waiting for Godot*. New York: Grove Press, 1954.

Beier, Ulli, ed. *A Dreaming Life: An Autobiography of Twins Seven-Seven.* Bayreuth: Bayreuth University, 1999.

Ben-Amos, Dan. "The Seven Strands of Tradition: Varieties in Its Meaning in American Folklore Studies," *Journal of Folklore Research* 21 (1984): 97–131.

Benfey, Christopher. *Red Brick, Black Mountain, White Clay: Reflections on Art, Family, and Survival.* New York: Penguin, 2013.

——. *At the Crossroads: Pottery by Mark Hewitt.* Boston: Pucker Gallery, 2015.

Berti, Fausto. *Il Museo della Ceramica di Montelupo: Storia, Tecnologia, Collezioni.* Firenze: Edizioni Polistampa, 2008.

Bird, Charles S. *The Songs of Seydou Camara.* Bloomington: African Studies Center, 1974.

Birks, Tony, and Cornelia Wingfield Digby. *Bernard Leach, Hamada and Their Circle.* Oxford: Phaidon-Christie's, 1990.

Bivins, John, Jr. *The Moravian Potters of North Carolina.* Chapel Hill: University of North Carolina Press, 1972.

Brackner, Joey. *Alabama Folk Pottery.* Tuscaloosa: University of Alabama Press, 2006.

Brears, Peter C. D. *The English Country Pottery: Its History and Techniques.* Newton Abbot: David & Charles, 1971.

Brennan, Anne, and Phyllis Blair Clark. *Ben Owen III: A Natural Influence.* Wilmington: Louise Wells Cameron Art Museum, 2004.

Bridges, Daisy Wade. *Ash Glaze Traditions in Ancient China and the American South.* Charlotte: Southern Folk Pottery Collectors Society, 1997.

Brisco, Bryce. *Bryce Brisco.* Raleigh: Lulu, 2011.

——. "Working Potter," *Ceramics Monthly* 61:6 (2013): 37–39.

Brown, Charlotte Vestal. *The Remarkable Potters of Seagrove: The Folk Pottery of a Legendary North Carolina Community.* New York: Lark Books, 2006.

——. *Pamela and Vernon Owens: Potters of Jugtown.* Raleigh: Gregg Museum, North Carolina State University, 2008.

——. *The Family Business: 175 Years of Pottery by the Owen/Owens Families.* Seagrove: North Carolina Pottery Center, 2008.

Bunzel, Ruth L. *The Pueblo Potter: A Study of Creative Imagination in Primitive Art.* New York: Dover, 1972 [1929].

Burrison, John A. "Alkaline-Glazed Stoneware: A Deep-South Tradition," *Southern Folklore Quarterly* 39:4 (1975): 377–404.

——. *The Meaders Family of Mossy Creek.* Atlanta: Georgia State University Art Gallery, 1976.

——. *Brothers in Clay: The Story of Georgia Folk Pottery.* Athens: University of Georgia Press, 1983.

——. *Shaping Traditions: Folk Arts in a Changing South.* Athens: University of Georgia Press, 2000.

——. *Roots of a Region: Southern Folk Culture.* Jackson: University Press of Mississippi, 2007.

——. *From Mud to Jug: The Folk Potters and Pottery of Northeast Georgia.* Athens: University of Georgia Press, 2010.

——. "Georgia Decoy Maker Ernie Mills: A Folk Artist Defines His Work," in Cashman, Mould, and Shukla, *The Individual and Tradition* (2011), pp. 408–428.

——. *Global Clay: Themes in World Ceramic Traditions.* Bloomington: Indiana University Press, 2017.

Burrow, Philip E. *Growing up Backwoods Southern: True Stories and Confessions of Being Raised by Grandparents on a Backwoods North Carolina Farm.* Sorrento: American Legacies, 2016.

Busti, Giulio, and Franco Cocchi. *Fatto in Deruta: Ceramiche Tradizionale di Deruta.* Perugia: Futura, 2004.

——. *Museo della Fabbrica di Maioliche Grazia di Deruta.* Perugia: Electa Editori Umbri Associati, 2009.

Campbell, John Lorne. *Stories from South Uist Told by Angus MacLellan*. London: Routledge & Kegan Paul, 1961.

Camus, Albert. *The Rebel*. Anthony Bower, trans. London: Hamish Hamilton, 1953.

Cardew, Michael. *Pioneer Pottery*. New York: St. Martin's Press, 1973 [1969].

———. *A Pioneer Potter: An Autobiography*. London: William Collins Sons, 1988.

Carswell, John. *Iznik Pottery*. London: British Museum Press, 1998.

Carter, Ben. *Mastering the Potter's Wheel: Techniques, Tips, and Tricks for Potters*. Minneapolis: Voyager Books. 2016.

Cashman, Ray. *Packy Jim: Folklore and Worldview on the Irish Border*. Madison: University of Wisconsin Press, 2016.

Cashman, Ray, Tom Mould, and Pravina Shukla, eds. *The Individual and Tradition: Folkloristic Perspectives*. Bloomington: Indiana University Press, 2011.

Cellini, Benvenuto. *The Life of Benvenuto Cellini Written by Himself*. 2 vols. John Addington Symonds, trans. New York: Brentano's, 1906 [c. 1559].

Chowdhury, Shafiqur Rahman. *Abdul Halim Bayati: Jiban o Sangit*. Dhaka: Bangla Academy, 2000.

Çini, Rıfat. *Ateşin Yarattığı Sanat: Kütahya Çiniliği*. Istanbul: Celsus Yayıncılık, 2002.

Clark, Garth. *Michael Cardew: A Portrait*. Tokyo: Kodansha, 1976.

Clark, Garth, and Mark Del Vecchio. *Dark Light: The Ceramics of Christine Nofchissey McHorse*. Albuquerque: Fresco Fine Art, 2013.

Compton, Stephen C. *North Carolina Pottery: Earthenware, Stoneware, and Fancyware: Identification and Values*. Paducah: Collector Books, 2011.

———. *A Handed Down Art: The Brown Family Potters*. Seagrove: North Carolina Pottery Center, 2014.

———. *Seagrove Potteries Through Time*. Croydon: Arcadia, 2016.

———. *North Carolina Potteries Through Time*. Croydon: Arcadia, 2017.

Coomaraswamy, Ananda K. *The Indian Craftsman*. New Delhi: Munshiram Manoharlal, 1989 [1909].

———. *The Transformation of Nature in Art*. Cambridge: Harvard University Press, 1935.

Copeland, Robert. *Spode*. Princes Risborough: Shire, 1998.

Cort, Louise Allison. *Shigaraki: Potters' Valley*. Tokyo: Kodansha, 1981 [1979].

———. *Seto and Mino Ceramics: Japanese Collections in the Freer Gallery of Art*. Washington: Freer Gallery, Smithsonian Institution, 1992.

———. "Asian Ancestors," in Millard, *Mark Hewitt* (1997), pp. 6–13.

———. "Portrait of a Moment: Japanese Ceramics from 1972–1973 in the Weyerhauser Collection," in Morse, *Shaped with a Passion* (1998), pp. 16–21.

Cort, Louise Allison, and Nakamura Kenji. *A Basketmaker in Rural Japan*. New York: Weatherhill, 1994.

Cort, Louise Allison, and Purna Chandra Mishra. *Temple Potters of Puri*. Ahmedabad: Mapin, 2012.

Coulter, Catherine. *A Unique Likeness: Pottery Exhibition 2009*. Rocky Mount: The Arts Center, 2009.

Crafts Advisory Committee. *Michael Cardew: A Collection of Essays*. New York: Watson-Guptill, 1976.

Crawford, Jean. *Jugtown Pottery: History and Design*. Winston-Salem: John F. Blair, 1964.

Dalglish, Naomi. "Pots, Purpose, and Place," *The Studio Potter* 46:1 (2018): 41–44.

Davies, Peter. *5 Devon Potters*. Birmingham: Jones and Palmer, 2004.

D'Azevedo, Warren L., ed. *The Traditional Artist in African Societies*. Bloomington: Indiana University Press, 1974.

Dégh, Linda. *Hungarian Folktales: The Art of Zsuzsanna Palkó*. New York: Garland, 1995.

De Mauri, Luigi. *Le Maioliche di Deruta: Una Pagina di Storia dell'Arte Umbra*. Milano: Bottega di Poesia, 1924.

DeNatale, Douglas, Jane Przybysz, and Jill R. Severn, eds. *New Ways for Old Jugs: Tradition and Innovation at the Jugtown Pottery*. Columbia: McKissick Museum, 1994.

Denny, Walter B. *Iznik: The Artistry of Ottoman Ceramics*. London: Thames and Hudson, 2004.

De Waal, Edmund. *Bernard Leach*. London: Tate Gallery Publishing, 1997.

Dillingham, Rick. *Acoma and Laguna Pottery*. Santa Fe: School of American Research Press, 1992.

Dobbie, Ian. *The Maker's Eye*. Rugby: Craft Council Exhibitions, 1981.

Duffy, Karen M. "The Work of Virgil Boruff, Indiana Limestone Craftsman," *Midwestern Folklore* 22:2 (1996): 3–71.

———. "Carry It On for Me: Tradition and Familial Bonds in the Art of Acoma Pottery." Ph.D. Indiana University, 2002.

———. "Bringing Them Back: Wanda Aragon and the Revival of Historic Pottery Designs at Acoma," in Cashman, Mould, and Shukla, *The Individual and Tradition* (2011), pp. 195–218.

———. "Pouring What the Vessel Holds: Four Southern Potters Speak," *El Palacio* 120:1 (2015): 56-61.

Edgeler, John. *Michael Cardew and the West Country Slipware Tradition*. Winchcombe: Cotswolds Living, 2007.

———. *The Fishleys of Fremington: A Devon Slipware Tradition*. Winchcombe: Cotswolds Living, 2008.

———. *Michael Cardew and Stoneware*. Winchcombe: Cotswolds Living, 2008.

———. *Slipware and St. Ives: The Leach Pottery, 1920–1937*. Winchcombe: Cotswolds Living, 2010.

Eliot, T.S. *Selected Essays*. New York: Harcourt, Brace & World, 1964.

Ellmann, Richard. *James Joyce*. New York: Oxford University Press, 1959.

Evans, Timothy H. *King of the Western Saddle: The Sheridan Saddle and the Art of Don King*. Jackson: University Press of Mississippi, 1998.

Faulkner, R. F. J., and O. R. Impey. *Shino and Oribe Kiln Sites: A Loan Exhibition of Mino Shards from Toki City*. Oxford: Robert G. Sawers, 1981.

Faulkner, William. *Intruder in the Dust*. London: Chatto and Windus, 1962 [1949].

Feintuch, Burt, ed. *Eight Words for the Study of Expressive Culture*. Urbana: University of Illinois Press, 2003.

Fernandes, Isabel Maria, ed. *Figurado Português: De Santos e Diabos Está o Mundo Cheio*. Porto: Livraria Civilização, 2005.

Ferris, William. *"You Live and Learn, Then You Die and Forget It All": Ray Lum's Tales of Horses, Mules, and Men*. New York: Anchor Books, 1992.

———. *James "Son Ford" Thomas: The Devil and His Blues*. New York: 8owse Gallery, 2015.

Fontana, Bernard L., William J. Robinson, Charles W. Cormack, and Ernest E. Leavitt, Jr. *Papago Indian Pottery*. Seattle: University of Washington Press, 1962.

Friedman, Martin. *Adolph Gottlieb*. Minneapolis: Walker Art Center, 1963.

García Márquez, Gabriel. *One Hundred Years of Solitude*. Gregory Rabassa, trans. New York: Harper & Row, 1970 [1967].

———. *Living to Tell the Tale*. Edith Grossman, trans. New York: Alfred A. Knopf, 2003.

Glasgow, Andrew. *Rich History, Vibrant Present: Ceramics by Ben Owen III*. Boston: Pucker Gallery, 2016.

Glassic, Henry. "William Houck, Maker of Pounded Ash Adirondack Pack-Baskets," *Keystone Folklore Quarterly* 12:1 (1967): 23–54.

——. *Pattern in the Material Folk Culture of the Eastern United States*. Philadelphia: University of Pennsylvania Press, 1968.

——. *Folk Housing in Middle Virginia: A Structural Analysis of Historic Artifacts*. Knoxville: University of Tennessee Press, 1976.

——. *Passing the Time in Ballymenone: Culture and History of an Ulster Community*. Philadelphia: University of Pennsylvania Press, 1982.

——. *The Spirit of Folk Art*. New York: Harry N. Abrams, 1989.

——. "A Master of the Art of Carpet Repair: The Life of Hagop Barın," *Oriental Rug Review* 9:6 (1989): 32–38; 10:1 (1989): 16–22; 10:2 (1990): 38–43.

——. *Turkish Traditional Art Today*. Bloomington: Indiana University Press, 1993.

——. *Günümüzde Geleneksel Türk Sanatı*. Istanbul: Pan Yayıncılık, 1993.

——. *Art and Life in Bangladesh*. Bloomington: Indiana University Press, 1997.

——. *Material Culture*. Bloomington: Indiana University Press, 1999.

——. *The Potter's Art*. Bloomington: Indiana University Press, 1999.

——. *Vernacular Architecture*. Bloomington: Indiana University Press, 2000.

——. "Tradition," in Feintuch, *Eight Words for the Study of Expressive Culture* (2003), pp. 176–97.

——. *The Stars of Ballymenone*. Bloomington: Indiana University Press, 2006.

——. *Mark Hewitt: Outside*. Wilmington: Louise Wells Cameron Art Museum, 2007.

——. *Prince Twins Seven-Seven: His Art, His Life in Nigeria, His Exile in America*. Bloomington: Indiana University Press, 2010.

——. "Mark in Place," in Hewitt, *Falling into Place* (2010), p. 5.

——. "Prince Twins Seven-Seven: 1944–2011," *African Arts* 45:1 (2012): 8–11.

——. "Architectural Vision in the Art of Winton and Rosa Eugéne," in Przybysz and Crosby, *Place It/Face It: Pottery by Eugéne* (2018), pp. 42–49.

Glassie, Henry, and Firoz Mahmud. *Contemporary Traditional Art of Bangladesh*. Dhaka: National Museum of Bangladesh, 2000.

——. *Living Traditions*. Dhaka: Asiatic Society of Bangladesh, 2007.

——. Glassie, Henry, Clifford R. Murphy, and Douglas Dowling Peach. *Ola Belle Reed and Southern Mountain Music on the Mason-Dixon Line*. Atlanta: Dust-to-Digital, 2015.

——. Glassie, Henry, and Pravina Shukla. *Sacred Art: Catholic Saints and Candomblé Gods in Modern Brazil*. Bloomington: Indiana University Press, 2018.

Goldstein, Kenneth S. "William Robbie: Folk Artist of the Buchan District, Aberdeenshire," in Beck, *Folklore in Action* (1962), pp. 101–111.

Grant, Alison. *North Devon Pottery*. Appledore: Edward Gaskell, 2005.

Griaule, Marcel. *Folk Art of Black Africa*. New York: Tudor, 1950.

Güner, Güngör. *Anadolu'da Yaşmakta Olan İlkel Çömlekçilik*. Istanbul: Ak Yayınları, 1988.

Hamilton, Mark. *Rare Spirit: A Life of William De Morgan, 1839–1917*. London: Constable, 1997.

Hansen, Gregory. *A Florida Fiddler: The Life and Times of Richard Seaman*. Tuscaloosa: University of Alabama Press, 2007.

Harpe, Jason, and Brian Dedmond. *Valley Ablaze: Pottery Tradition in the Catawba Valley*. Conover: Lincoln County Historical Association, 2012.

Harper, Suzanne, and John A. Burrison. *Georgia Clay: Pottery of the Folk Tradition*. Macon: Museum of Arts and Sciences, 1989.

Harrod, Tanya. "The Artist as a Young Man," in Hewitt, *Falling Into Place* (2010), pp. 1–2.

——. *The Last Sane Man: Michael Cardew: Modern Pots, Colonialism and the Coun-*

terculture. New Haven: Yale University Press, 2012.

Herold, Jane, ed. "Michael Cardew: Cardew's Legacy," *The Studio Potter* 22:3 (1994): 21–33.

Hewitt, Mark. "The Making of a Potter" *Ceramics Monthly* 39:1 (1991): 43–47.

——. "Tradition is the Future," *The Studio Potter* 28:2 (2000): 14–16.

——. "The Poetry in North Carolina Pottery," in Perry, *North Carolina Pottery* (2004), pp. 28–32.

——. "I Want to Lie Down and Sleep in its Shadow," in Bayer, *New Pots* (2007), pp. 7–19.

——. *Falling Into Place*. Durham: Nasher Museum of Art at Duke University, 2010.

——. "A Few of My Favorite Things about North Carolina Pottery," in Cashman, Mould, and Shukla, *The Individual and Tradition* (2011), pp. 454–70.

——. "A Few of My Favorite Things about North Carolina Pottery," in *Mark Hewitt's Big-Hearted Pots*. New Orleans: Ogden Museum of Southern Art, 2011, pp. 23–26.

——, ed. *Great Pots from the Traditions of North and South Carolina*. Seagrove: North Carolina Pottery Center, 2017.

Hewitt, Mark, and Nancy Sweezy. *The Potter's Eye: Art and Tradition in North Carolina Pottery*. Chapel Hill: University of North Carolina Press, 2005.

Hickman, Money L., and Yasuhiro Satō. *The Paintings of Jakuchū*. New York: Harry N. Abrams, 1989.

Holland, W. Fishley. *Fifty Years a Potter*. Tring: Pottery Quarterly, 1958.

Holm, Bill. *Smoky-Top: The Art and Times of Willie Seaweed*. Seattle: University of Washington Press, 1983.

Holtzberg, Maggie. *Keepers of Tradition: Art and Folk Heritage in Massachusetts*. Lexington: Massachusetts Cultural Council, 2008.

——. "Place Matters: A Wooden Boat Builder in the Twenty-First Century," in Cashman, Mould, and Shukla, *The Individual and Tradition* (2011), pp. 112–25.

Hoskins, W.G. *Devon*. London: Collins, 1954.

Huffman, Barry G. *Catawba Clay: Contemporary Southern Face Jug Makers*. Hickory: A.W. Huffman, 1999.

——. *Hand-in-Hand: Visions and Voices of North Carolina Folk Artists*. Hickory: Huffman, 2015.

Hunt, Marjorie. *The Stone Carvers: Master Craftsmen of Washington National Cathedral*. Washington: Smithsonian Institution Press, 1999.

——. Review of the MOIFA exhibition of southern pottery, *Journal of American Folklore* 129: 512 (2016): 243–46.

Huntington, David C. *The Landscapes of Frederic Edwin Church: Vision of an American Era*. New York: George Braziller, 1966.

Hurston, Zora Neale. *Barracoon: The Story of the Last "Black Cargo."* Deborah G. Plant, ed. New York: Amistad, 2018 [c. 1931]

Hyde, Douglas. *Mayo Stories Told by Thomas Casey*. Dublin: Irish Texts Society, 1939.

Hymes, Dell. *Foundations in Sociolinguistics: An Ethnographic Approach*. Philadelphia: University of Pennsylvania Press, 1974.

Impey, Oliver, ed. *Fourteenth Red: Sakaida Kakiemon XIV*. Fukuoka: Kataribe Bunko, 1993.

Ioannou, Noris. *Ceramics in South Australia, 1836–1986: From Folk to Studio Pottery*. Netley: Wakefield Press, 1986.

Ives, Edward D. *Joe Scott: The Woodsman-Songmaker*. Urbana: University of Illinois Press, 1978.

Johnston, Daniel. *Pots from an Apprenticeship*. Asheboro: Moring Arts Center, 2001.

Johnston, Kate. "Kate and Daniel Johnston," *Ceramics Monthly* 64:3 (2016): 30–33.

Jones, Matt. *Endurance: Potting in the Twenty-first Century*. Asheville: Jones, 2014.

Jones, Michael Owen. *Craftsman of the Cumberlands: Tradition and Creativity*. Lexington: University Press of Kentucky, 1989 [1975].

Jopling, Carol F., ed. *Art and Aesthetics in Primitive Societies: A Critical Anthology*. New York: E.P. Dutton, 1971.

Joyce, James. *Dubliners*. Robert Scholes, ed. London: Folio, 2003 [1914].

———. *A Portrait of the Artist as a Young Man*. New York: B.W. Huebsch, 1922 [1916].

———. *Ulysses*. Paris: Shakespeare and Company, 1922.

———. *Finnegans Wake*. New York: Viking Press, 1939.

———. *Stephen Hero: A Part of the First Draft of A Portrait of the Artist as a Young Man*. Theodore Spencer, ed. New York: New Directions, 1944.

Joyce, Rosemary O. *A Bearer of Tradition: Dwight Stump, Basketmaker*. Athens: University of Georgia Press, 1989.

Kandinsky, Wassily. *Concerning the Spiritual in Art and Painting in Particular*. New York: George Wittenborn, 1964 [1912].

Kandinsky, Wassily, and Franz Marc, eds. *The Blaue Reiter Almanac*. Klaus Lankheit, ed. New York: DaCapo Press, 1974 [1912].

Kawano Ryōsuke and Enomoto Toru. *Hagi: 400 Ans de Céramique*. Paris: Maison de la Culture du Japon à Paris, 2000.

Kay, Kathy L., ed. *Built upon Honor: The Ceramic Art of Ben Owen and Ben Owen III*. Charlotte: Mint Museum of Art, 1995.

Kenaan-Kedar, Nurith. *The Armenian Ceramics of Jerusalem: Three Generations, 1919–2003*. Tel Aviv: Eretz Israel Museum, 2003.

Kikuchi, Yuko. "Hamada and the *Mingei* Movement," in Wilcox, *Shoji Hamada* (1998), pp. 21–25.

Kimmelman, Michael. *Portraits: Talking with Artists at the Met, the Modern, the Louvre and Elsewhere*. New York: Modern Library, 1999.

Kirshenblatt, Mayer, and Barbara Kirshenblatt-Gimblett. *They Called Me Mayer July: Painted Memories of a Jewish Childhood in Poland before the Holocaust*. Berkeley: University of California Press, 2006.

Klee, Felix, ed. *The Diaries of Paul Klee, 1898–1918*. Berkeley: University of California Press, 1968 [1957].

Kociejowski, Marius. *God's Zoo: Artists, Exiles, Londoners*. Manchester: Carcanet, 2014.

Kolhan, Saim. *Çini: Sır Atındaki Aşk*. Istanbul: Minval Yayınları, 2015.

Korzon, Dave. "Studio Potter Mark Hewitt," *The Village Rambler* 2:2 (2005): 4–17.

Koverman, Jill Beute, ed. *I Made This Jar: The Life and Works of the Enslaved African-American Potter Dave*. Columbia: McKissick Museum, University of South Carolina, 1998.

———. *Making Faces: Southern Face Vessels from 1840–1990*. Columbia: McKissick Museum, 2000.

Kramer, Barbara. *Nampeyo and Her Pottery*. Albuquerque: University of New Mexico Press, 1996.

Kuroda, Ryōji, and Takeshi Murayama. *Classic Stoneware of Japan: Shino and Oribe*. Tokyo: Kodansha, 2002.

Lane, Arthur. *Later Islamic Pottery: Persia, Syria, Egypt, Turkey*. London: Faber and Faber, 1957.

Larson, Phoebe. "The Art of Repetition: North Carolina Potter John Vigeland," *Carleton College Voice* 79:3 (2014): 28–31.

Leach, Bernard. *A Potter's Book*. Levittown: Transatlantic Arts, 1973 [1940].

———. *A Potter in Japan, 1952–1954*. London: Faber and Faber, 1960.

———. *A Potter's Work*. London: Evelyn, Adams & Mackay, 1967.

——. *The Potter's Challenge.* David Outerbridge, ed. New York: E.P. Dutton, 1975.

——. *Hamada: Potter.* Tokyo: Kodansha, 1990 [1975].

——. "Introduction," in Crafts Advisory Committee, *Michael Cardew* (1976), pp. 7–8.

——. *Drawings, Verse & Belief.* London: Jupiter, 1977.

——. *Beyond East and West: Memoirs, Portraits and Essays.* London: Faber and Faber, 1978.

Lebow, Edward. "Mark Hewitt: Village Potter," *American Craft* 64:6 (2004–2005): 42–45.

Le Corbusier. *Journey to the East.* Ivan Zaknić, ed. and trans. Cambridge: The MIT Press, 1989 [1966].

Leiris, Michel. *Phantom Africa.* Brent Hayes Edwards, trans. Calcutta: Seagull Books, 2017.

Lévi-Strauss, Claude. *Tristes Tropiques.* John and Doreen Weightman, trans. New York: Penguin, 1992 [1955].

Lewis, J.M. *The Ewenny Potteries.* Cardiff: National Museum of Wales, 1982.

Lewis, Oscar. *Pedro Martinez: A Mexican Peasant and His Family.* London: Secker & Warburg, 1964.

Li, He. *Chinese Ceramics: A New Comprehensive Survey.* New York: Rizzoli, 1996.

Lock, Robert C. *The Traditional Potters of Seagrove, North Carolina: And Surrounding Areas from the 1800s to the Present.* Greensboro: Antiques and Collectibles Press, 1994.

MacCarthy, Fiona. *William Morris: A Life for Our Time.* New York: Alfred A. Knopf, 1995.

Mack, Charles R. *Talking with the Turners: Conversations with Southern Folk Potters.* Columbia: University of South Carolina Press, 2006.

Marriott, Alice. *María: The Potter of San Ildefonso.* Norman: University of Oklahoma Press, 1948.

Martins, Flávia, Rogerio Luz, and Pedro Belchior. *Nova Fase da Lua: Escultores Populares de Pernambuco.* Recife: Caleidoscópio, 2013.

McGara, Andrew. *Country Pottery: The Traditional Earthenware of Britain.* London: A&C Black, 2000.

Mecham, Denny Hubbard, Michelle Francis, and Charles Zug III. *The Living Tradition: North Carolina Potters Speak.* Conover: North Carolina Pottery Center, 2009.

Medley, Margaret. *The Chinese Potter: A Practical History of Chinese Ceramics.* Ithaca: Cornell University Press, 1976.

Mee, Charles L., Jr. *Rembrandt's Portrait: A Biography.* New York: Simon and Schuster, 1988.

Merton, Robert K. *On Theoretical Sociology: Five Essays Old and New.* New York: The Free Press, 1967.

Millard, Charles, ed. *Mark Hewitt: Potter.* Raleigh: Visual Arts Center, North Carolina State University, 1997.

Minchilli, Elizabeth Helman. *Deruta: A Tradition of Italian Ceramics.* San Francisco: Chronicle Books, 1998.

Mink, Janis. *Marcel Duchamp, 1887–1968: Art as Anti-Art.* Koln: Taschen, 2006.

Mino, Yutaka. *Freedom of Clay and Brush through Seven Centuries in Northern China: Tz'u-chou Type Wares, 960–1600 A.D.* Bloomington: Indiana University Press, 1980.

Moeran, Brian. *Lost Innocence: Folk Craft Potters of Onta, Japan.* Berkeley: University of California Press, 1984.

Moes, Robert. *Mingei: Japanese Folk Art.* Alexandria: Art Services International, 1995.

Morris, May, ed. *The Collected Works of William Morris.* 24 vols. London: Longmans, Green, 1910–1915.

Morris, William. *Hopes and Fears for Art: Five Lectures Delivered in Birmingham, London, and Nottingham.* London: Longmans, Green, 1898 [1882].

———. *Signs of Change: Seven Lectures*. London: Longmans, Green, 1903 [1888].

———. *News from Nowhere: Or, An Epoch of Rest, Being Some Chapters from a Utopian Romance*. Hammersmith: Kelmscott Press, 1892.

———. *Architecture, Industry and Wealth: Collected Papers*. London: Longsmans, Green, 1902.

Morse, Samuel C. *Shaped with a Passion: The Carl A. Weyerhauser Collection of Japanese Ceramics from the 1970s*. Duxbury: Art Complex Museum, 1998.

Morton, Robin. *Come Day, Go Day, God Send Sunday: The Songs and Life Story, Told in His Own Words, of John Maguire, Traditional Singer and Farmer from Co. Fermanagh*. London: Routledge and Kegan Paul, 1973.

Morton, Willard D., Jr. *Handmade: A History of the North State Pottery, 1924–1959, Sanford, N.C.* Boonville: Carolina Avenue, 2003.

Mould, Tom. *Gracious Fanatics: The Passion for Pottery in North Carolina*. Film. Burlington: PERCS, 2005.

Munsterberg, Hugo. *Mingei: Folk Arts of Old Japan*. New York: Asia Society, 1965.

Nagatake, Takeshi. *Kakiemon*. Tokyo: Kodansha, 1981.

Naipaul, V.S. *A House for Mr. Biswas*. New York: Alfred A. Knopf, 1983 [1961].

———. *Finding the Center*. New York: Alfred A. Knopf, 1984.

National Museum of Modern Art. *Kanjiro Kawai: Catalogue of Kawatsu Collection*. Kyoto: National Museum of Modern Art, 1983.

Newman, Barnett. *Selected Writings and Interviews*. John P. O'Neill, ed. Berkeley: University of California Press, 1992.

North Carolina Pottery Center. *The Collector's Eye, Series I: Seven Perspectives*. Seagrove, North Carolina Pottery Center, 2010.

———. *The Collector's Eye, Series II: Seven Perspectives*. Seagrove: North Carolina Pottery Center, 2012.

Notini, Anja. *Krukmakare: Möte med Tradition*. Stockholm: Streiffert, 1985.

Ó Duilearga, Séamus. *Seán Ó Conaill's Book: Stories and Traditions from Iveragh*. Dublin: Comhairle Bhéaloideas Éireann, 1981 [1948].

Olsen, Frederick L. *The Kiln Book: Materials, Specifications and Construction*. Iola: Krause, 2001.

Owen, Ray, Douglas DeNatale, and Stephen C. Compton. *The Busbee Legacy: Jugtown and Beyond, 1917–2017*. Seagrove: North Carolina Pottery Center, 2017.

Pearson, Barry Lee. *Virginia Piedmont Blues: The Lives and Art of Two Virginia Bluesmen*. Philadelphia: University of Pennsylvania Press, 1990.

Perry, Barbara Stone, ed. *North Carolina Pottery: The Collection of the Mint Museums*. Chapel Hill: University of North Carolina Press, 2004.

Peterson, Susan. *Shoji Hamada: A Potter's Way and Work*. Tokyo: Kodansha, 1974.

———. *Lucy M. Lewis: American Indian Potter*. Tokyo: Kodansha, 1984.

Pevsner, Nikolaus. *Pioneers of the Modern Movement: From William Morris to Walter Gropius*. London: Faber and Faber, 1936.

Piccolpasso, Cavaliere Cipriano. *The Three Books of the Potter's Art*. Bernard Rackham and Albert Van de Put, trans. London: Victoria and Albert Museum, 1934 [1548].

Pryzbysz, Jane, and Katherine Crosby, eds. *Place It/Face It: Pottery by Eugéne*. Columbia: McKissick Museum, University of South Carolina, 2018.

Recker, Keith. "The Potter is Present: Alex Matisse's Creative Cycle of Intention, Accident, and Community," *The Brooklyn Rail*, April 2014, pp. 53–54.

Reina, Ruben E., and Robert M. Hill II. *The Traditional Pottery of Guatemala.* Austin: University of Texas Press, 1978.

Rhead, G. Woolliscroft, and Frederick Alfred Rhead. *Staffordshire Pots and Potters.* New York: Dodd, Mead, 1907.

Rinzler, Ralph. *The Meaders Family: North Georgia Potters.* Film. Washington: Smithsonian Folkways Recordings, 1978 [1967].

Rinzler, Ralph, and Robert Sayers. *The Meaders Family: North Georgia Potters.* Washington: Smithsonian Institution Press, 1980.

Rose, Muriel. *Artist-Potters in England.* London: Faber and Faber, 1955.

Rosenberg, Neil V., and Charles K. Wolfe. *The Music of Bill Monroe.* Urbana: University of Illinois Press, 2007.

Rothko, Mark. *Writings on Art.* Miguel López-Remiro, ed. New Haven: Yale University Press, 2006.

Rushdie, Salman. *Imaginary Homelands: Essays and Criticism, 1981–1991.* London: Granta Books, 1991.

Ruskin, John. *The Stones of Venice.* 3 vols. London: Smith, Elder, 1851–1853.

———. *Lectures on Architecture and Painting, Delivered at Edinburgh, in November, 1853.* New York: John Wiley, 1864.

———. *The Nature of Gothic: A Chapter of the Stones of Venice.* Hammersmith: Kelmscott Press, 1892.

Sanders, Herbert H. *The World of Japanese Ceramics.* Tokyo: Kodansha, 1967.

Sani, Elisa P. *Italian Renaissance Maiolica.* London: Victoria and Albert, 2012.

Saramago, José. *Baltasar and Blimunda.* Giovanni Pontiero, trans. New York: Harcourt Brace Jovanovich, 1987 [1982].

———. *The Cave.* Margaret Jull Costa, trans. New York: Harcourt, 2002.

———. *Small Memories.* Margaret Jull Costa, trans. Boston: Houghton Mifflin Harcourt, 2011.

Sartre, Jean-Paul. *Between Existentialism and Marxism.* John Mathews, trans. New York: William Morrow, 1976.

Sawin, Patricia. *Listening for a Life: A Dialogic Ethnography of Bessie Eldreth through Her Songs and Stories.* Logan: Utah State University Press, 2004.

Sayers, Robert, and Ralph Rinzler. *The Korean Onggi Potter.* Washington: Smithsonian Institution Press, 1987.

Scarborough, Quincy. *The Craven Family of Southern Folk Potters: North Carolina, Georgia, Tennessee, Arkansas and Missouri.* Fayetteville: Scarborough Companies, 2005.

Sekino-Bove, Yoko. "Bryce Brisco: The Art of Serving," *Pottery Making Illustrated* 17:2 (2014): 17–20.

Serin, Muhittin. *Kemal Batanay: Bestekâr, Tambûrî, Hattat, Hâfız.* Istanbul: Kubbealtı, 2006.

Shah, Haku. *Form and Many Forms of Mother Clay.* New Delhi: National Crafts Museum, 1985.

Shah Jalal, Mohammad. *Traditional Pottery in Bangladesh.* Dhaka: International Voluntary Services, 1987.

Shapiro, Mark, ed. *A Chosen Path: The Ceramic Art of Karen Karnes.* Chapel Hill: University of North Carolina Press, 2010.

———. *500 Percent: Pottery by Mark Hewitt.* Boston: Pucker Gallery, 2017.

Shaw, Simeon. *History of the Staffordshire Potteries.* New York: Praeger, 1970 [1829].

Shukla, Pravina. *Costume: Performing Identities through Dress.* Bloomington: Indiana University Press, 2015.

Simmons, Leo W. *Sun Chief: The Autobiography of a Hopi Indian.* New Haven: Yale University Press, 1942.

Soyinka, Wole. *Art, Dialogue, and Outrage: Essays on Literature and Culture.* New York: Pantheon, 1994.

———. *Of Africa.* New Haven: Yale University Press, 2012.

Stein, Gertrude. *Picasso.* Boston: Beacon Press, 1959 [1938].

Strauss, Cindi, and Garth Clark. *Shifting Paradigms in Contemporary Ceramics: The Garth Clark and Mark Del Vecchio Collection.* New Haven: Yale University Press, 2012.

Summers, Wendy. "Making Mega-Pots with Mark Hewitt," *Clay Times* 10:6 (2004): 50–53.

Suzuki, Daisetz T. *Zen and Japanese Culture.* Princeton: Princeton University Press, 1993 [1970].

Sweezy, Nancy. *Raised in Clay: The Southern Pottery Tradition.* Washington: Smithsonian Institution Press, 1984.

Synge, John M. *The Aran Islands.* Dublin: Maunsel, 1906.

Szwed, John. *So What: The Life of Miles Davis.* New York: Simon & Schuster, 2002.

Tagore, Rabindranath. *Lectures and Addresses: Selected from the Speeches of the Poet.* Anthony X. Soares, ed. Delhi: Macmillan India, 1980.

Takahara, Takashi. "The World of Ogre-Tile Makers: The Onihyaku Line in Hekinan, Japan," in Cashman, Mould, and Shukla, *The Individual and Tradition* (2011), pp. 170–93.

——. *Onishi No Sekai.* Nagoya: Arm Inc., 2017.

Thomas, Dylan. *Portrait of the Artist as a Young Dog.* New York: New Directions, 1955.

Thompson, E.P. *William Morris: Romantic to Revolutionary.* New York: Pantheon, 1977.

Thompson, Robert Farris. *Black Gods and Kings: Yoruba Art at UCLA.* Los Angeles: Museum and Laboratories of Ethnic Art and Technology, 1971.

——. "Aesthetics in Traditional Africa," in Jopling, *Art and Aesthetics in Primitive Societies* (1971), pp. 374–81.

——. "Yoruba Artistic Criticism," in d'Azevedo, *The Traditional Artist in African Societies* (1974), pp. 18–61.

——. *African Art in Motion: Icon and Act.* Berkeley: University of California Press, 1974.

——. *Flash of the Spirit: African and Afro-American Art and Philosophy.* New York: Vintage, 1984.

Thoreau, Henry David. *Walden.* London: J.M. Dent, 1994 [1854].

Tichane, Robert. *Ching-te-chen: Views of a Porcelain City.* Painted Post: New York State Institute for Glaze Research, 1983.

Tidmore, Stacy Anne. "The Art of Collection: Personal Creativity and Presentation in Everyday Life." Ph.D. Indiana University, 2003.

Todd, Leonard. *Carolina Clay: The Life and Legend of the Slave Potter Dave.* New York: W.W. Norton, 2008.

Toynton, Evelyn. *Jackson Pollock.* New Haven: Yale University Press, 2012.

Uchida, Yoshiko, ed. *We Do Not Work Alone: The Thoughts of Kanjiro Kawai.* Kyoto: Kawai Kanjiro's House, 1973.

Vasari, Giorgio. *Lives of the Most Eminent Painters.* 2 vols. Marilyn Aronberg Lavin, ed. Verona: Limited Editions Club, 1966 [1568].

Vermelho, Joaquim. *Barros de Estremoz: Contributo Monográfico para o Estudo da Olaria e da Barrística.* Estremoz: Compta, 1989.

Vlach, John Michael. *The Afro-American Tradition in Decorative Arts.* Cleveland: Cleveland Museum of Art, 1978.

——. *Charleston Blacksmith: The Work of Philip Simmons.* Columbia: University of South Carolina Press, 1992 [1981].

Von Friesen, Otto. *Krukan från Raus.* Stockholm: Nordiska Museet, 1976.

Waiboer, Adriaan, ed. *Vermeer and the Masters of Genre Painting: Inspiration and Rivalry.* New Haven: Yale University Press, 2017.

Wardropper, Ian. *Bernini's Rome: Italian Baroque Terracottas from the State Hermitage Museum, St. Petersburg.* Chicago: Art Institute of Chicago, 1998.

Waterhouse, Max. *Clive Bowen*. Uppingham: Goldmark Gallery, 2014.

Wheeler, Ron, and John Edgeler. *Sid Tustin, Winchcombe Potter: A Celebration*. Winchcombe: Cotswolds Living, 2005.

White, Matt. "Artist and Residence: Mark and Carol Hewitt Build a Famed Pottery Studio and a Home," *Chatham Magazine*, February-March 2018, pp. 72–88.

Whybrow, Marion. *The Leach Pottery and Its Influence*. Bristol: Sansom, 1996.

——. *Leach Pottery St. Ives: The Legacy of Bernard Leach*. St. Ives: Beach Books, 2006.

Wiedemann, Barbara. *Controlled Burn: Wood-fired Pottery in Seagrove, North Carolina*. Seagrove: North Carolina Pottery Center, 2017.

Wigginton, Eliot, and Margie Bennett, eds. *Foxfire 8*. New York: Anchor Books, 1984.

Wilcox, Timothy, ed. *Shoji Hamada: Master Potter*. London: Lund Humphries, 1998.

Williams, Sean, and Lillis Ó Laoire. *Bright Star of the West: Joe Heaney, Irish Song Man*. Oxford: Oxford University Press, 2011.

Wilson, Richard L. *Inside Japanese Ceramics: A Primer of Materials, Techniques, and Traditions*. New York: Weatherhill, 1995.

Wingard, Philip. *Swag and Tassel: The Innovative Stoneware of Thomas Chandler*. Columbia: McKissick Museum, 2018.

Woods, Vincent, and Henry Glassie. *Borderlines*. Carrick on Shannon: Leitrim County Council Arts Office, 2018.

Wright, Richard. *Native Son*. New York: Harper Collins, 2005 [1940].

——. *Black Boy: A Record of Childhood and Youth*. New York: Harper & Brothers, 1945.

Yager, Jay. *4000 Gallons: Daniel Johnston's 100 Large Jar Project*. Video. Jay Yager, 2011.

Yanagi, Sōetsu. *Folk-Crafts in Japan*. Tokyo: Kokusai Bunka Shinkokai, 1958.

——. *The Unknown Craftsman: A Japanese Insight into Beauty*. Bernard Leach, ed. Tokyo: Kodansha, 1978.

Yeats, W.B. *The Cutting of an Agate*. London: Macmillan, 1919.

——. *Later Poems*. New York: Macmillan, 1924.

——. *Autobiographies: Reveries Over Childhood and Youth and The Trembling of the Veil*. New York: Macmillan, 1927.

Zug, Charles G., III. "Pursuing Pots: On Writing a History of North Carolina Folk Pottery," *North Carolina Folklore Journal* 27:3 (1979): 34–55.

——. *The Traditional Pottery of North Carolina*. Chapel Hill: Ackland Art Museum, University of North Carolina, 1981.

——. *Turners and Burners: The Folk Potters of North Carolina*. Chapel Hill: University of North Carolina Press, 1986.

——. *Burlon Craig: An Open Window on the Past*. Raleigh: Visual Arts Center, North Carolina State University, 1994.

——. "Consuming Pots: Listening to Mark Hewitt's Customers," in Millard, *Mark Hewitt* (1997), pp. 14–19.

——. "Entering Tradition: Kim Ellington, Catawba Valley Potter," in Cashman, Mould, and Shukla, *The Individual and Tradition* (2011), pp. 27–45.

——. *"Remember Me as You Pass By": North Carolina's Ceramic Grave Markers*. Seagrove: North Carolina Pottery Center, 2011.

——. "The Alkaline Glaze," in Hewitt, *Great Pots* (2017), pp. 99–101.

——. "The Salt Glaze," in Hewitt, *Great Pots* (2017), pp. 147–49.

Zug, Charles G., III, and Mark Hewitt. *Mark Hewitt: Stuck in the Mud*. Cullowhee: Belk Gallery, Western Carolina University, 1992.

INDEX

Daniel Johnston at his installation, June 25, 2019